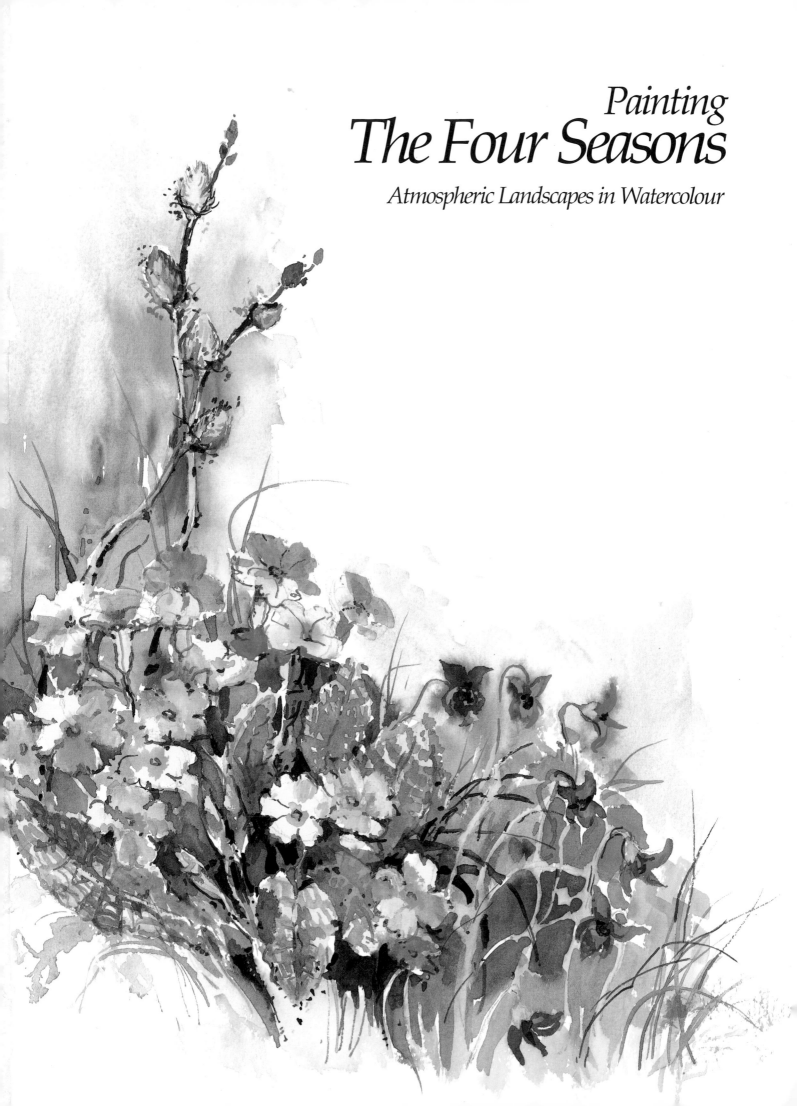

Painting
The Four Seasons
Atmospheric Landscapes in Watercolour

Painting
The Four Seasons

Atmospheric Landscapes in Watercolour

Dale Evans · Wendy Jelbert
Aubrey Phillips · Timothy Pond

Search Press

First published in Great Britain 1994

Search Press Limited
Wellwood, North Farm Road,
Tunbridge Wells, Kent TN2 3DR

There are references to sable and other animal-hair brushes
in this book. It is the Publishers' custom to recommend
synthetic materials as substitutes wherever possible. There
are now many brushes available made of artificial fibres
which are as satisfactory as brushes made of natural fibres.

ISBN 0 85532 753 7

Colour separation by P&W Graphics Pte Ltd., Singapore.
Printed in Spain by Elkar S. Coop, 48013, Bilbao.

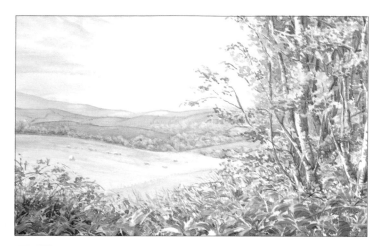

CONTENTS

Preface

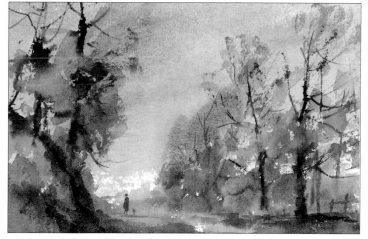

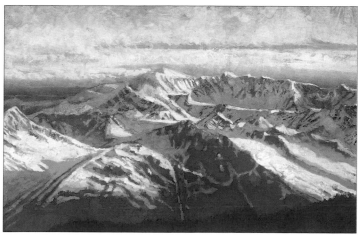

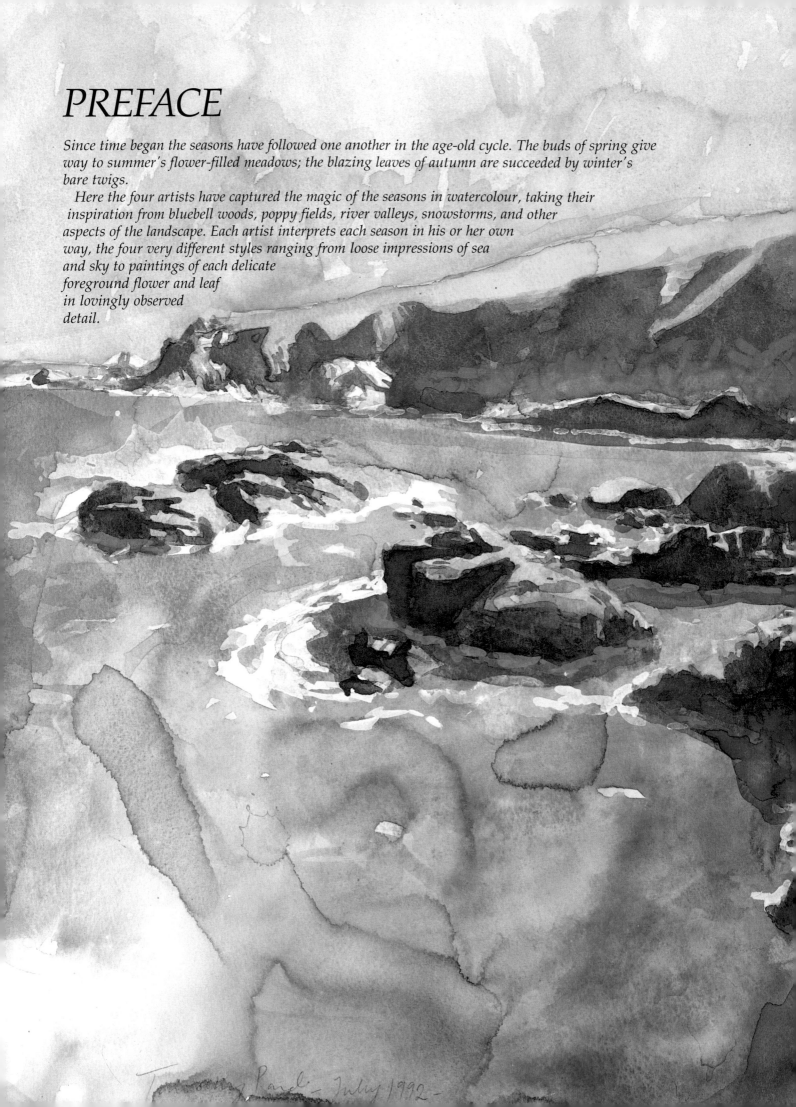

PREFACE

Since time began the seasons have followed one another in the age-old cycle. The buds of spring give way to summer's flower-filled meadows; the blazing leaves of autumn are succeeded by winter's bare twigs.

Here the four artists have captured the magic of the seasons in watercolour, taking their inspiration from bluebell woods, poppy fields, river valleys, snowstorms, and other aspects of the landscape. Each artist interprets each season in his or her own way, the four very different styles ranging from loose impressions of sea and sky to paintings of each delicate foreground flower and leaf in lovingly observed detail.

Each of these approaches is equally valid. You, as the artist, have the freedom to interpret the landscape in whichever way you choose, and to decide which aspect or mood to paint.

Over the next few pages, the four artists give you an insight into their thought-processes, their various ways of working, and their views about the seasons.

Dale Evans

Dale Evans spent her childhood on a small farm in South Wales. Always keen on natural history and painting, she took a degree in botany and zoology at University College Swansea but then switched careers and took a course in botanical illustration, followed by an M.A. in graphic design at Manchester Polytechnic.

From 1982 she worked full-time as a botanical illustrator at the National Museum of Wales, producing both paintings and wax models of plants for gallery display. In 1990 she became full-time self-employed as a natural history illustrator, and in 1991 was awarded the Linnaean Society's silver medal for her published botanical work. These days her illustrative work is varied and is constantly demanding new skills. She exhibits regularly with the Watercolour Society of Wales and in her free time she continues to 'explore different avenues'.

As a natural history illustrator I specialised in botanical work and for years I have worked in a traditional, tight, dry-brush manner. Although not conspicuous features in my work, background landscapes are an important element, providing habitat information and contributing a mood. They are generally quite lightly and loosely painted.

My landscapes are imaginary and complement main subjects which, due to seasonal or geographical availability, or rather unavailability, are more often than not reconstructions based on reference sources such as museum collections, photographs, videos, written descriptions, and illustrations. My approach to creating both subject and landscape is therefore similar, and so before starting a painting I familiarise myself with the species characteristics of my subject and also check that any 'props', as I call extra pictorial elements (which includes the landscape backgrounds), are appropriate for the natural history of that particular species. After this research I plan out and paint the picture, which is, by this stage, constructed in my 'mind's eye'.

For most illustrators this approach is second nature, since the chance of finding images exactly as specified in a brief are remote. It was appropriate for the atmospheric landscapes in this book, since I planned to create landscapes that would capture my own 'personal' seasons and I would therefore have to rely almost entirely on imagination fed by reference material.

Without specific places to paint, and despite having a seasonal theme, the scope was enormous and needed to be tightened up. I started by sifting through memories. Gradually I isolated the feelings and colour associations that I felt captured my mood for that time of year. Then I sat down, and, without having any clear images in mind and with the choice of a full palette, produced a sheet of small seasonal 'landscapes' in colour. These clarified the colour differences between the final paintings and helped to establish the mood and direction for adaptations of reference material. I could then start choosing the motifs that fitted my associations and begin composing my image.

The hours I spend in apparent idleness, browsing through books, sitting, thinking and doodling, are actually my busiest time. This is when I sift through ideas, selecting or discarding images until gradually the compositions evolve.

Once I knew my main motif I produced quick colour roughs incorporating elements I thought might work together. Some did; some did not. This narrowed the choices even further and I could then search for specific reference for the motifs and details needed.

Without a 'real' landscape as a starting point, all aspects of the paintings needed consideration. The problem is typical of illustration work and my preliminary roughs are essential for quickly testing overall composition and feel and for revealing deficiencies in my imagination!

The painting of these watercolour landscapes was a challenge. Not only were they to stand alone, without a detailed main subject to focus attention, but also the elements had to maintain a mood. I found that a new way of thinking about colour and composition was required, since just one misplaced element could destroy the mood.

I have no regular technique, and although my style is still essentially illustrative, constant experiment broadens my approach. As I play with different media, paper, and styles I pick up quicker, easier ways of achieving particular effects. I always choose the best of the materials available: the struggle to control paint is tough enough without contending with the unpredictable quirks of less expensive brands. For my dry-brush work, I use the finest sable brushes, but some time ago I discovered some fat French squirrel-hair brushes that are marvellous for larger-scale looser work. Despite their home-made appearance, three sizes of these provided all that I needed for these paintings.

My associations with each season may or may not be shared by others. I was particularly amused to discover that despite the vast range of landscape material I looked at before starting (some very exotic), the final selections for the paintings seem to have been determined very much by a likeness to places I have actually visited.

Wendy Jelbert

Wendy Jelbert studied sculpture, abstract art, pottery and printmaking at Southampton College of Art. She is a teacher and a professional artist who works in pastels, oils, acrylics and watercolour. She enjoys experimenting with different ways of using mixed media and texture and her sometimes unconventional methods often produce surprising and original results.

She lives near Andover, and has three children, two of whom are professional painters.

Galleries in Southampton, London, Brighton, Cornwall and Oxford regularly exhibit her work, and she has had a number of articles published in *Leisure Painter*.

Wendy has written four books on art and has made a video on mixed media.

I do not have a favourite season – as an artist I can see interest in all of them – but I find that as each season unfolds, it offers its own personal beauty and atmosphere.

I have illustrated this approach in four step-by-step projects, one for each of the seasons, and, by using the same cameo in each, I have highlighted and contrasted the colours, textures and moods of each.

Too many profound works have been written about watercolours! There are those who say that 'holy' watercolours should never be desecrated by adding anything but water. Little do they know that through the ages 'secret' ingredients such as flour, salts, turpentine and alcohol have been used to achieve that individual and elusive effect!

Watercolour is one of my favourite media. Its versatility and quick-drying qualities and the contrasting beauties of translucent and opaque washes make watercolour exciting and challenging. The limitations lie within the artist himself. I hope some of the ideas I suggest in my sections of this book will help you discover many new ways of painting in watercolour – there really are so many possibilities.

I use watercolours both in pans and in tubes, both artist and student quality, as each varies in colour and texture; gouache, again in pans, or in tubes for a thicker and bolder application; 300gsm (140lb) Not watercolour paper; and, to round off the list of materials, three main brushes; a 1.25cm (half-inch) flat-headed squirrel or ox brush, a round-headed watercolour brush, and a No. 1 rigger brush.

Like most painters, I went through a basic training. That introduction was only the beginning of my learning process. Since then, my techniques have evolved over many years of painting and teaching. The best form of learning is to learn from your mistakes. Remember that the faint-hearted never progress! Do not be afraid to attack a piece of watercolour paper with determination and courage!

You may, as most painters do, have adopted certain techniques that suit your temperament. In the projects in this book, I have endeavoured to use a wide range of different techniques, such as glazes, wet-into-wet, dry-brush work and the introduction of salts into watercolour washes to create special effects. I hope you will find something here to whet your appetite.

Aubrey Phillips

Aubrey Phillips is a member of the Royal West of England Academy and the Pastel Society. He was a Gold Medallist at the Paris Salon and is a regular exhibitor in London and the provinces. His pictures are in collections throughout England and overseas.

He lectures at the Bournville School of Art, besides running his own art courses on pastel, watercolour and oils in the West Country and Wales.

I am essentially a countryman with a great love of the open air and the changing seasons of the year, and I carry out as much of my work as possible on the spot, endeavouring to convey this love of nature through my painting.

I was born in Worcestershire, in that lovely Welsh Border county so beloved of Elgar, Housman and others. From my home I look up to the gentle contours of the Malvern Hills, and from their elevated shapes I can view the pastoral farmlands and homesteads of Herefordshire and see as far as the distant mountain peaks of Wales. In the east I see the Severn, winding its quiet journey over the plain, and the Avon, snaking through Evesham Vale southward towards the Cotswold Escarpment, with Housman's Bredon Hill presiding over the 'Coloured Counties'. When I look to the north I see the 'High-reared Head of Clee' and the other Shropshire hills.

It is in this setting that I watch the changing pageant of the seasons. I see the snows of winter surrender to the soft April breezes, and the sheltered hollows become bright with primroses and celandines. Once more the woods are carpeted with bluebells, and windflowers toss their cream-coloured heads in the breeze, with the hawthorn blossom white against the soft warm leaves of beech, larch and silver birch.

Gradually these soft tints are subdued into the general heavy greens of high summer, brightened by the banks of rosebay willowherb. The summer's heat begins to soften into days of mellow sunshine, and mists gather in the lower slopes until the sun breaks through on October dawns, making us aware that autumn is colouring the scene once more.

Soon the heavy storm-clouds begin to assemble their forces on the western horizon until they sweep in to deluge the scene with rain, changing to sleet, hail, and snow; and once again winter seizes the land in an icy grip.

I consider the choice of subject-matter to be important. I love an open landscape under a big sky, with a feeling of distance and space with an indication of the weather, while the closer confines of a woodland subject, perhaps seen on a misty morning or evening, could be interpreted too in large washes blending together, using true watercolour style. I myself tend to avoid subjects containing large areas of low key and detail.

In Britain the climate lends itself naturally to interpretation in watercolour, and I have always been fascinated by watercolour and its unique qualities, the most essential thereof being its transparency. To me, watercolour means transparent washes applied in as direct a way as possible.

In each section of this book I give some ideas on watercolour – washes, studies, or hints on paper, brushes, etc.

Lastly, my advice to every watercolourist is this: study the work of the early English school of watercolour painters. By this I mean Thomas Girtin, John Sell Cotman, Peter de Wint, David Cox, and, in particular, J.M.W. Turner, whose style Ruskin described as 'form dissolved in light': truly, the essence of watercolour.

Timothy Pond

Timothy Pond was born and brought up in Horsham, West Sussex, in the south of England. Interested in drawing and painting from an early age, he gained a B.A. in Fine Art at Bristol Polytechnic and is now teaching art in Suffolk.

In 1991 Timothy took part as the artist in an Alaskan expedition, where his interest in painting in watercolour began. He chose to capture the cold light and the immense scale of Alaska's landscape of glaciers and mountains. Since then Timothy has worked and painted in Cyprus and recently spent a summer sketching in Cornwall. Some of the work in this book comes from these periods and reflects his interest in light, colour and atmosphere.

Each new season inspires me to go out and capture it in paint! Although I live in a town where one could live through the year without really noticing the changes between the seasons, to someone like a farmer the seasons have real meaning: every task he carries out, whether ploughing, harrowing, sowing, or reaping, constantly reminds him of the season of the year. To an artist, too, the seasons are of great importance, and I find the changing moods will lure me out into the countryside...

When sketching out of doors, first of all I spend some time walking about in the vicinity of the view I want to paint, looking for not only the most satisfying composition, but also a comfortable place to sit out of the wind (I find bulldog clips useful for stopping sketchbook pages from flapping about in the wind). This will stop discomfort distracting me from painting! Looking about also lets me soak up the atmosphere. Painting the landscape should be influenced by your frame of mind – a simple statement of fact is not everything.

I try to record the overall effect without becoming bogged down in details. Everyone has his own approach: I prefer to indicate things simply. For example, I may abbreviate cows in a field to a few simple marks to give an overall impression of the animals.

With a wide panorama, I can sometimes feel a little intimidated about trying to capture the whole view, so I will sometimes choose just a small part of the scene in the first place. If there are aspects of the composition that do not please me, I may take a few liberties with their position, or remove objects. Remember – *you* compose the picture: the scene does not necessarily dictate to you. This will give your picture more authority.

First I decide upon a tonal key for my painting. An overall lightness in the painting will give an airy, morning feel, whereas a low key will give a moodier painting.

To keep the painting as translucent as possible I work from light to dark. First I decide which areas to leave white (I may save these areas with masking fluid). Areas of white are often not white at all, but a very light warm or cool tint. If this is the case, I lay a very pale wash which covers the whole of the page, unifying the composition.

I establish the next darkest tone, which I draw in with the brush, and then the next darkest, and so on.

Then I start laying in light washes of French ultramarine in the shadows, still drawing with the brush. This will create a tonal underpainting. In nature, the range of tones from dark to light is far wider than we can hope to put down on paper; so it is important to be selective and to mass together adjoining shapes of similar tone.

One way of building up a dark area is repeatedly to lay washes over a colour which has already dried. However, too many layers will make the area become dull and the watercolour will lose its translucency.

The beauty of watercolour is its transparent quality, and often I mix the colours on the page. If I want, say, a green and I already have a yellow wash on the paper, placing a blue one over the top will give me my green.

My palette is restricted to around twelve colours: French ultramarine; Prussian blue; cerulean blue (useful for painting skies); alizarin crimson (good for mixing purples); cadmium red; lemon yellow; cadmium yellow deep; yellow ochre; Hooker's green (useful if I want to get a very saturated dark green). From the variety of blues and yellows I have in my palette I can mix an infinite number of greens, and it is important that I do not become lazy and always use the ready-made green in my palette!

Other colours I find useful are raw umber, Payne's grey, and ivory black, which is useful for making quick sketches; with it I can mix some lovely smoky blue-greys.

I like to use sable brushes because they hold more water and give a sweeter mark, and I prefer cold-pressed paper, as this both allows you to get textural richness and is fine enough to allow for details. A 300gsm (140lb) paper is heavy enough not to buckle when covered by a wash, so it need not always be stretched.

I find it more economical to use watercolour pans rather than tubes, as I usually put too much paint from the tubes on to my palette, and it gets wasted. The pans are also easier to use out of doors.

Being out of doors, of course, is the only real way to appreciate the seasons properly – so pick up your painting gear now!

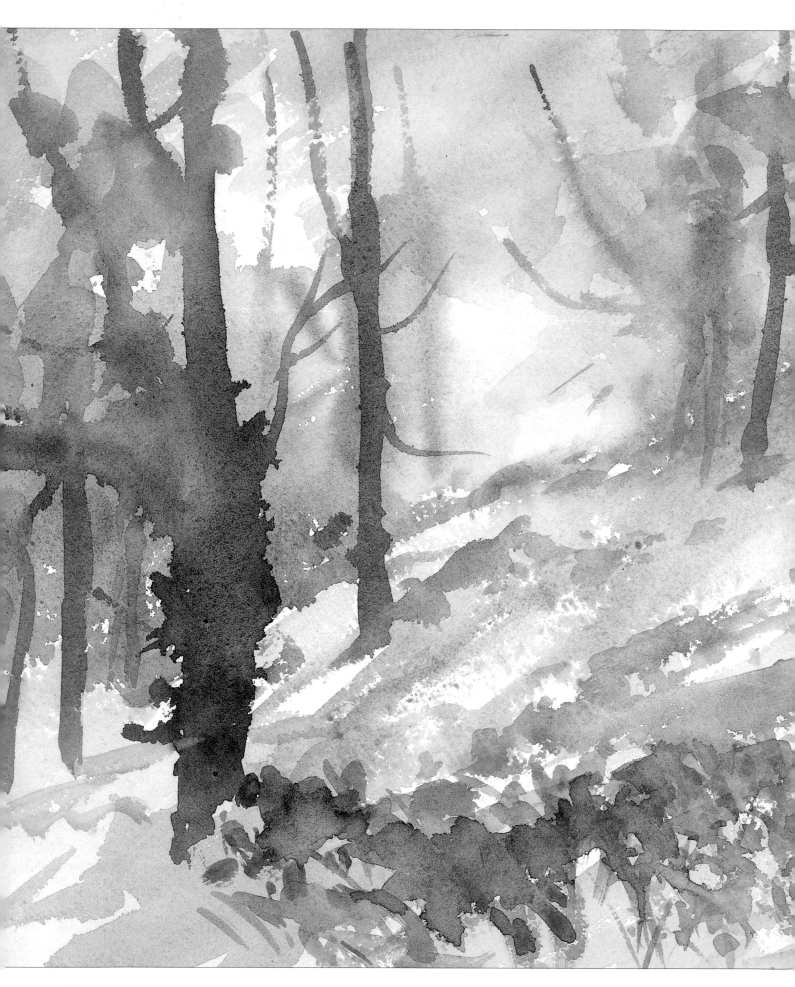

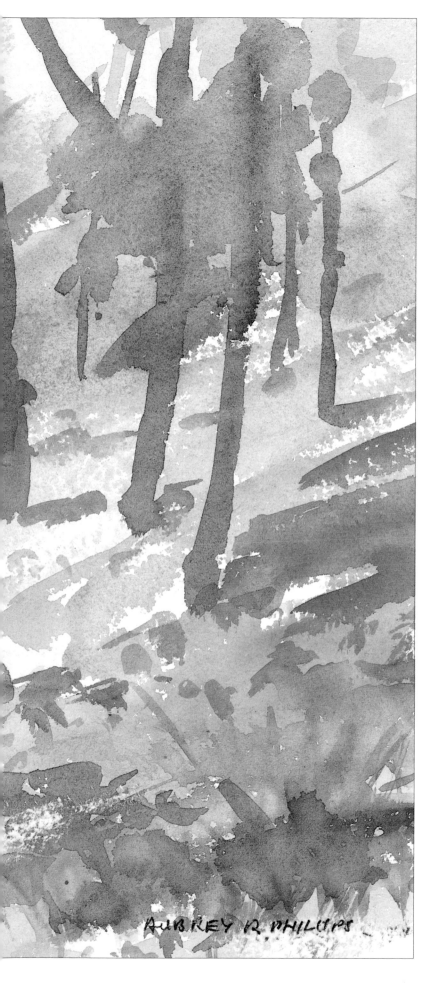

Spring

'The sun breaks through morning mists, casting shadows of the trees across the banks of bluebells and the creamy-white windflowers.'

Bluebell glade by Aubrey Phillips

Aubrey Phillips

I love each season of the year, different as they are. Spring, with its soft atmosphere and that sense of the rebirth of nature, is a season I particularly appreciate after the bleak frosts and storms of the long winter months. (I also derive great satisfaction, during the dark, cold days of winter, from taking out the studies I made during the brighter days of the year, and working from them in the comfort of my studio; although I do try to work out of doors in winter too.)

Spring sketchbook

I like to use fresh, clean colours in my spring paintings, such as soft greens and lemon yellow, which you will see in the exercises below. I use 'artist's' quality paint in tube form, which I squeeze into the pans in my box. The paint is then moist and ready for use.

I find a dozen colours sufficient for my use throughout the year. These are: lemon yellow; raw sienna; burnt sienna; light red; burnt umber; cobalt blue; ultramarine; monestial blue; viridian; cadmium red; alizarin crimson; and raw umber.

For paper, I generally choose the rough or Not surfaces, which allow me to make use of the surface texture. I find Bockingford a good inexpensive paper, and I also like handmade types such as RWS and Richard de Bas. Ordinary cartridge paper is also fine; it is made up in sketchbooks, and is suitable for pencil, pen and charcoal work.

As for brushes, for most of my work I use a No. 12 sable-hair brush. I know these brushes are expensive, but no other type holds the wash and retains its point as a sable does. I use a 7.5cm (3in) Hake brush, which is particularly useful when applying broad washes, as in a sky, and for large work such as 55 x 75cm (22 x 30in). I also use smaller brushes, such as Nos. 5 and 8 and a rigger. The rigger has bristles about 2.5cm (1in) long, comes to a fine point for drawing, and can be used on its side to create textured effects. The smaller brushes, the No. 5 and the rigger, have nylon bristles, which I find satisfactory. A hog-hair oil brush (No. 5) is useful for softening any hard edges that may occur on washes at times. I also keep a few old brushes for use with Indian ink, as I am reluctant to use sables for that purpose, and I am careful to wash out all the ink before it can dry.

Here I have set out a few exercises in watercolour to suit the season.

Early spring trees

On a dry surface, these trees, with their mist of young leaves, were washed in with a soft green (made up of lemon yellow, raw sienna and viridian) into which, while it was still wet, I applied a mixture of monestial blue and burnt sienna, with added monestial blue for the distance. Compare the drifting-in approach I use here with the dragged-brush technique in the next tree exercise.

Trees

I prepared a strong wash of monestial blue and burnt sienna. Using a No. 12 sable brush on its side, I quickly dragged it over the rough surface of the dry paper, using the point to draw in the trunks and branches. At the base of the tree, I washed in more monestial blue to the same mixture and drifted in a little lemon yellow.

14

Landscape *(above)*

I painted this with a No. 12 brush on to paper which had been washed over with clear water and allowed to dry a little before the washes were added. I used monestial blue in the upper sky, drifting it into a pale wash of burnt umber and ultramarine. The distant hill to the right was painted using a darker wash of the same mixture.

For the light-green field I used lemon yellow, raw sienna and viridian, drifting into burnt sienna in the foreground. The group of trees to the left was again painted in ultramarine and burnt umber, with a touch of burnt umber dropped in below and repeated to the right, at the base of the hills. A little to the left of it, I added some more ultramarine.

Clouds and sky *(below)*

I painted this demonstration sky study on rough-surfaced dry paper, using a No. 12 brush.

In the upper area to the left is a wash of monestial blue which is repeated lower down towards the horizon. The warm tint in the clouds is a mixture of light red and raw sienna, and drifted into it is a grey mixture of ultramarine and burnt umber. The same mixture in a darker tone has been washed to represent darker tones at the horizon, blending in to the lower area of the sky. I made use of the white paper as highlights.

Compare the result of working on dry paper with the landscape study on *damp* paper (above).

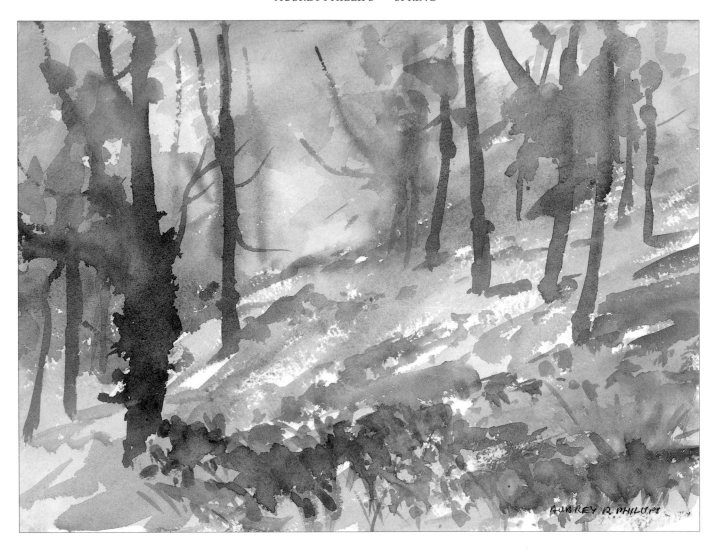

Bluebell glade

Original size: 27 x 37cm (10 $\frac{1}{2}$ x 14 $\frac{1}{2}$in).
Paper: RWS 300gsm (140lb) rough.
Brushes: Nos. 8 and 12; rigger.

In this picture I have tried to capture the soft, moist atmosphere of a woodland glade, with the sun breaking through morning mists and casting shadows of the trees across the banks of bluebells and the creamy-white wind-flowers (wood anemones).

I washed in the distant background with monestial blue, lemon yellow and raw sienna, keeping some areas lighter than others, to suggest sunlight breaking through the foliage. While this wash was still wet I drew in the darker shades of the distant trees, using a mixture of monestial blue and burnt sienna, which blended into the background wash and softened the forms of the trees.

While this background was still moist I began to wash in ultramarine, and blended in some monestial blue, with a little alizarin crimson in places, allowing the colours to blend together. Into this I drifted a light green made of lemon yellow, viridian and raw sienna to suggest areas of grass, and taking care to retain areas of white paper to suggest clumps of windflowers. Then, as the surface of

the paper began to dry, I applied a wash (darker than I had used before) of monestial blue and burnt sienna for the more clearly defined shapes of the trees in the middle distance.

I then used a stronger wash of the same mixture, but with a little more burnt sienna, for the nearer darkest tree on the left. Warmish tones of burnt umber and burnt sienna were applied for the shadow of this tree across the foreground, suggesting the texture of the old bracken and rough grass, but retaining areas of the blue wash and white paper.

Darker tones of blue and grey were applied for the shadows cast by the trees on the right, and in the middle distance.

In order to convey the soft misty atmosphere, particularly in the distance, I had to work quickly into the background washes (giving me soft edges), before they could dry out. The nearer, more clearly defined tree-shapes, washed on to a dry background, contrasted firmly with the soft distance.

I attempted to keep the work as direct and simple in treatment as possible in order to convey the soft atmosphere of a morning in spring.

(This painting is shown much larger on pages 12–13.)

Spring mists on the Avon

Original size: 27 x 38cm (10½ x 15in).
Paper: 425gsm (200lb) Bockingford.
Brushes: 7.5cm (3in) hake; No. 12; No. 4 rigger.

The Avon has provided me with many subjects in all seasons, particularly where it flows on its tranquil course through Evesham Vale, which provides the setting for this picture.

It was one of those still mornings in spring; the landscape was veiled in a white mist which was rising from the river and softening the forms of the distant trees, creating an air of mystery.

I began with the sky, washing in the upper part with monestial blue and drifting in a little light red to the lower area, into which I then added a few touches of grey (mixed using ultramarine and burnt umber) suggesting the vague shapes of distant trees. I mixed a little lemon yellow, viridian and raw sienna and drifted this in to suggest a soft light breaking through the trees.

I applied the same wash to the light areas of the fields on each side and added burnt sienna to it for the foliage of the nearest trees on each bank. I made the nearest of the grey trees on the right a little stronger, and then began to deal with the warm tones of the riverbanks on each side, using burnt sienna and burnt umber with monestial blue. I carried these washes down into the water area, together with the grey tones of the distant trees for reflections, blending them into the same soft tones as I used in the sky.

I completed the picture by drawing in the trunks and branches of the foreground trees on each side with the point of the brush, using a mixture of burnt sienna and monestial blue and adding the reflections on the right, with a few darker touches on the riverbanks.

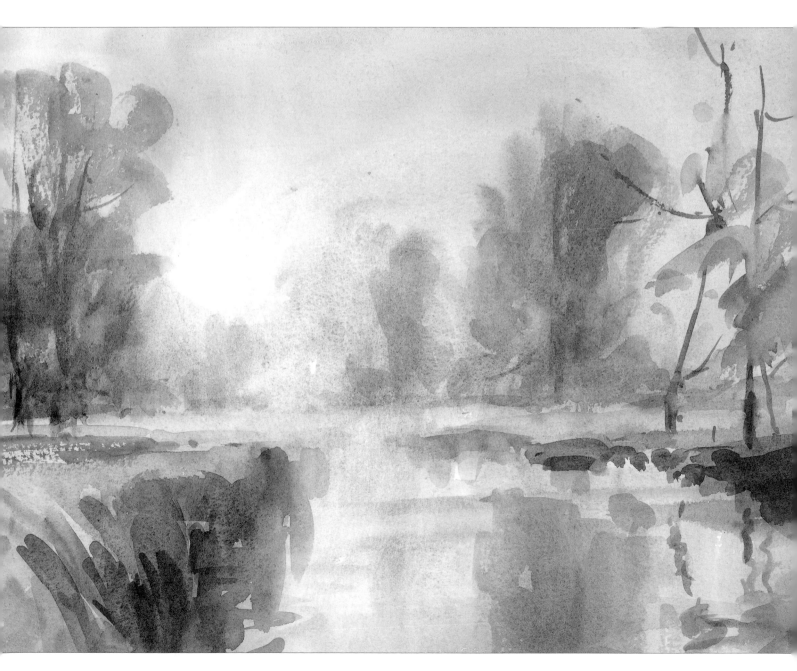

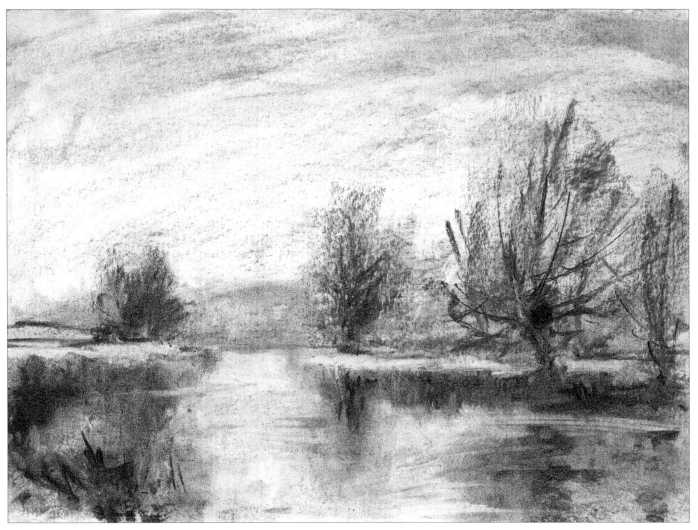

April evening on the Windrush: preliminary charcoal sketch.

April evening on the Windrush

Original size: 28 x 38cm (11 x 15in).
Paper: Richard de Bas rough 480gsm (300lb).
Brushes: 7.5cm (3in) hake; No. 12; No. 4 rigger.

The River Windrush is a gentle stream that flows quietly through the soft Cotswold landscape, reflecting in its waters the mellow stonework of peaceful villages and the green shade of banks of leaning willows. It is a lovely river with a romantic-sounding name. After its birth in the high wolds and its youth flowing through gentle pastures, it mingles its waters at its journey's end with those of its larger sister, the Thames, amid a very different setting.

It was a calm evening in spring with a warm glow in the sky reflected on the quiet water, and the distant landscape softened by the rising mists. In such a damp atmosphere it is difficult to work direct in watercolour, as washes refuse to dry: so at times like this I find a charcoal study a great help in working out composition, tonal relationships and general drawing. I also make a few written notes on colours.

I like 'scene-painter's' charcoal, which is produced in rather large sticks which I use on their side, and I have a putty eraser for 'lifting out' areas from the charcoal drawing. I use cartridge paper for my sketches.

Stage 1

I begin with a pale mixture of light red and raw sienna, strengthening it towards the horizon and lifting off some of the wash to create a lighter area to the left of centre. I carry this pale wash into the lower part of the paper, leaving the paper untouched to make the reflection of the light on the distant part of the river.

Before this large wash dries, I add a little monestial blue to the top left area of the sky, followed by a mixture of burnt umber and ultramarine to the right. The same mixture is added for the distant grey area to the right and the smaller touches to the left.

A little of this grey wash is blended into the raw-sienna/light-red wash below. This is all carried out before the washes dry.

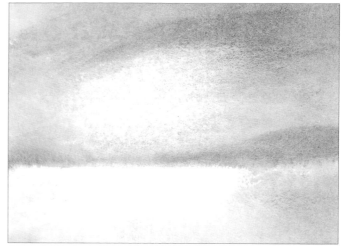

Stage 1.

Stage 2

I prepare a mixture of viridian and raw sienna for the foliage of the nearer willow trees on the river bank on the right. The background wash is dry when I lay this on, using the No. 12 sable brush on its side.

I use this green wash for the distant soft trees to the left, adding a little more of the burnt umber/ultramarine mixture and softening the edges with a damp brush. I use these colours for the riverbanks and for the reflections of the trees to right and left, softening them too.

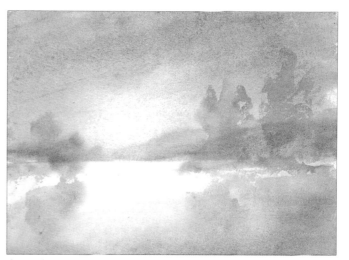

Stage 2.

Stage 3 – the finished painting (shown overleaf)

I now need to create more definite form in the foreground trees on the right and in those which balance them on the left. I mix monestial blue with burnt sienna to make a rather strong wash, and, again using the brush on its side, I suggest the rather open spring foliage and branch formations in both groups. The same wash is used for the reeds on both banks, with a little burnt sienna drifted in for warmth. I wash in a mid-toned wash of ultramarine and burnt umber behind the trees on the right and echo it on the left.

These washes are applied to make reflections in the water and are softened again with a damp brush.

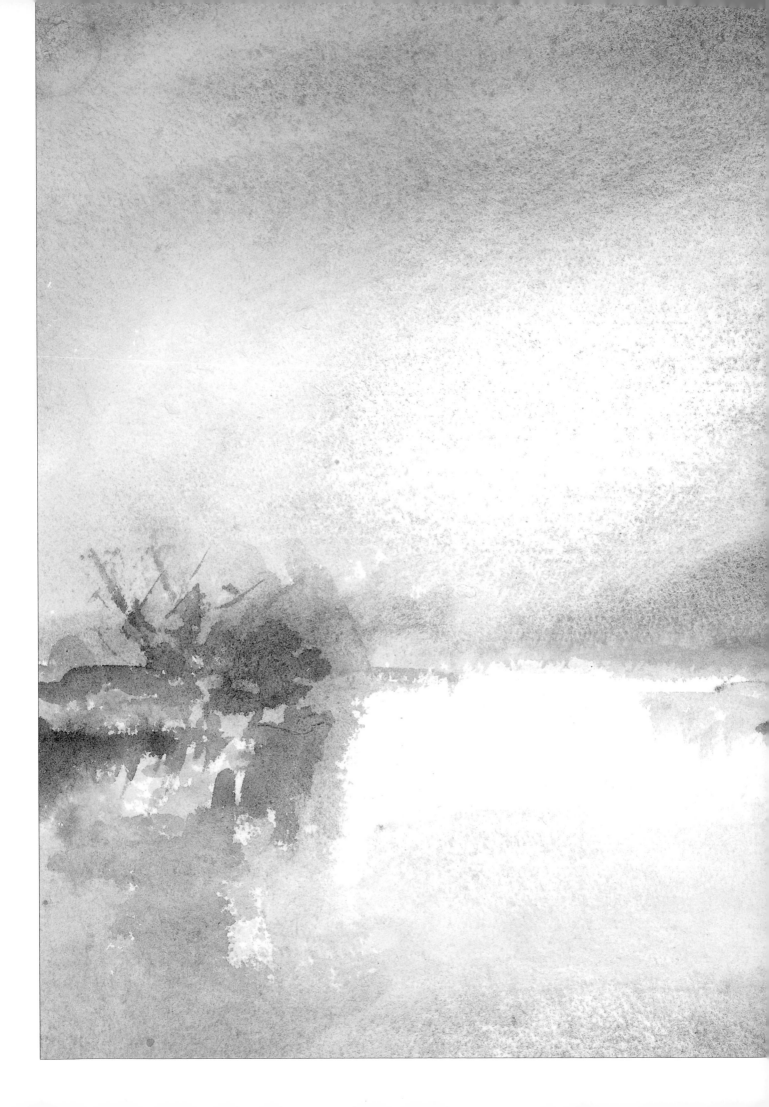

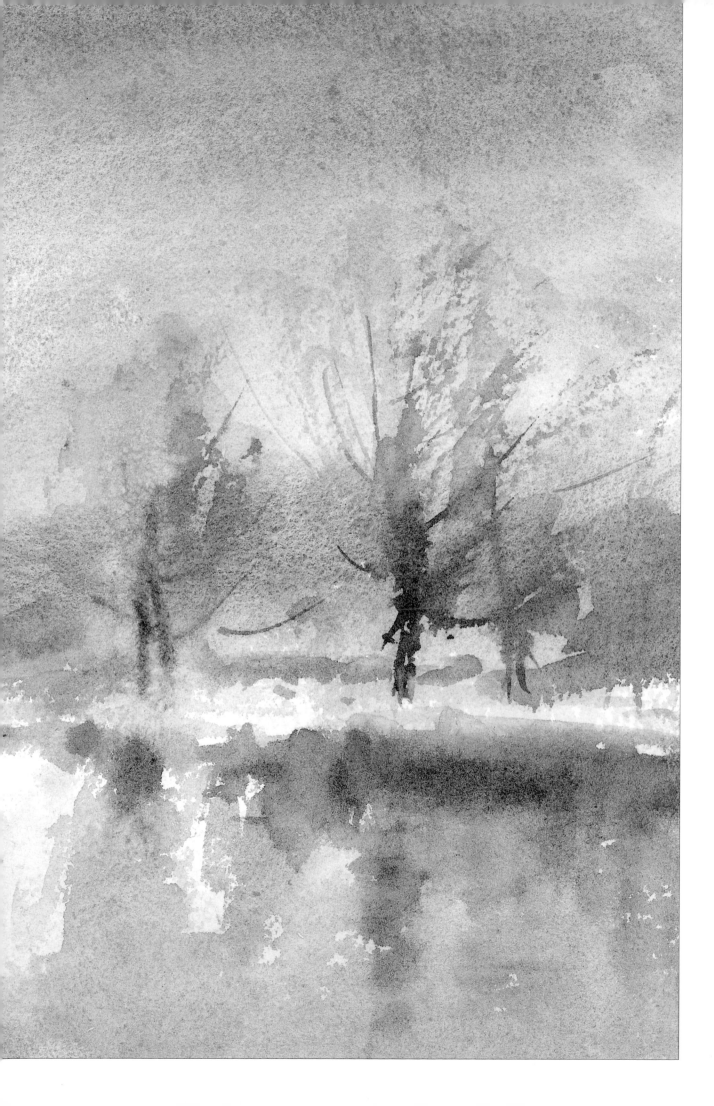

Dale Evans

Spring is my time of year, a time when something stirs inside me. No doubt for the usual reasons – longer days, a bit of warmth and sunshine, etc. – but also because I have an interest in plants, and this is their magical season, when colours seem at their brightest.

The phenomenal rate of growth and change in the spring countryside drives me frantic. Each spring I plan to paint flowers – not botanical studies, but paintings to capture, for example, the sparkle of morning sunlight on snowdrops, or, later on, a bed of tulips. But each year the snowdrop season, just two or three weeks long, passes in a flash, the city parks department starts tearing out spent tulip bulbs to make way for summer bedding plants, and I have completely missed the bluebells. So I have to wait another year for the next opportunity! The months are just never long enough for me. (My photographs fail miserably to capture the quality I associate with these early spring months.)

I eventually isolated just what it is about spring that excites me. Primarily it is the surprise and brilliance of the contrast of the first delicate colours against the grey-brown bedraggled remnants of winter; then the sprouting, budding, surging and opening of plant growth, upwards and outwards, filling in all the spaces in the landscape. Finally, there is that fresh watery quality of the air, unmistakable even in the middle of a city, that makes me aware of breathing.

Colours

This is my spring colour impression: cadmium yellow pale, viridian, and Winsor violet, with a watery cobalt blue sky; *i.e.* the colours of early flowers and shoots.

Foliage at this time of year is a delicate light-yellowish or bright green and has yet to acquire the wind-battered, sun-scorched dark olive tones of summer. My impression is that the colours of spring wild flowers are generally more delicate than those of summer varieties, although this idea does not stand close examination and is probably due more to their smaller size and the context in which they occur than any colour attributes of the petals themselves. I decided that strong contrasts would be needed to capture the delicacy of these spring colours.

First colour impression.

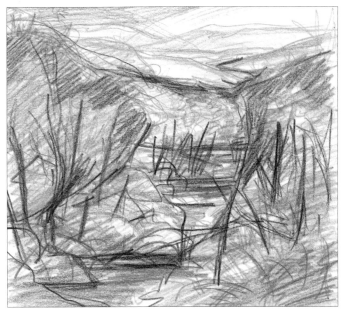

Leafy gorge – first sketch.

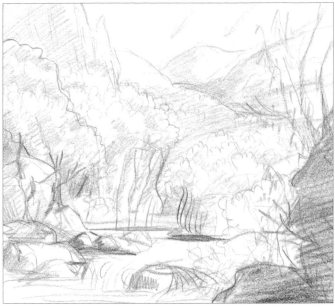

Leafy gorge – second sketch.

Spring sketchbook

Leafy gorge

Vertical patterns immediately came to mind with my spring feeling of surging upwards and gradually opening out. This is the first exploratory doodle I made in coloured pencil. Initially I drew a stream with bare tree trunks with sparse foliage providing the vertical lines, and I decided to follow this line of thought for my demonstration painting. However, as the doodle progressed, the mossy-banked stream suggested a gorge or ravine. This suggested a second theme to explore, since natural crevices in the rock walls would provide strong spreading vertical lines, lifting the eye to an open sky. The stream suggested a waterfall, which is corny perhaps, but rushing water is springtime for me, and I recognised that tumbling water suited my mind's eye very well; even in midsummer a cool, shady gorge with running water and sunlight far above has the fresh, invigorating quality of springtime.

Leafy gorge – trial paintings

Original size: 22 x 34cm (8¹/₂ x 13¹/₂ in).
Paper: 300gsm (140lb) Not surface.

I liked my first attempt (overleaf) very much, but the fantasy went too far somehow and I felt that I had missed my real spring mood. I could see from this that to achieve the sense of emerging I needed to exaggerate the dark tones that gradually lighten towards a pale sky; also, stronger contrasts were needed to capture the translucent glow of spring foliage in sunlight. The vegetation was too dense and green, needing to be sparser, with bright yellowish tones, to give the delicacy I wanted.

However, the underpainting of cadmium yellow pale captured the sense of 'filling with light' that I had planned. I decided therefore to keep a light source from the right, together with the distant view in full sunlight along the bottom of the gorge, and to exaggerate the contrasts between the deeply shaded sides. This, I hoped, would create the effect of vegetation catching the morning sun. I also wanted to emphasise the water; for this my viewpoint would need lowering and so the proportions of the picture area also needed altering. Essentially, I needed a new picture.

After two attempts at creating my final painting, I had to come to terms with the fact that it was going to remain a vision in my mind's eye! The more I tried to resolve the difficulties of a side light-source catching the tips of the leaves and the perspective of a gorge receding into the distance, the tighter and heavier the painting became . . . my light spring feeling evaporated beneath my hand. So

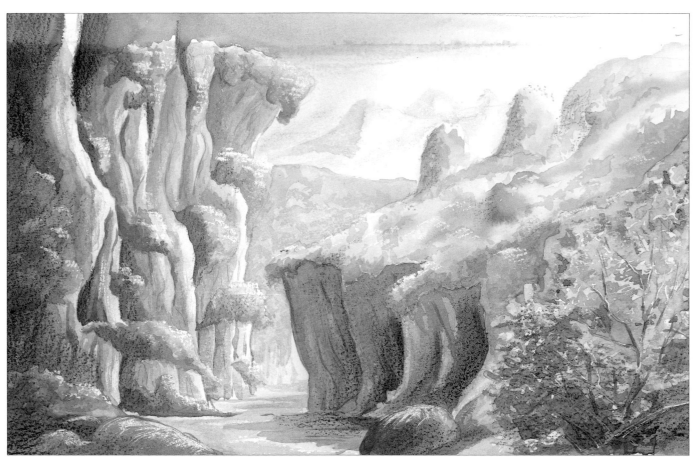

Leafy gorge – first attempt.

many variables could have been responsible for its fail-ure: the height of one or all of the gorge sides; the scale of the vegetation in relation to the rocks; or the exact shade of spring green for the foliage required to achieve the most brilliant contrast with the rocks – at any rate, one of them eventually defeated me!

In some ways I suppose that the inability to make radical changes to a painting is the real disadvantage of watercolour. Had I been using heavy opaque paint, I could have blocked in the basic composition without needing to know in advance where to place my foliage tips, highlights, waterfalls, etc., and the painting could have evolved on the paper. Perhaps one solution would be to resolve all the problems of light and perspective in an acrylic painting and only then to set about translating the image into a watercolour!

However, I still had the other vision of the spring woodland up my sleeve and could (and did) pursue this avenue for my expression of springtime.

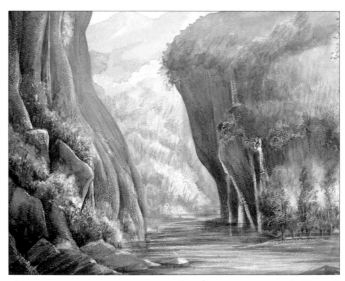

Leafy gorge – second attempt.

Spring woodland with ramsons

Preliminary painting

Original size: 28 x 32cm (11 x 12¹/₂in).

This quickly tested out my colours and 'feel'. I quite liked the relatively low horizon and the slight elevation of the foreground and birch trees. I also decided that this cloud-type against a bright-blue sky, suggesting unsettled weather, worked well, but that the aurora yellow in the foliage was too dull and I preferred the lighter yellow of my initial colour scheme.

I also concluded that although the ploughed field introduced a rusty red that balanced the mass of yellows and greens, it was too prominent a man-made feature and would need rethinking.

Preliminary painting.

The painting

Original size: 34 x 41cm (13¹/₂ x 16in).
Paper: 300gsm (140lb) Not surface.

First I dampened the paper and washed aurora yellow over the whole area, then lightly lifted out the main clouds with tissue. When this was dry I dampened the paper again and applied a light wash of alizarin crimson, carrying it down to fade off below the horizon.

I then masked off any pale areas that cut into the sky, such as the main foreground birch trunks, foliage highlights, and foreground details such as the white flowers and leaf highlights of the ramsons (wild garlic). I have used brown masking fluid, as for a demonstration it shows up better than the transparent type.

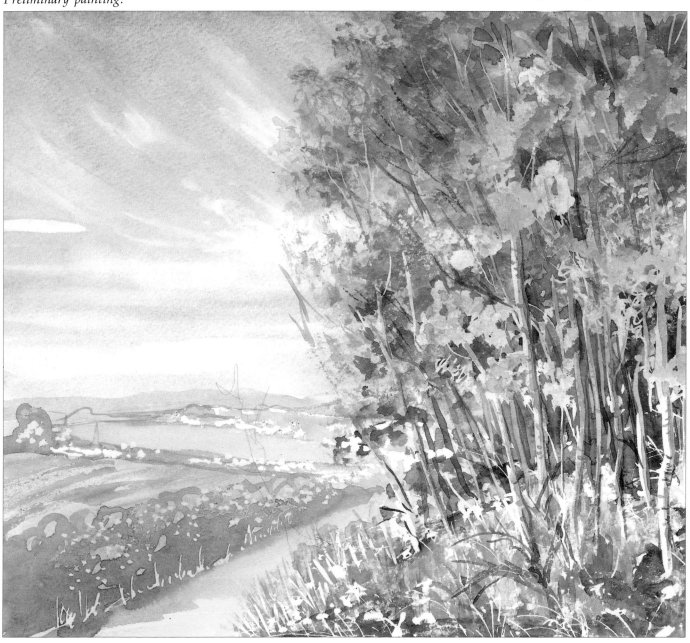

I wet all the paper and laid a wash of cyanine blue, dragging it to fade off below the horizon and just past the masked foliage of the tree. While it was wet I lifted off the clouds with tissue and sponged out the wispy cirrus clouds, then carried across small patches of blue behind the treetops. I added some distant mountains with the aurora/cadmium-yellow and cyanine-blue washes of the field in the foreground.

With mixes of cadmium yellow pale, aurora yellow, cyanine blue and brown madder (alizarin) I dabbed on areas of foliage and undergrowth, progressively masking off light areas before applying darker tones, then painted the woodland tree trunks with a bluish mix of cyanine blue, aurora yellow and brown madder (alizarin). After removing the masking fluid, I used a similar mixture for the details on the light birch trunks and the shadowed area in the left foreground. When this area had dried, I masked off details of leaves and stalks, etc., before adding further darker washes. Masking fluid creates the effect of a carpet of ramsons under the trees.

My four main colours were cadmium yellow pale, aurora yellow, cyanine blue and brown madder (alizarin), with a touch of viridian for the darker greens.

Stage 1 – detail

The paper already has a light wash of aurora yellow and the main tree trunks were masked off before the blue of the sky was laid on.

Ramsons have broad shiny leaves with a characteristic arching growth-form and a head of pure white flowers on a single stalk. I simplify the ramsons to a tight group of blobs at the top of a single stalk and draw these on with a draughtsman's pen, along with light sketchy lines to represent grass stalks and twigs. Shiny highlights of the leaves are also drawn, with strokes of the pen following the pattern of the arching curves. At this stage I also mask off small patches of the birch foliage that I want to keep pale, and mask the tops of the trees in the hedgerows with a light stippling effect; then I apply a wash of a mix of aurora yellow, cadmium yellow pale and cyanine blue over both background and foreground.

Stage 1 – detail of foreground.

Stage 2 – detail

Using an old paintbrush for a broader, uneven line, I now mask off more ramson leaves and broaden those that have already been highlighted, again following their arched curves. The ploughed field is painted in with brown madder (alizarin) and aurora yellow, and a light mix of aurora yellow, blue, and brown madder is used to model the form of the trees in the distant hedgerow.

I now apply a darker mix of my green loosely over the area of ramsons and over the background fields, and I add blotches to the tree foliage. When the paint is dry, again using brush strokes that follow the curve of the leaves, I add a few darker leaves.

Stage 2 – detail of foreground.

Stage 3 – detail

Using a bluish mix of my three colours, I paint in darker areas between the trees. Mixing a rich brown from cyanine blue, brown madder (alizarin) and aurora yellow, I dab in areas at the base of the ramson leaves to represent leaf litter and soil, and also add a few splashes in the undergrowth. These red-browns help counteract the predominantly green feeling of the painting.

Stage 4 – detail

I rub off the masking fluid and now begin to build up the form of the tree trunks and add details to the ramsons.

All the stages outlined here have been simplified for the purpose of showing the process. I actually used four or five stages of progressive masking for the ramson foliage, and the distant hedgerow has been worked up in much more detail on the finished painting. As a general rule, the more accuracy applied to each successive masking in terms of shape of the masked area, colour, and depth of tone, the more complete the painting is when the masking fluid is finally removed – and the less touching up is needed. The masking fluid removes some of the colour, increasing the contrast between masked areas and adjacent paint.

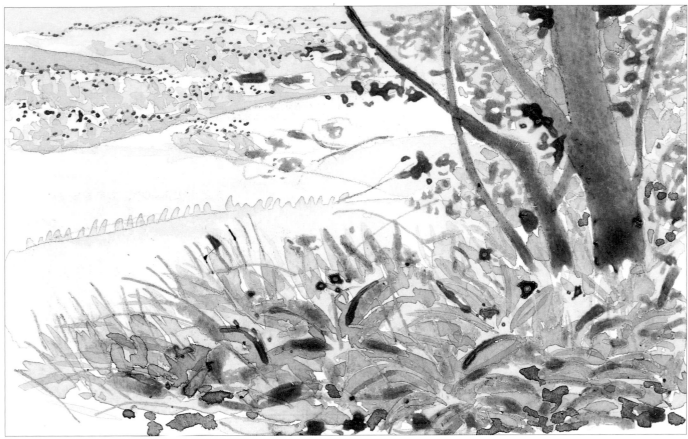

Stage 3 – detail of foreground.

Stage 4 – detail of foreground.

The finished painting.

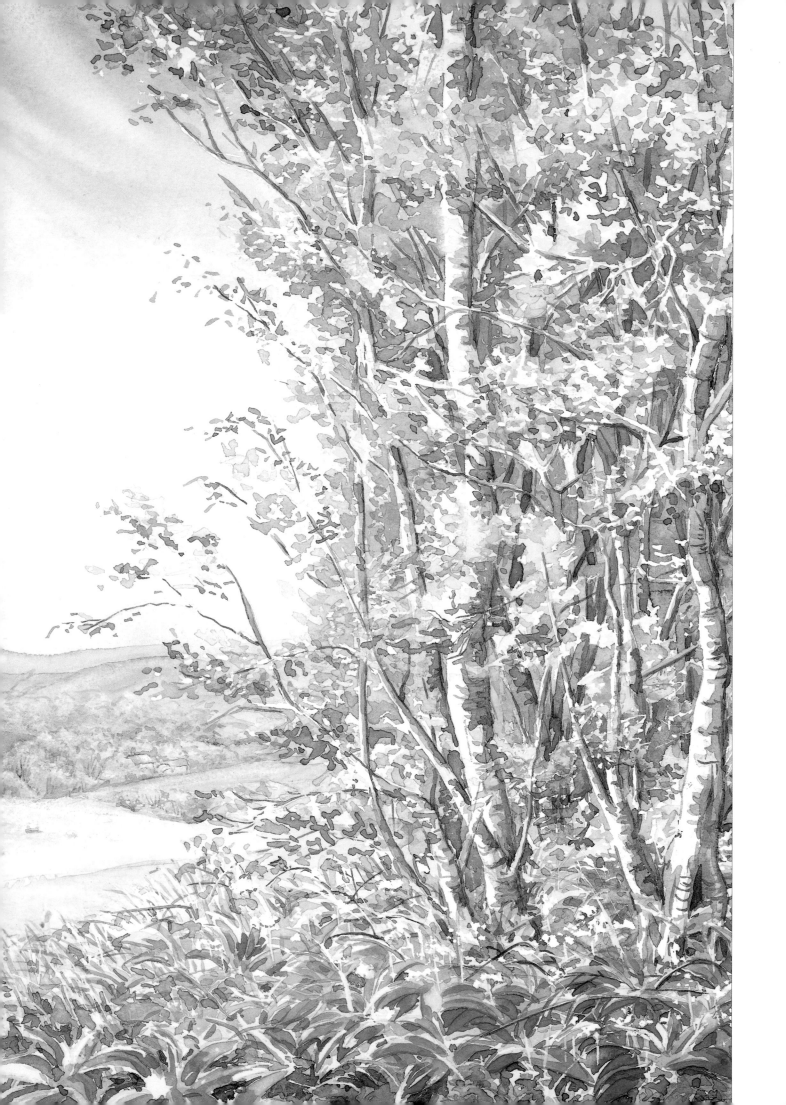

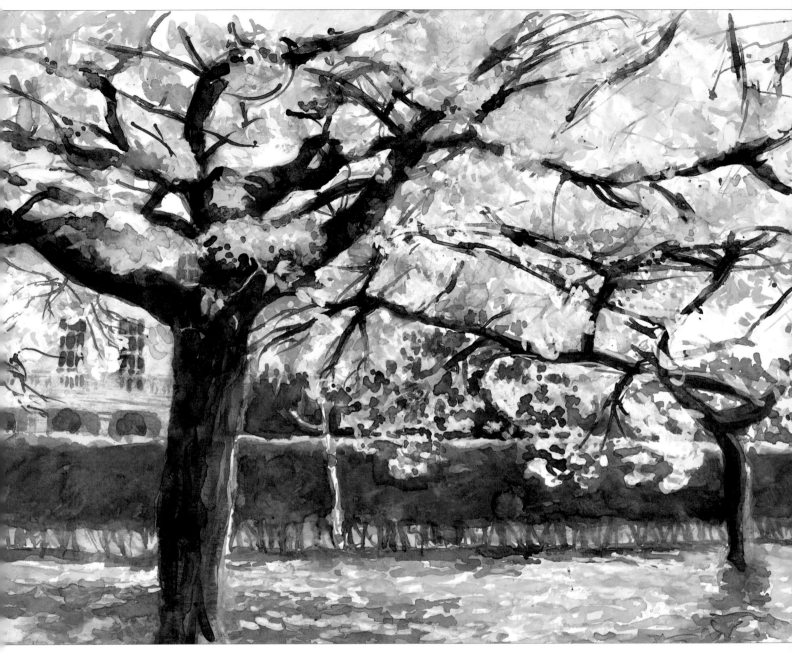

Blossoms in Regent's Park: study No. 1.

Timothy Pond

As winter draws to a close the air warms up; the sun rises higher and shines for longer periods of the day, which acts as a trigger to activity in the natural world. The birds start to sing, as if celebrating the beginning of a new, milder season after the long hard winter in which a lot of them may have died of cold or starvation, and start to look for a mate. Now, too, seeds that have lain dormant since autumn sprout roots, and buds begin to open. Somehow we instinctively recognise the spirit of spring.

In Alaska the snows begin to melt and avalanches come tumbling down the side of mountains; fresh green and yellow shoots push their way through the thawing soil; and small flowers start to bloom. In Britain the daffodils are tossing their golden heads in the breeze, followed by the pink and white blossoms that look so fragile and delicate. In short, spring is a time of hope; a time of regrowth and of new beginnings.

All this provides me with a wealth of interesting subjects to go out and paint and draw.

To really get a feel that 'spring is in the air', ideally I try to take myself out into the country to sketch, but there is plenty of fresh new life in the park as well!

Spring sketchbook

Blossoms in Regent's Park

Original size: No. 1 – 31 x 42.5cm (12½ x 17in).
No. 2 – 27.5 x 40cm (11 x 16in).

I was really excited by these trees when I came across them, as they made such a terrific subject for a spring painting: in fact, I made a couple of studies on the spot. Fortunately, I had brought my sketching stool with me, so I had the freedom to position myself where I liked beneath the blossoming boughs. The first painting was made looking up into the shapes of the branches, where the pinkish-white plumes of petals proved very challenging to paint.

In the second study I was more successful at capturing the mass of blossoms. By painting from further away I was able to see the blue shadow on the underside of the tree and the shadow cast on the ground. By making a note of these I was able to give the blossoms a sense of form. I particularly liked the dappled light and fallen petals on the ground, which I captured by dragging my brush across the tooth of the paper.

I made this study of daffodils in the park.

Blossoms in Regent's Park: study No. 2.

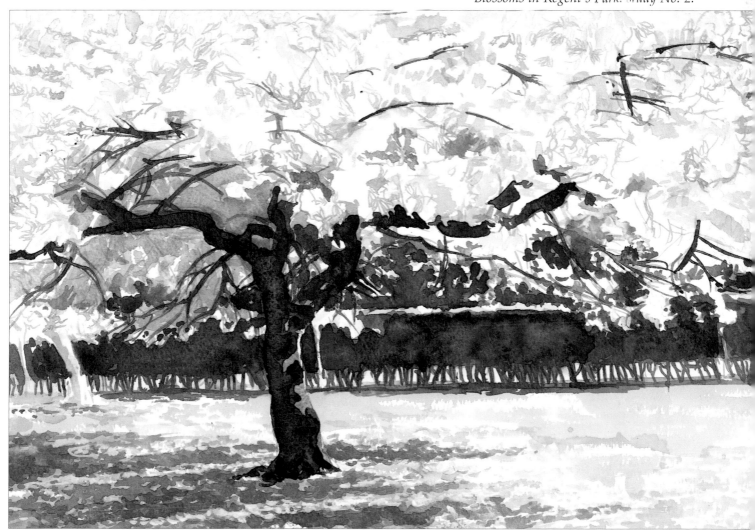

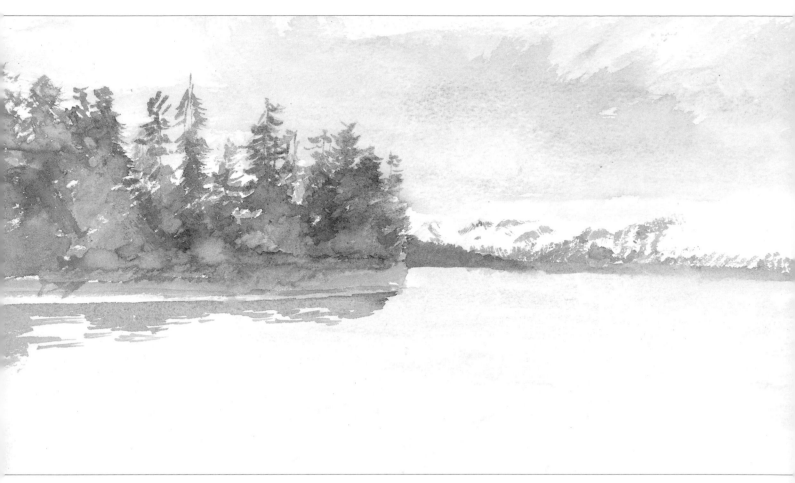

Early-morning sketch, Harrison Lagoon, Alaska.

Early-morning sketch, Harrison Lagoon, Alaska

Original size: 38 x 46cm (15 x 18in).
Paper: 300gsm (140lb) mould-made acid-free.
Brushes: Nos. 1 and 4; rigger.

This sketch was made at dawn, when a silvery light created a harmony of pearly greys. The waters of the Prince William Sound were as calm as a mill-pond that morning, and only the occasional sea-otter feeding its young made ripples on the surface.

The trees are painted in without any underdrawing, in one unified green. All the colours in this painting are muted, and painting a scene like this is a good exercise in learning to differentiate between the greys.

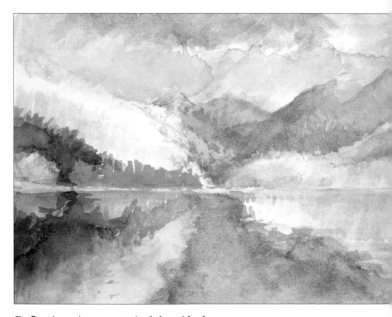

Reflections in mountain lake, Alaska.

Reflections in mountain lake, Alaska

Original size: 28 x 36cm (11 x 14in).
Paper: 300gsm (140lb) mould-made acid-free.
Brushes: Nos. 1 and 4; rigger.

The translucent quality of watercolour is perfect for capturing reflections in water. This lake is fed from the melting snows that run off the surrounding mountains.

Early spring: Chugach National Forest, Alaska

Original size: 29 x 42cm (11¹/₂ x 16¹/₂ in).

Spring came late to Alaska the year I was there. This sketch was made in Moose Pass just as the snows had begun to retreat up the sides of the mountains. In this study I made only the faintest underdrawing in pencil and was careful to draw with the brush while actually painting with colour.

The lake in front of the mountains, which is still frozen, is painted with a thin wash of cerulean blue.

Paradise Peak, Alaska

Original size: 24 x 33cm (9¹/₂ x 13in).
Paper: 300gsm (140lb) mould-made acid-free.
Brushes: Nos. 1 and 4; rigger.

This scene struck me the moment I saw it: the enormous mountain framed by fir trees on either side, with muskeg or Alaskan moss in the foreground. The long tufts of grass growing in this were painted with yellow ochre, capturing the way the grass swayed and bent in the wind.

Early spring: Chugach National Forest, Alaska.

Paradise Peak, Alaska.

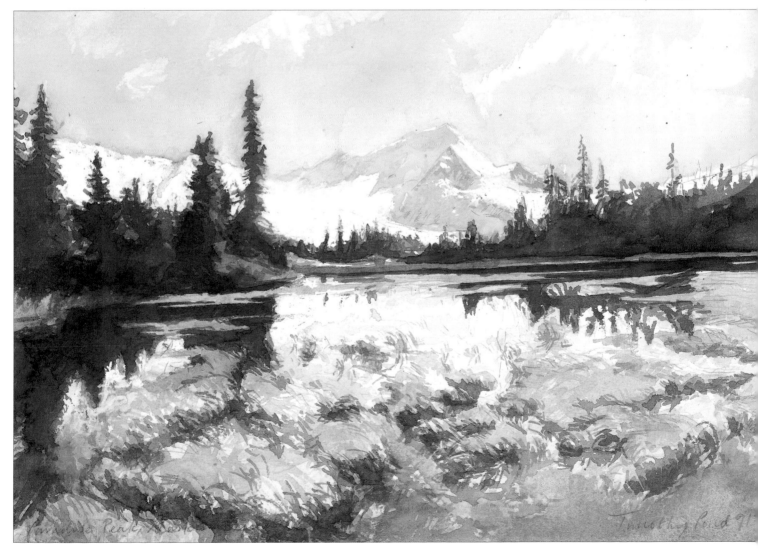

Alaskan spring

Original size: 29 x 42cm (11³/₄ x 16¹/₂in).
Paper: 300gsm (140lb) acid-free watercolour paper.
Brushes: Nos. 1, 2, 5, 7 and 10.

At the end of Alaska's long, dark winter comes spring, with a sudden energetic spurt of growth like a shout of joy. The warm sun begins to melt the snow and ice, thawing out the top layer of soil and encouraging seeds to sprout.

In the Prince William Sound, the area of Alaska where I made this sketch, there is a high level of precipitation, which makes it a very lush and green area. I was drawn to paint this view because I liked the dead white trees that were standing on the beach and the patch of mauve flowers, which are one of the first to come into bloom. The fir tree on the right of the composition casts a horizontal shadow across the picture which helps accentuate depth and creates a strong design. In this painting I wanted to capture the quality of a crisp, clear spring morning.

I carried out the initial drawing with a fine brush and French ultramarine, a technique I in fact developed in Alaska, while I was working as the expedition artist with Raleigh International. During the expedition I did not have much time and wanted to get into the painting of the picture as quickly as possible without having to worry about finding and sharpening pencils. In atmospheric perspective, colours become bluer in the distance, and the blue underpainting will fall into the shadows and help emphasise a feeling of depth. This technique lent itself well to the Alaskan landscape, where sunlight on the snow forms bright-blue shadows. However, since painting again in Britain I have found this a good sketching technique because wherever you are painting there is always an element of blue in the shadows.

Stage 1

First of all I start drawing out the composition with a fine brush and French ultramarine. It is important for me to

get the intervals between the trees in their right proportion and capture the character of the bleached, gnarled roots and trunks.

Stage 2

The colours of spring should be fresh and joyous, the yellows and greens of new shoots. I start laying in my lightest and brightest colours, to capture the new foliage in broad washes.

There are many shades of green in this painting; some light, some dark; some cool greens and some warm. I try to keep my colour mixture simple by not mixing together more than three colours to achieve the desired shade; this prevents my colours from becoming muddy.

The bleached trees have a slight pinkish tinge to them, and I now lay this in with a light wash of alizarin crimson. The sky is painted with a loose wash of cerulean blue. Then I mix lemon yellow with Hooker's green to get the lime green for the sprouting bush in the bottom right-hand corner. A complete contrast with this is the ruddy colour of last year's dead bracken stalks to the left of the composition. I sketch this in with Indian red, dragging the colour, using quite a dry consistency over the surface, making use of the rough texture of the paper to suggest the coarse quality of the dead stalks.

Next I mix the colour of the mauve flowers by adding a little French ultramarine to alizarin crimson and blob their shapes loosely with the brush. The middle area of green behind the flowers is a cool green, made by adding some Prussian blue to Hooker's green. The colour of the shadows in this area is created by mixing together Payne's grey, Prussian blue and Hooker's green.

Stage 3

Now I begin working the painting up as a whole. Imagine a photograph in the developing tray: first it appears as a faint image; then, as the developing fluid takes effect, the tones become bolder. Instead of completing one area at a time, I try to develop all the areas of a painting at the same time.

The bleached trees are developed by overlaying their shadows with a mixture of French ultramarine and alizarin crimson. The mountains and glaciers in the far distance are overpainted with pure French ultramarine. The shadows cast on the grass and the trees further away are painted in with a mixture of Prussian blue, Hooker's green and ivory black.

Stage 1.

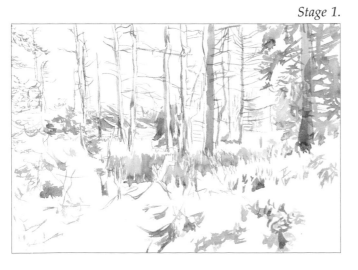

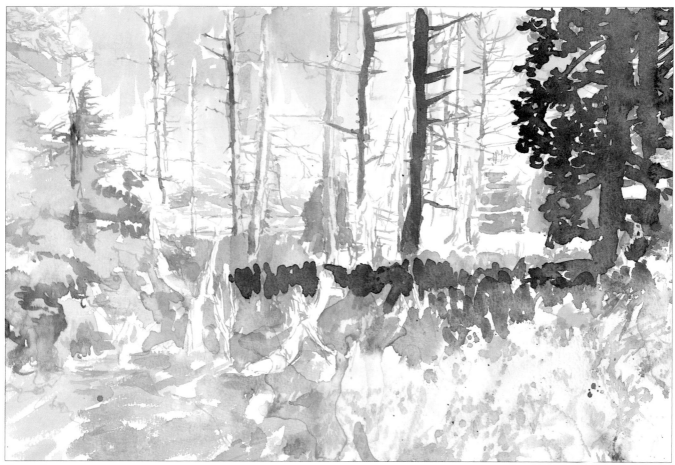

Stage 2.

Stage 3.

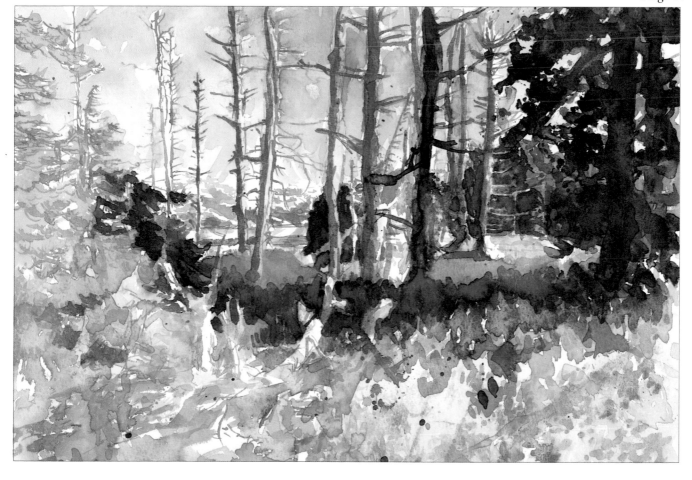

Stage 4 – the finished painting

By now I have got the painting to a stage where I can start responding to it without always having to look at what I am drawing from. Little adjustments can be made here and there.

For example, I accentuate the whiteness of the tree trunks with permanent white gouache (gouache is more opaque than Chinese white watercolour and is more satisfactory for picking out highlights). Then I develop the shadows on the bush at the left-hand side of the composition, which gives a sense of form.

Finally, I splatter and flick orange paint in the foreground to convey an impression of a thorny bush. However, I am careful not to overwork the painting, as I want to create a fresh impression of spring.

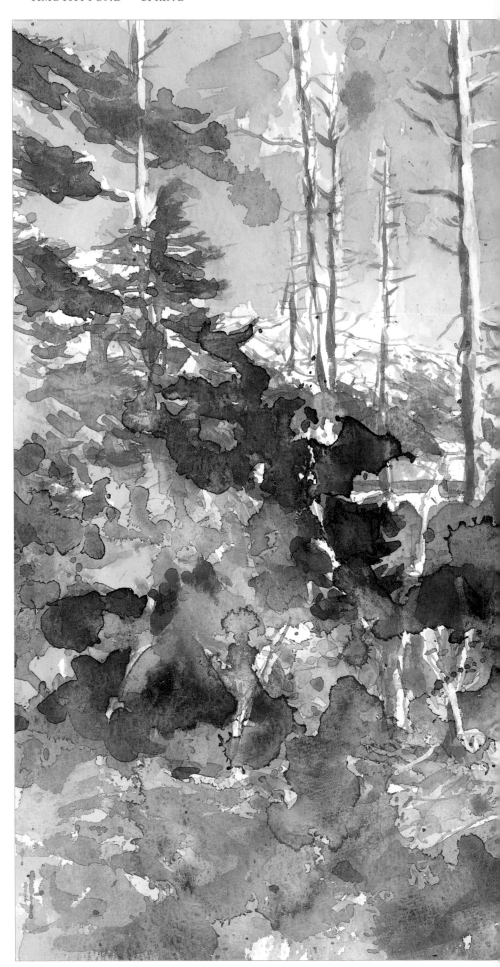

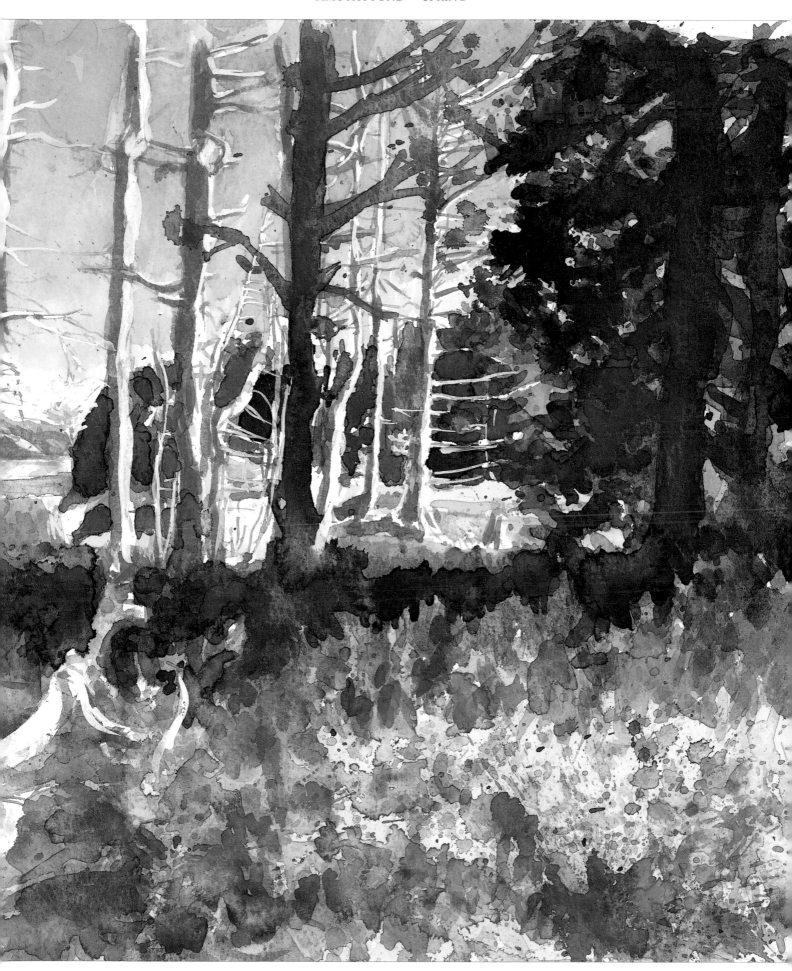

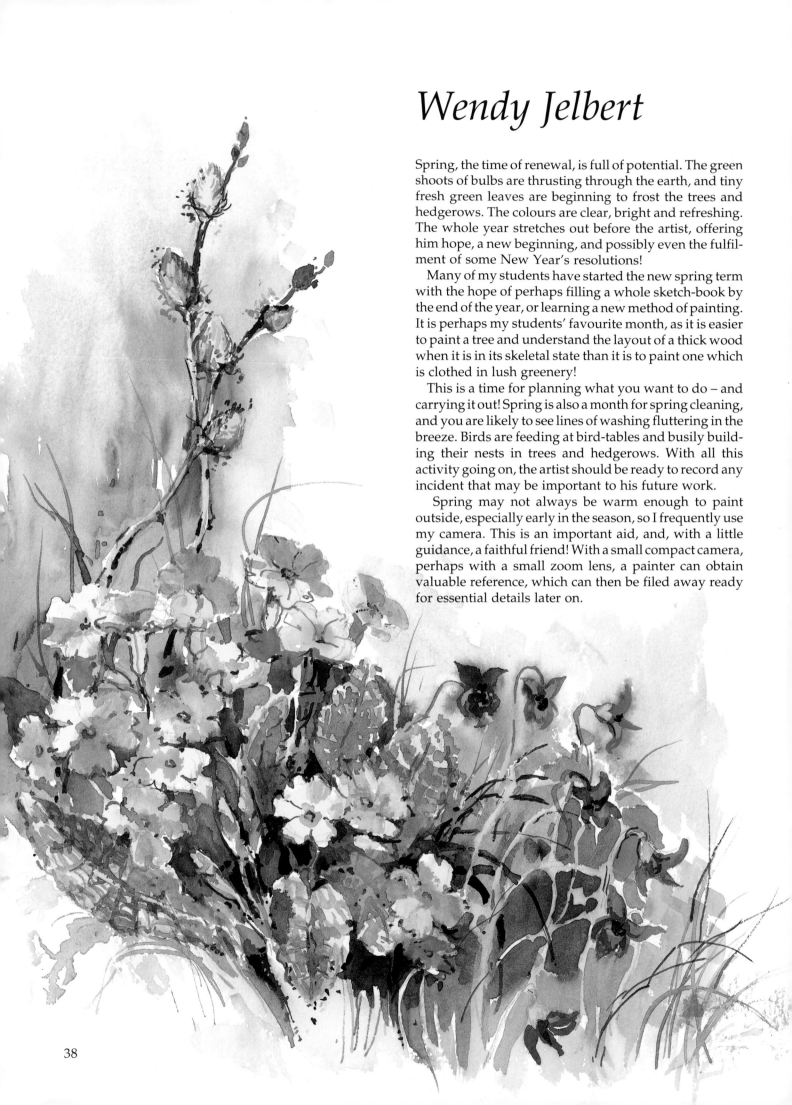

Wendy Jelbert

Spring, the time of renewal, is full of potential. The green shoots of bulbs are thrusting through the earth, and tiny fresh green leaves are beginning to frost the trees and hedgerows. The colours are clear, bright and refreshing. The whole year stretches out before the artist, offering him hope, a new beginning, and possibly even the fulfilment of some New Year's resolutions!

Many of my students have started the new spring term with the hope of perhaps filling a whole sketch-book by the end of the year, or learning a new method of painting. It is perhaps my students' favourite month, as it is easier to paint a tree and understand the layout of a thick wood when it is in its skeletal state than it is to paint one which is clothed in lush greenery!

This is a time for planning what you want to do – and carrying it out! Spring is also a month for spring cleaning, and you are likely to see lines of washing fluttering in the breeze. Birds are feeding at bird-tables and busily building their nests in trees and hedgerows. With all this activity going on, the artist should be ready to record any incident that may be important to his future work.

Spring may not always be warm enough to paint outside, especially early in the season, so I frequently use my camera. This is an important aid, and, with a little guidance, a faithful friend! With a small compact camera, perhaps with a small zoom lens, a painter can obtain valuable reference, which can then be filed away ready for essential details later on.

Planning a picture

The three essentials for all watercolour paintings are paper, brushes and paint. The requirements are readily available and uncomplicated. Papers come in a wide range of thicknesses, tones, surfaces (smooth, Not and rough) and sizes and forms (pads, sheets and boards). Here I have used a 300gsm (140lb) Not spiral-bound Bockingford paper, size 42 x 29cm (16½ x 11¾in). You could use a 160gsm (90lb) paper for your experiments, and this should be fastened to a board with gummed or masking tape.

Choosing brushes is a very personal thing, but usually expensive brushes really are the best. I use a selection of squirrel or ox watercolour brushes, both flat-headed and round-headed. However, a combination of two varieties is adequate. (A sable and nylon brush is excellent.) In this book I have used a 1.25cm (½in) flat-headed ox brush, a No. 6 round-headed squirrel brush and a No. 1 nylon rigger. Selecting the most suitable for your own use can take time, and I find in my classes that many of the students will try each other's brushes before venturing out to buy a special one.

Watercolours come in all shapes and sizes of tubes and pans, and are offered in different qualities and in a vast selection of colours. All this can be very confusing, especially for the beginner!

Pans, for example, are especially convenient for working outside or on a small painting in the studio. Tubes are very popular and are easy to use on a palette. Gouache also comes in tubes and pans, and is excellent worked together with or instead of watercolours. I always carry a tube of white designer's gouache as a sort of 'first-aid kit' for painting mishaps. There are many makes of good-quality gouache. I suggest that when you are first trying out a medium, you should buy only a few colours: the three primary colours (the purest you can find), plus yellow ochre, light red, and a deep violet. You can add to the list later on.

Trying things out

After setting out your paints and paper, begin by discovering how the colours react together when mixed with water and with each other. Spring colours are clear, bright and fresh.

Here I have used my own favourites: cadmium and permanent yellows; Hooker's and olive greens; and Winsor and cerulean blue. These delightful combinations of blues and yellows give a wide selection of lovely crisp greens. When trying this exercise, note the flow and merging of the individual colours. Many act differently, and 'star' or 'run', when dropped into areas of washy paint.

As for the way I paint my pictures, behind the scenes of most of them there have been many 'costume changes'! I go out with some kind of theme, and sketch out many ideas stemming from the first.

Spring sketchbook

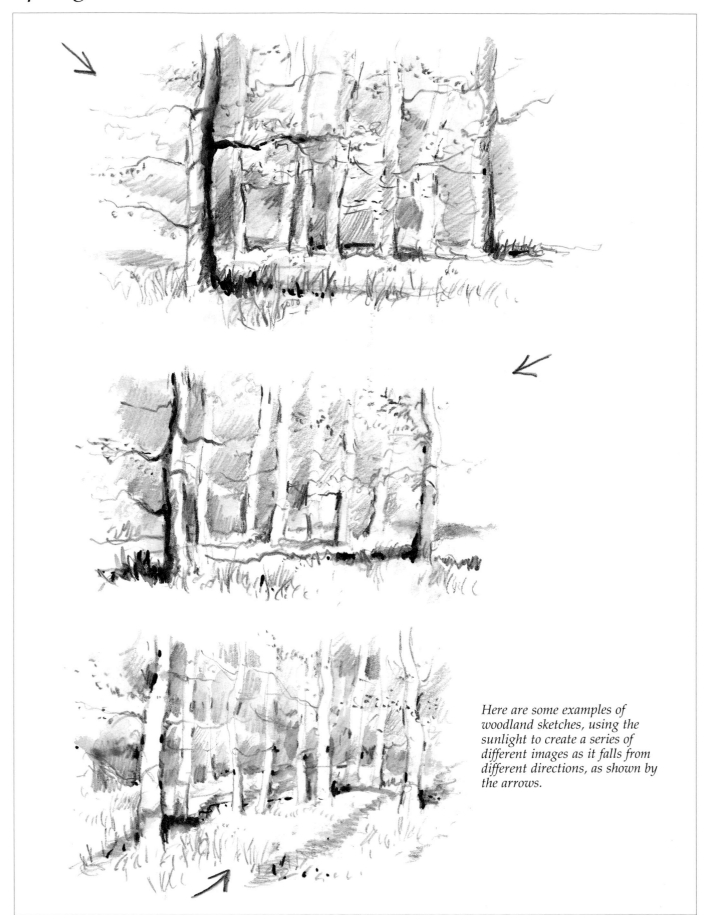

Here are some examples of woodland sketches, using the sunlight to create a series of different images as it falls from different directions, as shown by the arrows.

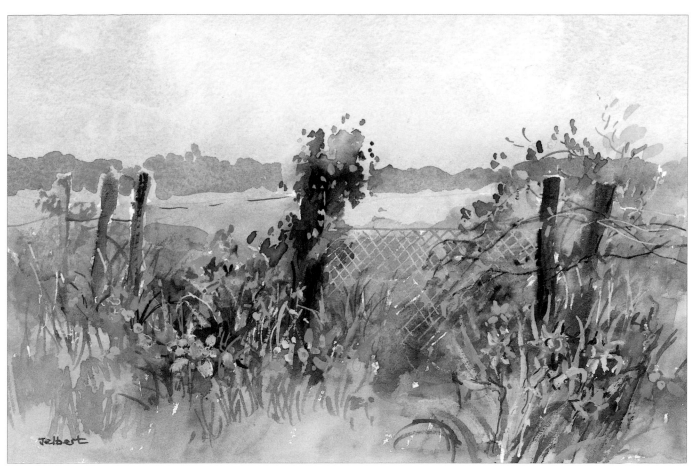

Daffodils and primroses.

Daffodils and primroses

Original size: 18 x 25cm (7 x 10in).

Here is a small watercolour painting of a typical spring scene, with a fence on a field boundary studded with daffodils and primroses. This was painted on the spot, while the other pictures of this fence in different seasons shown later in the book were produced by altering the mood to suit the given season. This is an exciting project to try out yourself!

The small, lighter details were all drawn in with a ruling pen and masking fluid. The fresh greens were mixed with Winsor blue, cadmium yellow, yellow ochre and a little light red, and the sky of cerulean blue was given a tinge of burnt sienna towards the horizon. The same colour mix, only a little darker, was used for the silhouette of the chain of distant trees.

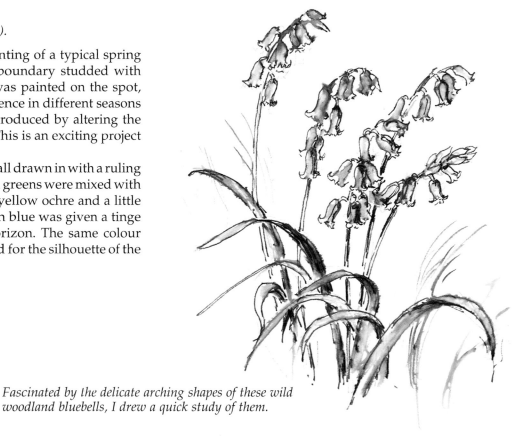

Fascinated by the delicate arching shapes of these wild woodland bluebells, I drew a quick study of them.

41

The bluebell wood

Original size: 30 x 40cm (12 x 16in).
Paper: 300gsm (140lb) watercolour paper.
Brushes: 1.25cm (½in) flat-headed brush; No. 4 round-headed brush; No. 1 rigger.

This glorious woodland scene simply cried out to be painted! I liked the fresh spring colours and the way the sun fell in bright shafts through the new leaves.

Stage 1

First of all, develop a simple sketch in violet aquarelle (water-soluble) pencil, drawing in the main features. The lighter details are penned in using masking fluid and a ruling nib, establishing a network of small sunlit branches and leaves.

Stage 1.

Stage 2

When the masking fluid is bone dry, prepare your first wash of olive green, yellow ochre, and Naples yellow. Apply this initial wash with your flat-headed brush over the whole of the sky and tree areas, leaving a trail of stronger Naples yellow over the bluebell carpet. You are building up the rich 'glow' so necessary for that final sunlit image.

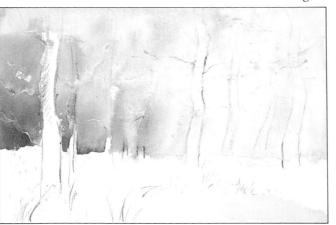

Stage 2.

Stage 3

While the paint is still wet (rewet it if necessary), drop areas of Hooker's green, yellow ochre and olive green in various shades and masses over the landscape, giving a general leaf-canopy effect. Allow this to flow freely. Then paint in cerulean blue for the distant ribbons of flowers, and a small fluttering of crimson and violet (ultramarine blue and crimson) to give interest and detail. Butt tufts of green up to this base, giving the impression of diffuse plant activity. Next, paint in an assortment of staggered tree-trunks, using Vandyke brown, trying to vary their intensity with a little water and a touch of cerulean blue for a more natural look.

Stage 4

From now on, refine the masses and begin to add more details.

The olive-green clumps of leaves that need to be splattered overhead should be thickened up. (I use an old toothbrush in order to create that 'random' effect.) Mix up some Hooker's green and splash the wash into the previous one, diffusing it slightly. With a little of the same mixture and a spot of ultramarine blue, deepen the shadows and flower details below, making them more convincing, and carefully paint in the smaller branches with Vandyke brown and a rigger brush. Another wash of crimson and blue is now applied to bed in the flowers.

When everything has dried, rub off the masking fluid, exposing the highlighted details of the tree and forest floor.

Stage 5 – the finished painting *(shown overleaf)*

The white 'ghosts' left by the masking fluid are now quickly washed over with a sunlight colour of permanent yellow, which gives the whole picture the anticipated glow. Smaller details, such as lighter branches and additional leaves, can now be painted in using your rigger brush with pale yellow and gouache.

Now refine and paint in the bluebells still further with tiny stabs of cerulean blue and violet. Olive green is used for the darker painting of the leaves. To complete this bluebell picture, create the shafts of sunlight by mixing up Naples yellow in the palette and applying streamers of light with the flat-headed brush. Carefully try one stroke at a time, ensuring that the paint below is not disturbed. Allow this layer to dry thoroughly, and then apply a second, creating varying widths and depths of sunlight strokes. Note, too, that these bands of sunlight fall on the intricate parts of the flower carpet. You may find that additional layers are needed and more highlighted flower details are essential for the final stage.

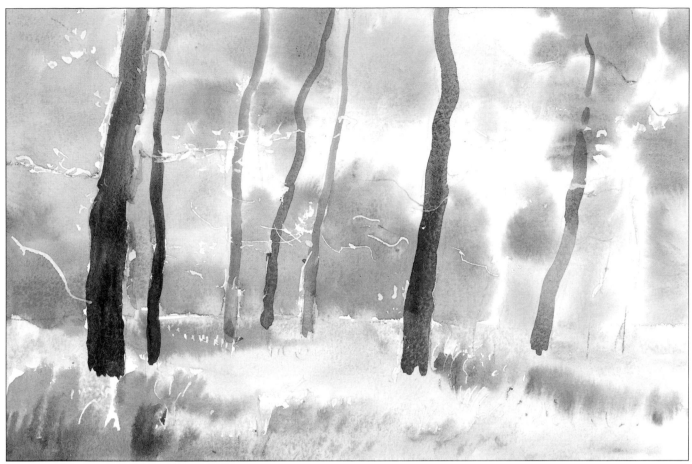

Stage 3.

Stage 4.

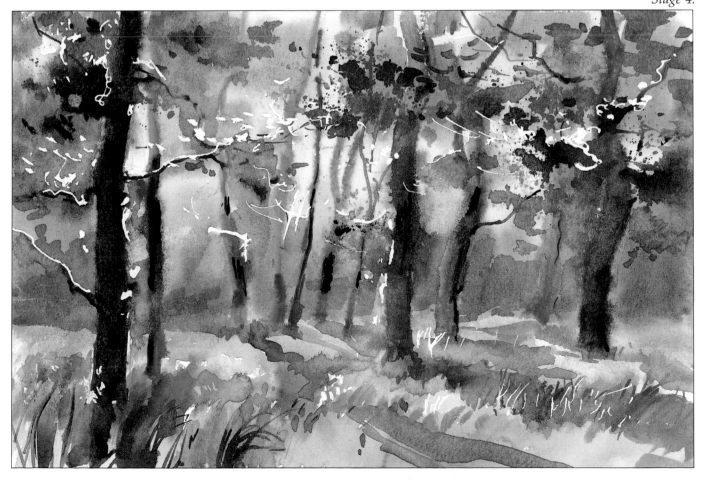

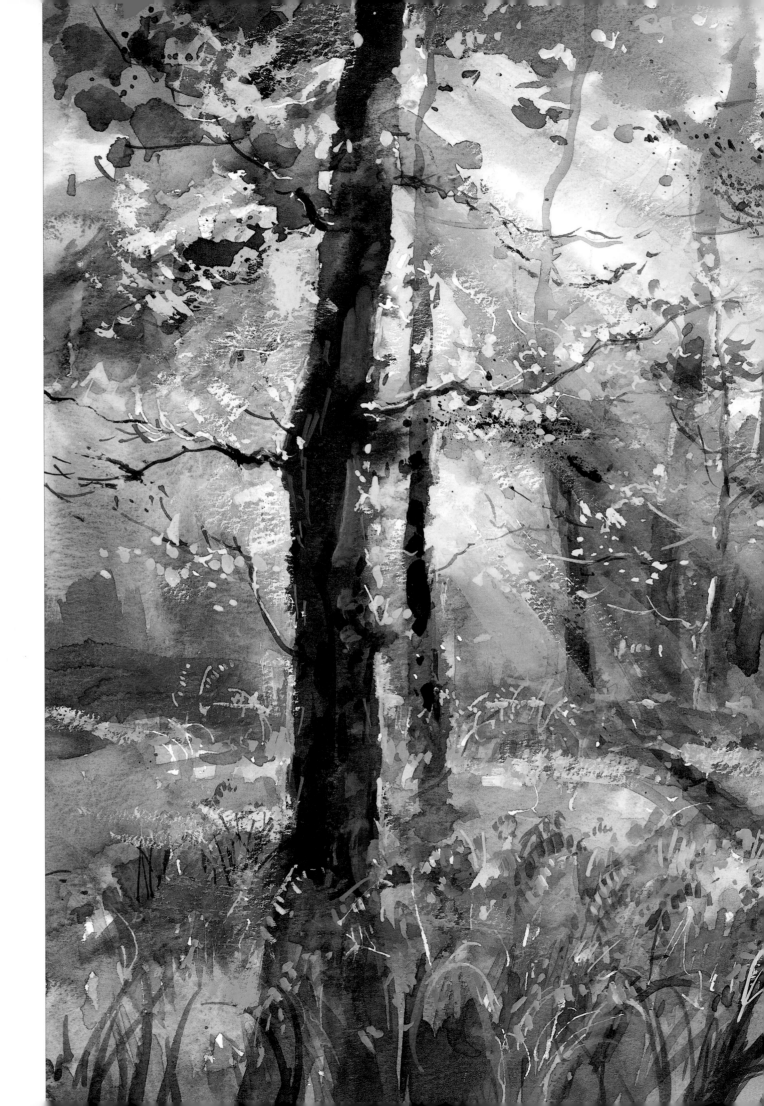

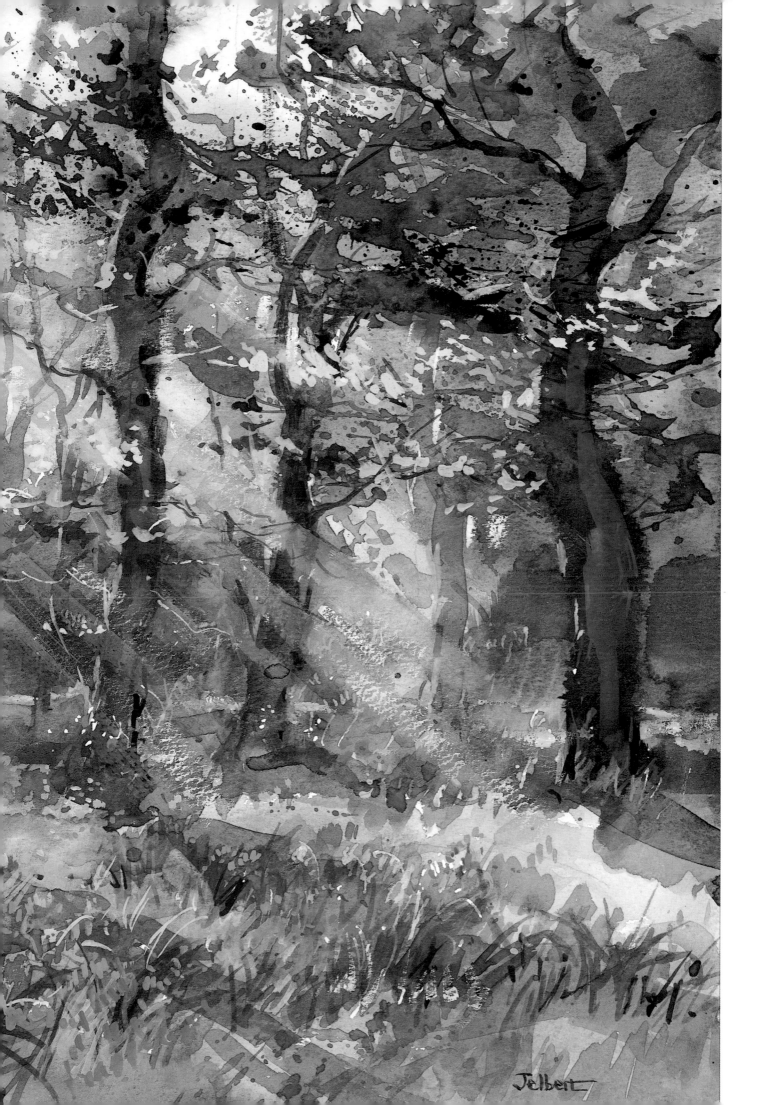

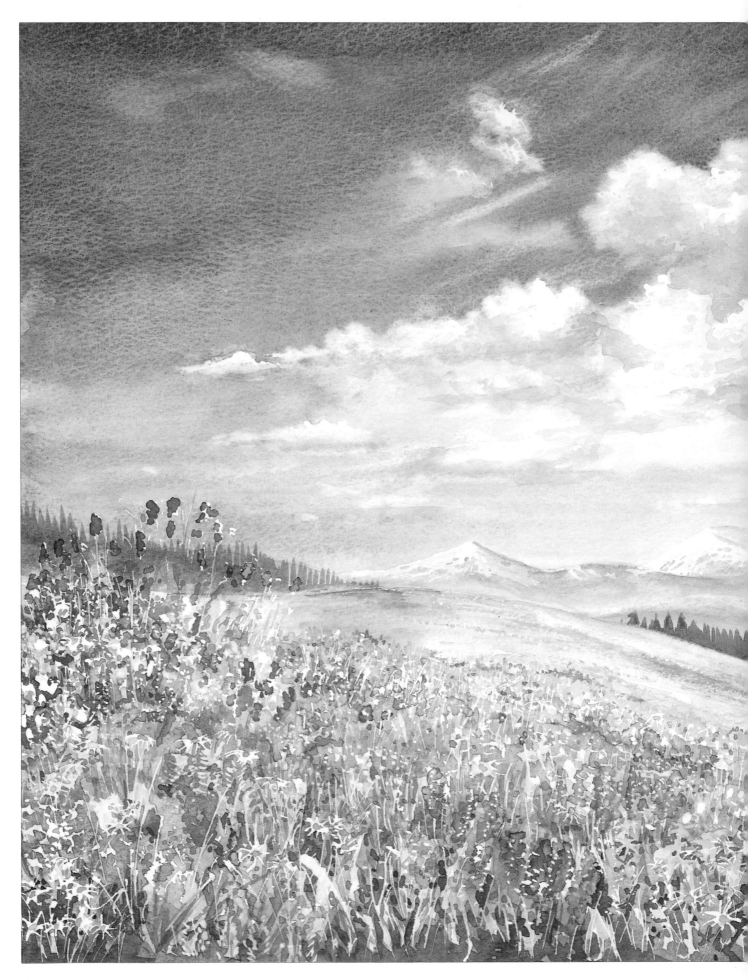

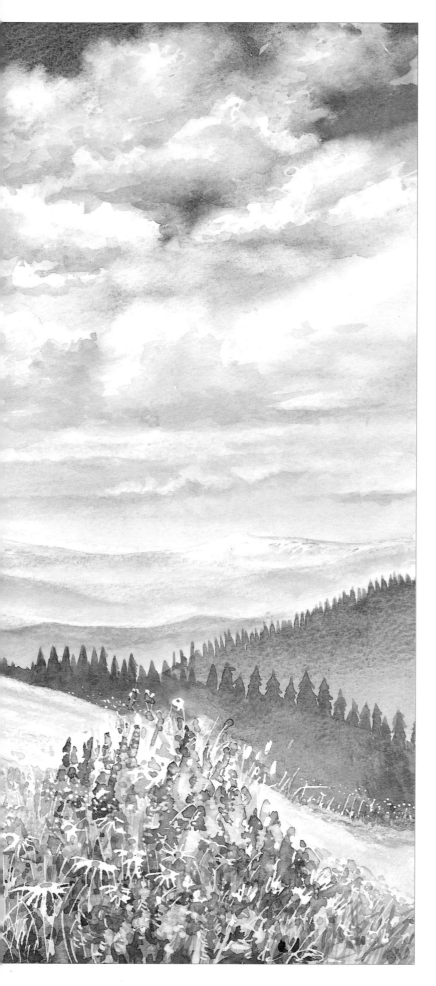

Summer

'The high clouds moving across a blue sky add to my sense that this place offers room to breathe.'

Alpine Meadow by Dale Evans

Dale Evans

Summer, for me, is a low-energy season when things just tick along day by day, somewhat heavily: I do not enjoy excessive heat, and, apart from sleeping in the sun, my tendency when not working is to stay cool indoors. From this you can gather that summer is not my favourite season and that my choice of subjects was strongly influenced by my association of the summer months with lethargy and oppressive heat.

I eventually isolated two visions of summer: one of trees heavy with grey/green dense summer foliage in a low-lying hazy meadow, and the other, almost an anti-dote to this lethargic scene, an Alpine meadow with fresh colours and a bright blue sky . . . a truly escapist vision.

When I had finished *Misty Morning* I recognised it as originating from early-morning hay-bale-turning sessions in my childhood. The accuracy of the setting is almost spot-on and my struggle with the sense of oppression perfectly understandable. Our hay fields were in a particularly low-lying area in the Usk valley and were suffocatingly hot in summer. Bale-turning, luckily, took place very early in the morning, so that the dew-sodden undersides of the bales would dry in the morning sun before being collected up, loaded on to lorries and taken away. For the rest of the day we would swelter.

My colourful Alpine meadow stems from a mixture of associations with visits to mountains in Britain and abroad, and does exaggerate the truth a bit. Arctic and Alpine summers are very similar to Britain's temperate late springs, and whereas in Britain summer heat-haze, pollen and dust tend to obliterate distant views, Arctic or mountain air in summer is very clear, giving wonderful views of meadows filled with wild flowers, with crystal-clear mountain backdrops. Apparently this type of meadow first occurs on lower mountain slopes in late spring and moves higher up the slopes throughout the summer months, reaching the highest altitudes in late summer. As a result this summer scene has the same fresh glorious colour that I associate with spring.

Summer sketchbook

Colours

This was my first summer colour impression: cobalt blue, Winsor violet and dull greens. It really does capture my lack of enthusiasm for summer! Intense, full summer light bleaches colours, and the tired, dusty summer in my mind has dense olive foliage with pinky-grey fields as grasses flower and pollen thickens the air. My 'late summer' is dominated by straw browns and blue/grey

First colour impression.

hazy horizons, with everything just a little out of focus. On the whole this did not seem to offer a particularly romantic or interesting summer palette.

Misty morning

I decided I would have to avoid a midday landscape and wondered if a misty morning treatment might work; I could relieve the heaviness of summer foliage by using a light, more romantic palette. Interestingly, in this first doodle there is a hint of the grassy upland meadow already lurking (unbeknown to me at this stage) in my mind's eye – it popped out later unexpectedly.

Thinking about misty summer mornings, I produced this sketch. The main motif is the large tree standing alone by the river. I needed a tree silhouette that captured the density of heavy summer canopies of foliage which spread to intercept every ray of light. Not all trees would be suitable, but oaks, I found, have the heavy irregular growth-form I wanted. Flanked by a bank of dense vegetation and vague background, the tree was to be quite dominant and needed to be convincingly drawn. Horizontal lines provided by the river and long shadows would introduce, I hoped, that sense of quiet stillness as the sun rises: respite before another oppressively hot day.

Misty morning: first sketch.

Preliminary painting

This is based on my first sketch of the meadow. The choice of a dawnish sort of light with a low light angle did help to avoid dull summer greens. Even so, I felt the foliage was still too green, and for the finished painting I decided to exaggerate the dawn colours and mistiness even further by going for a wet-in-wet approach. The slow meandering line of the river lying almost horizontally across the picture has provided a sense of stillness, as I hoped, but the single dominant tree does not work too well and needs rethinking.

Preliminary painting.

The painting (shown overleaf)

Original size: 30 x 43cm (12 x 17in).
Paper: 300gsm (140lb) Not surface.

I let this painting evolve on the paper by loosely following the first rough and letting each element added dictate the next. Working on damp paper, I graduated a wash of cobalt blue, alizarin crimson and cadmium yellow pale across the sky. When this was completely dry, I wetted the lower half of the painting and added the hard-edged mass of the background hills with a mixture of all three colours, letting the colours fade off down the wet paper. When this dried, I dampened the whole paper and washed on raw sienna; then, quickly, working wet-in-wet, I established the main tree masses with a mixture of cobalt blue, alizarin crimson and raw sienna, allowing the paint to feather and blend to give soft edges.

When this was dry, I masked the reflections and with a very light mixture of all three colours I added a wash for the water and gradually modelled the form of the trees. The grasses and umbellifers were added in darker mixtures of the same paints, using the masking technique.

On the whole I think this painting could have done with stronger colours. Having explored the subject in this painting, I felt that some day I would like to do it again, possibly using wax resist in the foreground. The general soft effect is typical of the backgrounds I use to complement a detailed foreground painting.

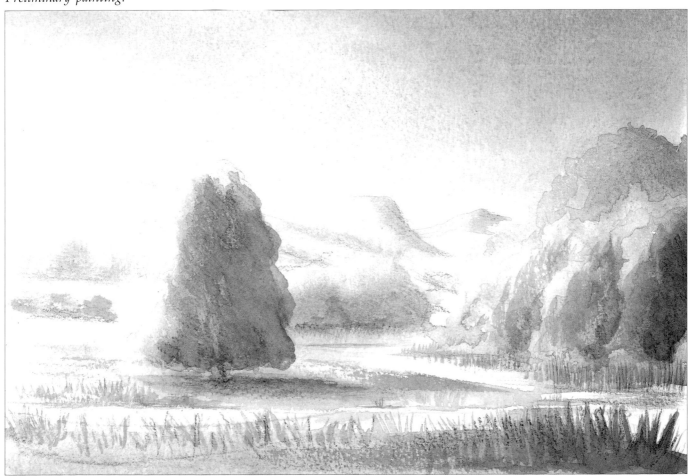

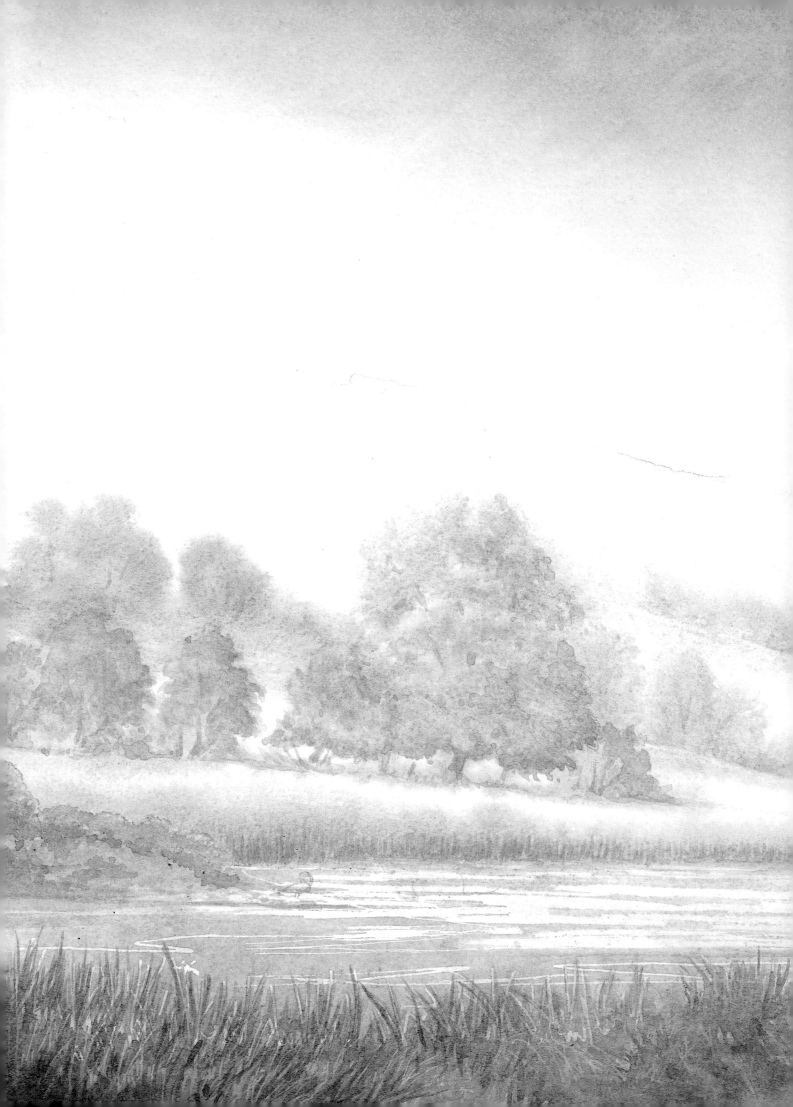

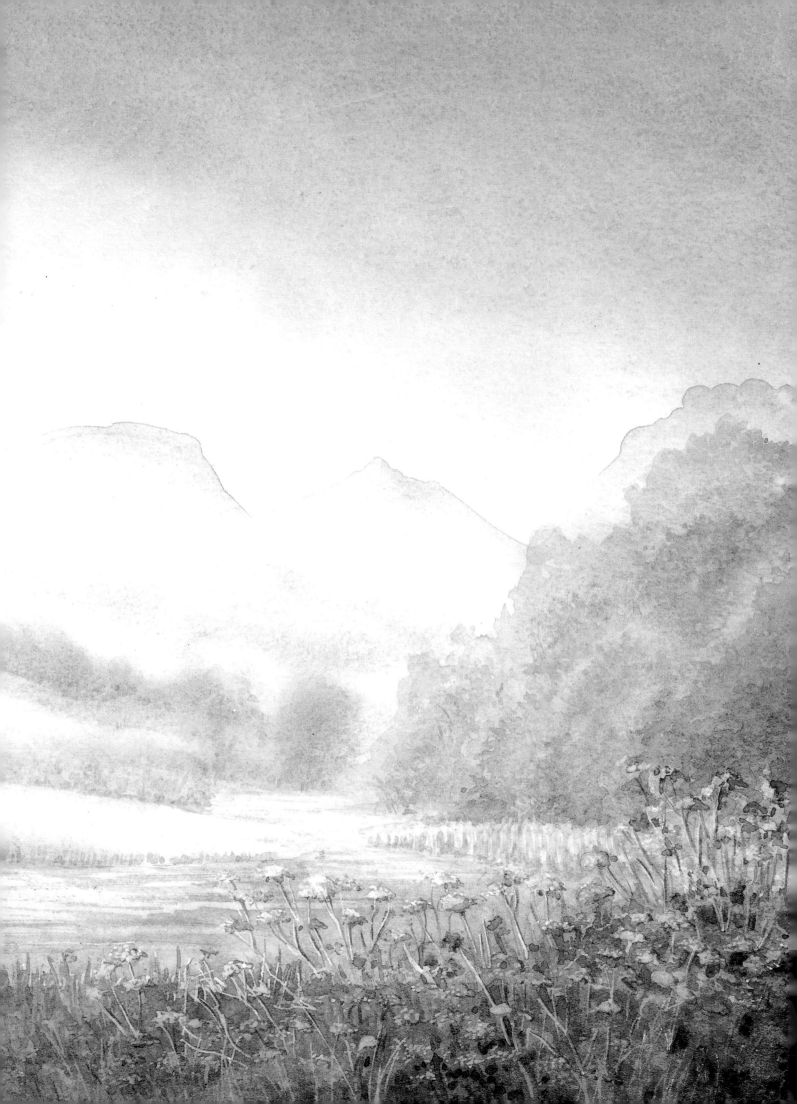

Alpine meadow

This Alpine-meadow idea arrived later and required no preliminary planning; the first colour rough seemed just about right.

Preliminary painting

Having rejected image after image of dark heavy summer trees, I was thinking in terms of dramatic sunsets, etc., when this preliminary painting of an Alpine meadow just popped out in about half an hour one day. I instantly recognised that this glorious riot of colour, rather than hot dusty greens and browns or blinding sandy beaches, was *my* summer.

Although they are not so common in Britain, I have photographed such meadows in Iceland and Greece, and this type of landscape, for me, is sheer joy. Full-summer herbaceous borders evoke the same response in me. The high clouds moving across a blue sky add to my sense that this place offers room to breathe.

Preliminary painting.

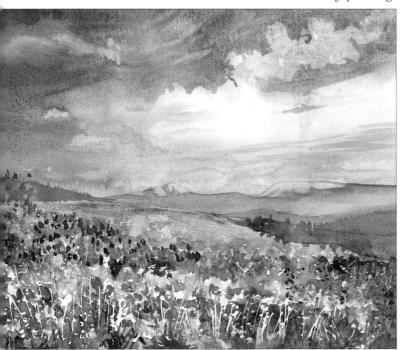

The painting

Original size: 35 x 43cm (14 x 17in).
Paper: 300gsm (140lb) Not surface.

I liked the composition of the rough, so I copied it same size, adding extra sky and broadening the vista. A light wash of aurora yellow over the whole area, slightly denser towards the horizon, took the white off the paper, and while it was still wet I lifted out the areas of cloud.

When it was dry, I masked off snow-caps, white edges of cloud-forms, and areas where vegetation cut into the skyline before dragging a wash of alizarin crimson down the page, fading away just below the horizon. This was followed by a wash of cyanine blue (with a darker mix of cobalt blue up in the left-hand corner), also washed down to fade off below the horizon to knit land and sky together. White clouds were lifted out with tissue paper. The background hills were added progressively, moving forward using blues and purples, and the trees were painted using a mixture of viridian and brown madder (alizarin), which separates of its own accord to give a range of colours for the trees.

I removed the masking fluid from the clouds and built up their form with various mixtures of the colours in the rest of the painting, softening edges here and there with a cotton bud. The treatment of the flowers is demonstrated stage by stage below.

I have taken an area of the meadow to show the process of masking that I use to achieve the appearance of detail quickly without getting bogged down in painting actual flowers. (I apply masking fluid with a draughtsman's pen or old paintbrush). Masking gives a painting a sparkle, as many areas are covered by just a single coat of paint.

Stage 1 – detail

This first application of masking fluid will protect the lightest areas. I reduce the assorted flowers to different-sized shapes or groups of blobs of masking fluid. I mask off all the white flowers and highlights (these will not be unrealistically pure white due to the first wash of aurora yellow over the whole paper). In the foreground I make the blobs recognisable shapes, but as the flowers recede with distance the blobs are simply made smaller. I use short thin lines to mask the lightest, most prominent stalks.

Stage 2 – detail

I add 'flowers' by loosely dabbing on pure flower colours such as Winsor violet, rose madder and cadmium yellow. I then fill the areas between with a light green made up of cobalt blue and cadmium yellow pale, allowing colours to run together and using different intensities of paint, keeping darker tones to the foreground.

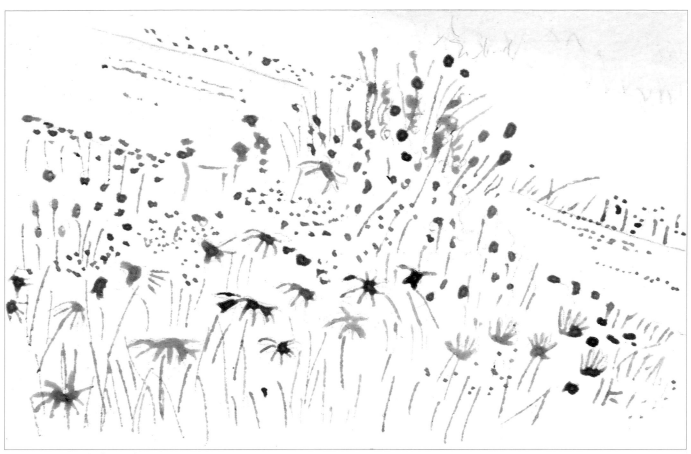

Stage 1 – detail of meadow.

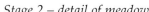

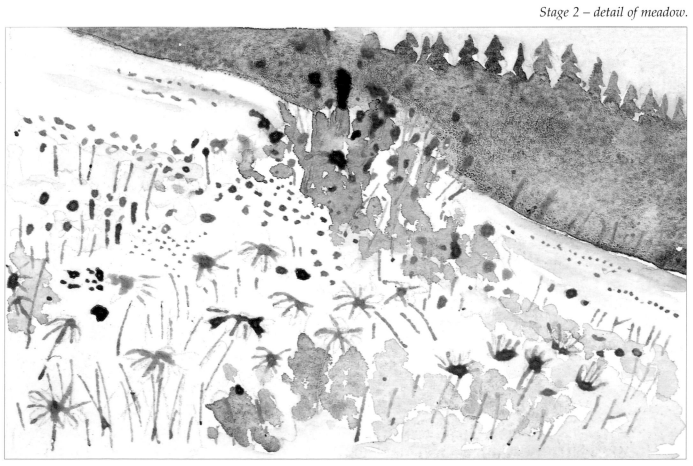

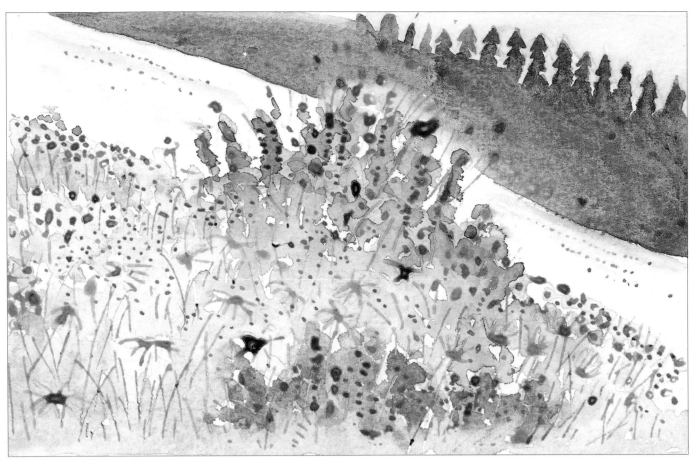

Stage 3 – detail of meadow.

Stage 4 – detail of meadow.

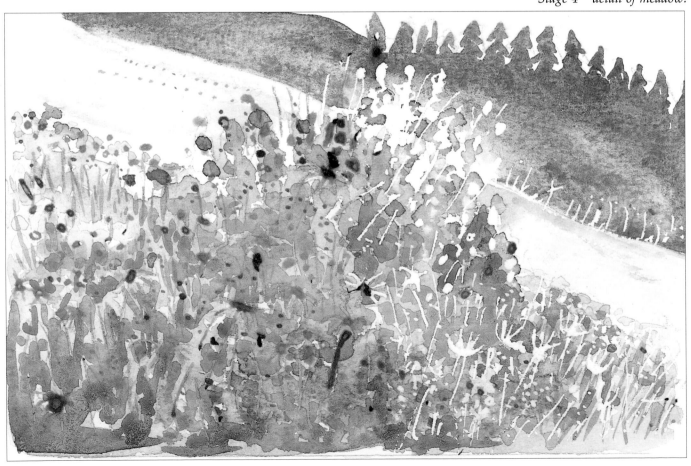

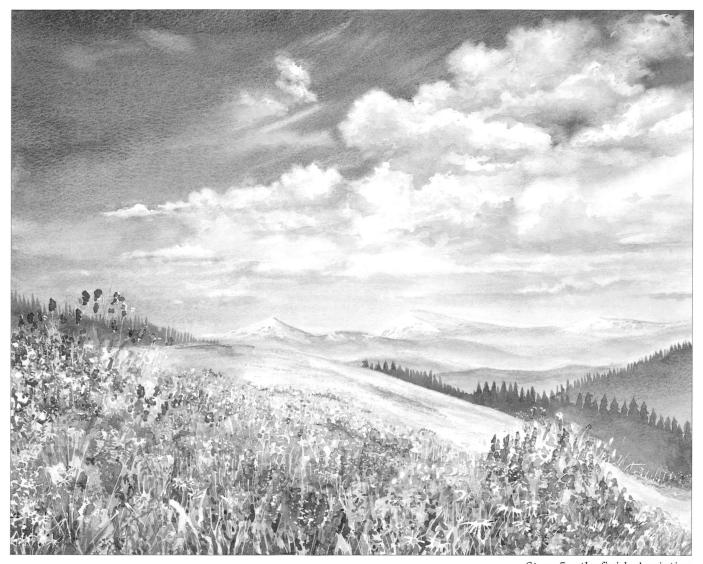

Stage 5 – the finished painting.

Stage 3 – detail

When the first colours are dry, I mask blobs and flower shapes over each coloured area. When these are dry, I dab on another over-layer of each colour; this will give a variety of tone to each 'flower' group. Intermediate green stalks are now masked off.

Stage 4 – detail

I add more greens with a mixture of cobalt blue, viridian and cadmium lemon in different densities, mixing in a little brown madder (alizarin) for the darker tones. I add the darkest greens towards the foreground to give shadows and depth to the tangle of stems and leaves. When the paint is dry I rub off the masking fluid and look at what I have got: this is always a surprise.

Stage 5 – the finished painting

Finally, I add the cadmium-yellow centres to the daisies and lightly touch up any areas needing more colour or definition.

This painting is shown much larger on pages 46 and 47.

Timothy Pond

I remember summer from childhood as being a happy, carefree time. To me, it conjures up images of sun-soaked beaches, sunbathers, and swimmers; of eating ice-cream; of men in white flannels playing cricket on the village green; or perhaps the buzzing of bees collecting nectar in the clover. British summers are not always like this, of course – they can often be rather wet! Nevertheless, there is more sunshine than usual and this will bring fields of flowers into bloom – poppies, cornflowers, speedwell...

Watercolour is the ideal medium to capture the luminous colours of summer, from the bright vivid colours of the umbrellas, towels and windbreaks that litter the beach to the soft translucent layers of colour found in rockpools. Cornwall is a place that has inspired many artists over the years. I myself am drawn to it for its rugged coastline and sandy beaches, and one summer I spent six weeks sketching along its glorious coastline.

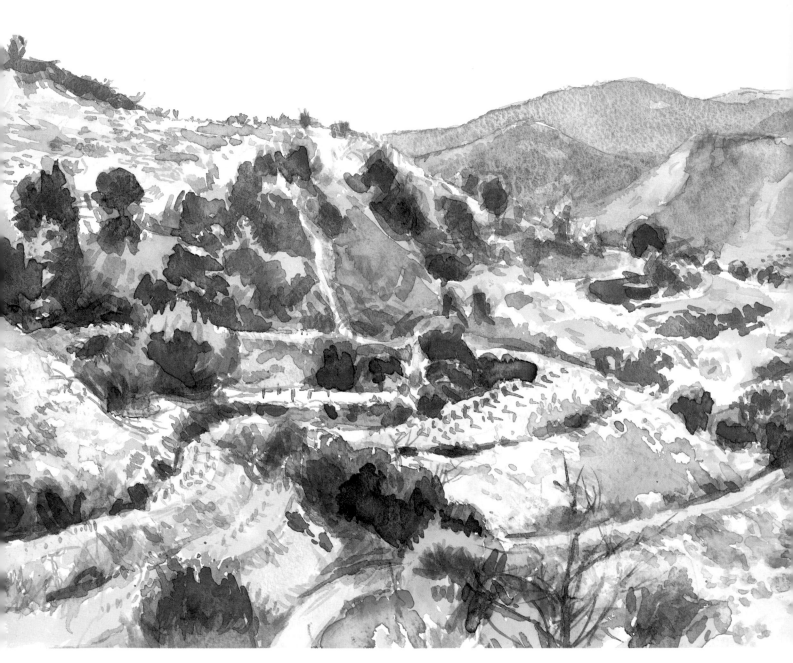

Summer sketchbook

Cyprus landscape

Original size: two pieces of paper taped together,
 each 29 x 42cm (11¹/₂ x 16¹/₂in).
Paper: 300gsm (140lb) mould-made acid-free.
Brushes: Nos. 1 and 4; rigger; 20mm (³/₄in) Dalon brush.

A very important piece of equipment to the landscape artist is the sketchbook. I take mine with me on holiday in case I spot something that interests me. Sketchbooks are a very good way of experimenting and trying out new ideas without having to worry about making mistakes! This painting takes up two whole pages of my 'landscape-format' sketchbook and makes a very long composition.

The landscape of Cyprus is very different from that of Britain and presents its own problems. I painted the bushes and olive trees in a variety of shades of green, which I blobbed on quite loosely but in an observed fashion. I made these blobs smaller and bluer in the distance.

Drawing is again established by the shape of colour. The colour of the sun-baked earth comes through these blobs and suggests a dry, arid climate.

Cyprus landscape.

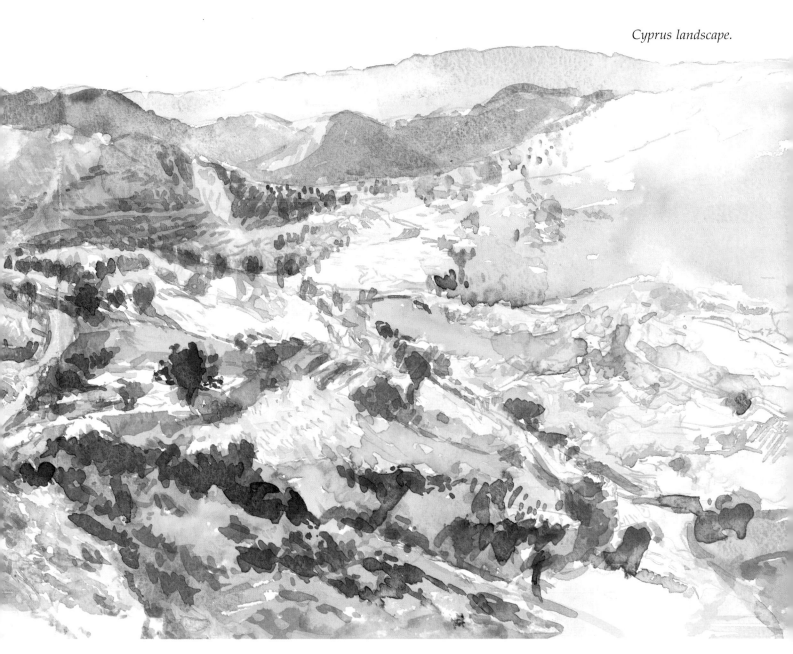

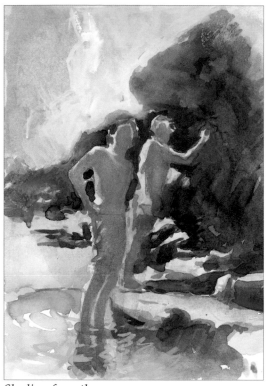

Shading from the sun

Original size: 33 x 23cm (13 x 9in).
Paper: 300gsm (140lb) mould-made acid-free.
Brushes: Nos. 1 and 4; rigger.

This composition caught my eye because of the unusual lighting effect. My friends appear to be mainly in shadow except for the sliver of light that makes them stand out dramatically against the dark rocks.

Cornish beach scene

Original size: 33 x 51cm (13 x 20in).
Paper: 300gsm (140lb) mould-made acid-free.
Brushes: Nos. 1 and 4; rigger.

Initially I was drawn to paint this scene because I was attracted to the light shining through the red and white umbrella, but as I started to sketch, the painting grew, and I began to become interested in the hard midday light that created a strong tonal contrast on the rocks, creating dark

Shading from the sun.

Cornish beach scene.

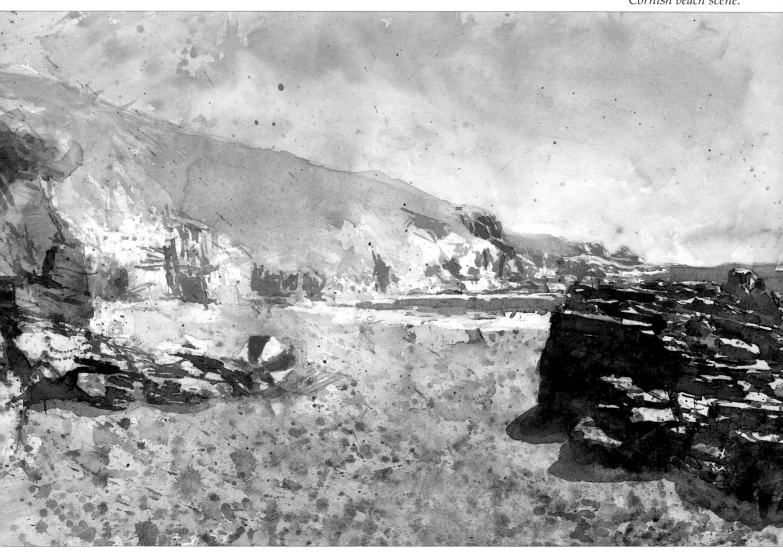

shadows and bright highlights. In the distance children run in and out of the sea and all in all it is a very relaxed summery landscape.

To give an impression of the texture of sand in the foreground I flicked paint with the brush.

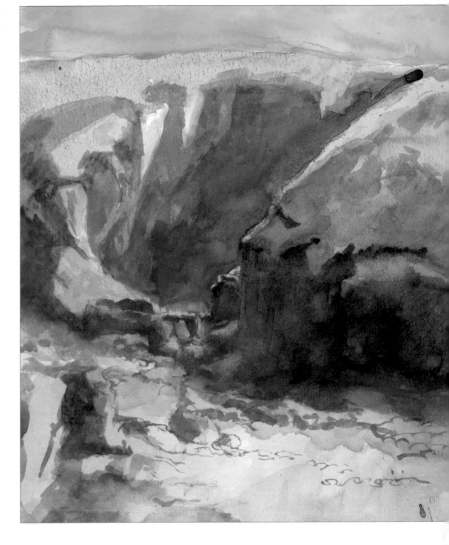

Gurnard's Head: study

Original size: 43 x 36cm (17 x 14in).
Paper: 300gsm (140lb) mould-made acid-free.
Brushes: Nos. 1 and 4; rigger.

In this study of Gurnard's Head, in Cornwall, I was trying to see how dark I could make the shadows before they looked dead or lost their airy quality. I was also experimenting with ways of painting the pebbles in the foreground without having to indicate each one individually. This was a really useful exercise and I went on to paint the full-scale panoramic picture with a good idea of what I wanted.

Gurnard's Head: study.

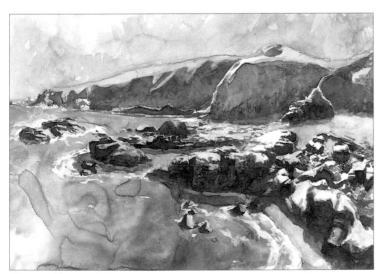

Gurnard's Head.

Gurnard's Head

Original size: 46 x 69cm (18 x 27in).
Paper: 300gsm (140lb) mould-made acid-free.
Brushes: Nos. 1 and 4; rigger.

Gurnard's Head, near Zennor in Cornwall, is so named because the rocky outcrop on the far left of this composition is supposed to look like the face of a gurnard fish.

The sea is very clear in this cove. I painted its unusual colour with a mixture of cerulean blue and lemon yellow. Painting in the small stones and pebbles on the beach gives a sense of scale to the massive cliffs in the background.

It is always a good idea to use a variety of sizes of brushmarks in a picture.

This picture is shown much larger on pages 6–7.

Two fishing boats (right)

Original size: 30 x 33cm (12 x 13in).
Paper: 300gsm (140lb) mould-made acid-free.
Brushes: Nos. 1, 3 and 4; rigger.

I spotted these two fishing boats pulled up on a sandy cove in Cornwall. I sketched them from above; this opened up the hulls into nice pear shapes, which made a simple design on the page. In the bottom of the blue boat there were still some mackerel that the fisherman was busy removing: I indicated these with a few strokes of a brush.

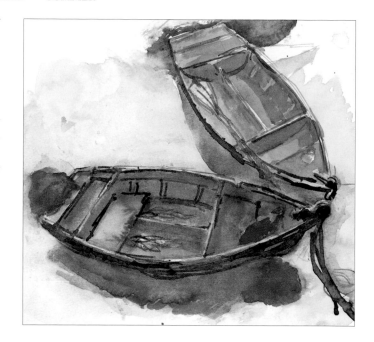

The cove

Original size 23 x 29cm (9 x 11½in).
Paper: 300gsm (140lb).
Brushes: Nos. 1, 2, 5, 7 and 10.

I painted this small painting in Cornwall looking down from the clifftop on a summer's afternoon. There is an abstract quality about the composition; I liked the way the swirling shapes of the sea contrasted with the hard, angular shapes of the rocks.

Stage 1

First of all, with a fine rigger brush I sketch out the design of my composition by drawing the cracks between the rocks with Payne's grey.

Stage 1.

Stage 2

Next I start laying in broad washes of colour with a wide brush. I want to capture the sunlight on the rocks, so I put down a wash of yellow ochre. The clear summer light makes the sea appear deep blue! I paint this with a wash of pure Prussian blue, using the brush in a feathery motion to convey the white foamy crests of the waves and taking advantage of the rough texture of the paper by dragging my brush across it, leaving flecks of white. The tall grey rocks on the right of the composition, which are in shadow, are painted in with raw umber and French ultramarine.

Stage 3

A watercolour brush can make many different kinds of mark, depending on how you hold it, whether you paint with the tip of the brush or its side, and at what speed you make the mark. In this painting I want to accentuate the swirling rhythmic quality of the sea crashing against the rocks.

I make long slender marks to suggest the rock formation on the bottom right of the painting, using Indian red.

This sketch was made at about midday, when the sun is overhead and shines down on the top of things. This places the top planes of the rocks in light, whereas the sides are in shadow. I start developing the form of the yellow rocks by painting their shadows with a mixture of alizarin crimson, French ultramarine and raw umber.

The shadows of the grey rocks are painted in with a mixture of French ultramarine and Payne's grey. At this stage, I also redraw the cracks between the rocks where they need more definition, using Payne's grey.

Stage 2.

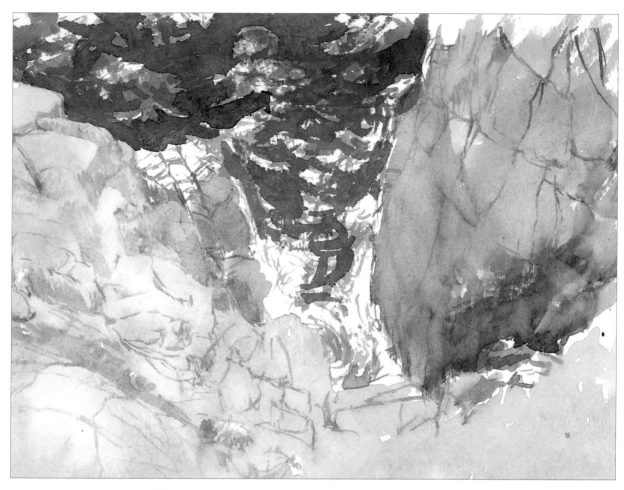

Stage 3.

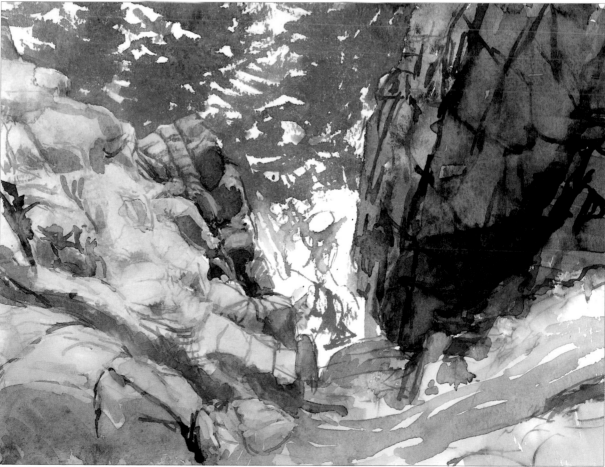

Stage 4 – the finished painting

In the final stage I pep up the colour of the sea by laying a fresh wash of Prussian blue over the old one. Now I take some care to draw and describe the shape and form of the rock formations. With white gouache I add touches to the white foam and flick the brush to suggest spray as a wave breaks on the cliff-face.

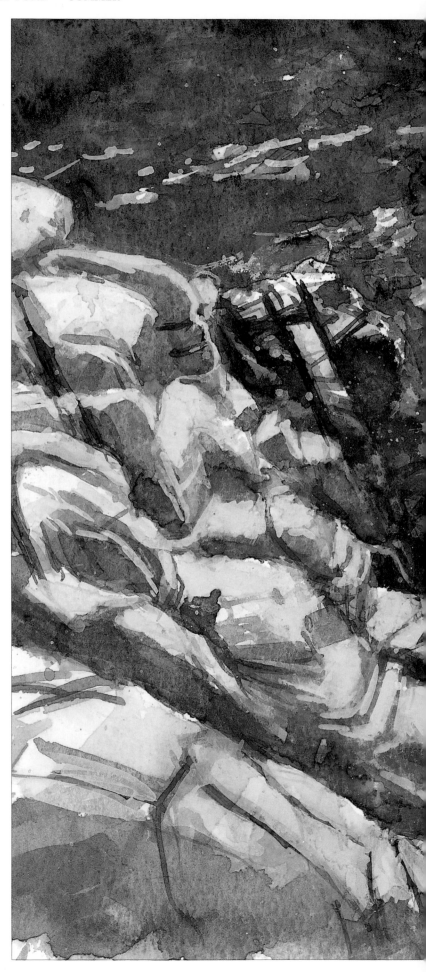

Stage 4 – the finished painting.

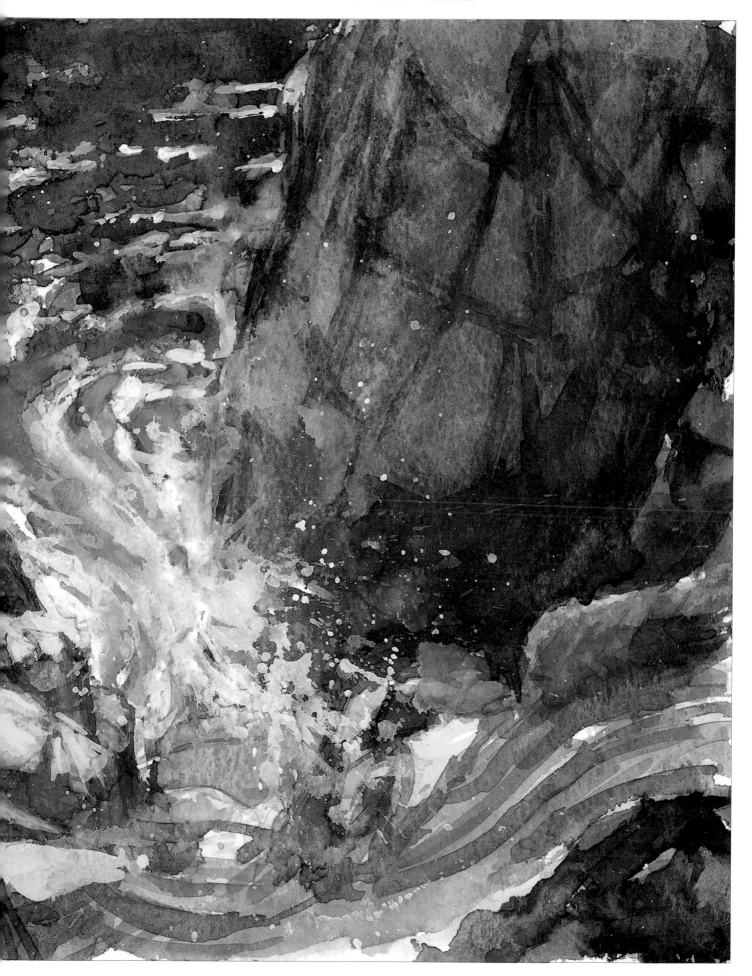

Wendy Jelbert

Summer is a glorious season of lush growth and flamboyant flowers, of hazy sunny days, long, light evenings and smouldering alizarin sunsets. I have wonderful memories of painting outings where we were obliged to shelter under trees, either from a sudden downpour of rain or from a genuine heatwave which would send us into the shade to escape from the dazzling light falling on our delicate canvases! Children laughing and kicking joyfully in the surf and the soft sigh as the sea is dragged back across the sand; the sleek gleam of boats and the murmuring and clinking of their tall masts in a gentle breeze as they rest in the protective arms of a calm harbour…all these are glimpses of a perfect summer! As with all successful outings, you have to prepare for them, and in summer, a painter's thoughts turn to venturing into the great outdoors and to pastures new.

I have selected several small packs of different media in order to be prepared for any occasion. These consist of sets of assorted pastels (oil, water-based, or soft); watercolours (in pans or a miniature box); a set of aquarelle (water-soluble) pencils, and several sketchbooks (the size depends on what I am hoping to do); assorted brushes in a protective box, some masking fluid, and a ruling pen; a pencil case with several drawing pencils and pens; a camera, a fisherman's stool, and a large carrier bag. A raincoat and a sun-hat round off the list and make me feel prepared for any eventuality!

Summer colours

Here is a mixture of my favourite summer colours.

Starting from the left we have viridian green, flesh, crimson, light red, Payne's grey, emerald green, permanent yellow, and Naples yellow. From a mixture of these 'foundation' colours I mix most of my remaining colours.

Mixing greens

The greatest difficulty my students face is the mixing of natural greens. We all have some ready-mixed greens such as sap green or Hooker's green. These are excellent bases, but care should be taken to get a pleasing effect, and not a sharp and vivid colour that makes your eyes water! As the time approaches to take my art class outside, we prepare for the difficulties ahead by suggesting that the students try out all their original greens and make up a chart using additional colours to widen their scope. I have laid out a list of easily obtainable colours that will have lovely results. Try mixing half of each colour to start with, and then perhaps with a ratio of one-quarter to three-quarters.

		ASSORTED COLOURS							
		Burnt sienna	Crimson	Flesh	Orange	Blue	Violet	Sepia	Yellow
READY-MIXED GREENS	Sap								
	Hooker's								
	Olive								
	Viridian								
	Emerald								

Try taking half of each green, then vary it by adding first a quarter of green and then three quarters of other colours.

Summer sketchbook

Wild poppies

The glowing colours of these field poppies embody the spirit of high summer.

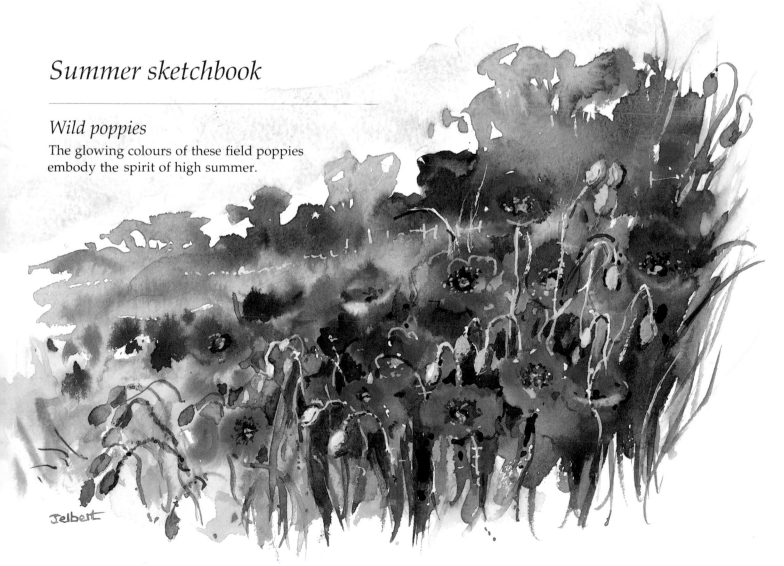

Jelbert

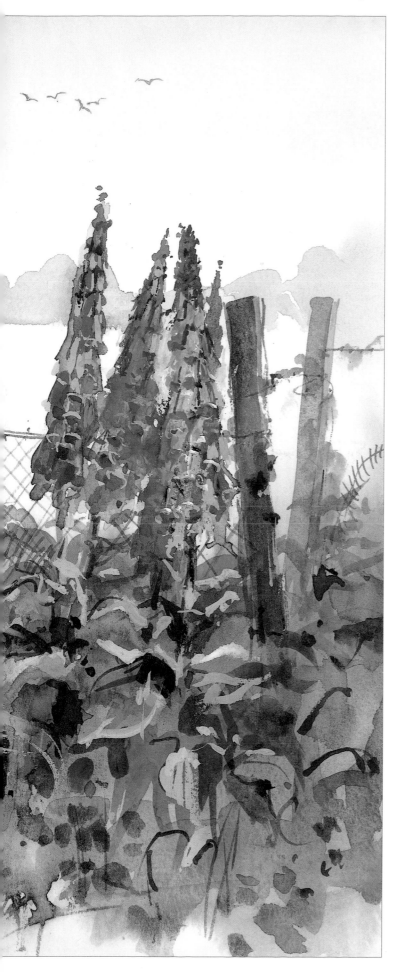

Foxgloves and ivy

Original size: 27 x 37cm (10 ¹/₂ x 14 ¹/₂ in).
Brushes: No. 7 round-headed; No. 1 rigger.

I adore the summertime – the hotter the better. I cycle when I can, as I find that I discover many more nooks and crannies when doing so. I also take a lot of photographs, and many of these are later developed into full-blooded paintings. These summer hedgerow pictures are another example in this series.

First, sketch out the main features and flood the foreground and middle distance with permanent yellow. While it is still damp, place in the hedgerow shape and the ivy-clad post, allowing them to become slightly diffused, blurring the edges of the foliage.

As the wash dries, add more details using the varying greens I mentioned in the previous section. Use mainly viridian, mixing in with this a little violet and burnt sienna or light red and cerulean blue. This blue is also used for the graded sky; add a dot of light red to the horizon.

Paint the distant tree silhouette in cerulean blue to create a contrast to the yellow field in the middle distance. The focal point consists of a bird singing on a fence-post, surrounded by foxgloves which are alert and upright and help to soften the line of fence-posts.

The shadowed leaves are painted in with thick olive green and touches of violet and blue; use a No. 1 rigger brush for the details of the curling ferns and trailing ivy. Paint in the wire fence carefully, using olive green and the rigger brush, and then the highlighting on the flowers, using white gouache and crimson.

Finally, add the light foxglove-leaf details using white gouache and a little yellow.

Summer sunset

Original size: 30 x 41cm (12 x 16in).

The warm afterglow in this harbour gives a feeling of tranquillity at the end of a long summer's day.

Stage 1

Draw in the outline of the boats, taking care to be accurate, and not being too heavy with your blue aquarelle pencil! Using a drawing pen and masking fluid, highlight the shape of the sun, the edges of the boats, and ripples on the water.

Stage 1.

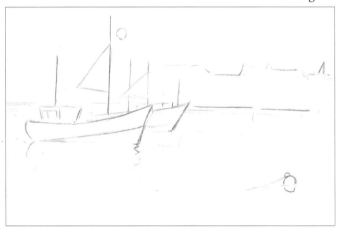

Stage 2

Using a 1.25cm (half-inch) flat-headed brush, put in a wash of alizarin crimson and Naples yellow over the sky and the corresponding area in the water. Permanent yellow is painted in immediately as a bright halo around the sun.

Stage 2.

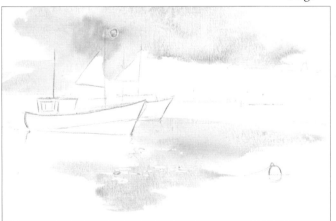

Stage 3

While the painting is still wet, quickly add a wash of blue and a mixture of ultramarine blue and crimson together for a velvety covering into the surrounding areas in the sky and sea. Use a mixture of burnt sienna and blue for the harbour and its distant buildings.

Stage 4

Now for the details of the boats. Add burnt sienna to the small sails, and blue for the boats themselves, varying the colours for added interest and impact. Touch in the buoy with a combination of violet (blue and crimson) and green (blue and permanent yellow) for the reflections.

After the masking fluid has completely dried, briskly rub it off, exposing your original masking work.

Stage 5 – the finished painting (shown overleaf)

Fill in the white marks preserved by the masking fluid by adding a wash of pale yellow for the sunlit features and pale blue for those in shadow. Pattern the water with pale yellow and reinforce it with squiggles of white gouache and pale pink (crimson and Naples yellow), applied with a rigger, then paint in the overall effect of massed boat details with quick impressions. Use assorted strokes and dots, again using the same brush, with a touch of blue and burnt sienna.

The shape of the sun is painted in with Naples yellow, as is the colour being reflected into the sea below.

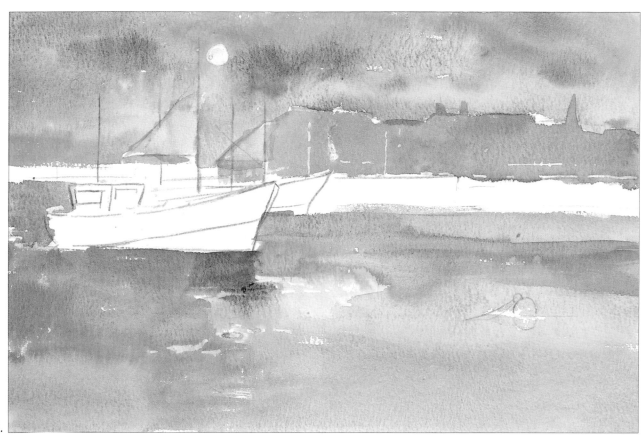

Stage 3.

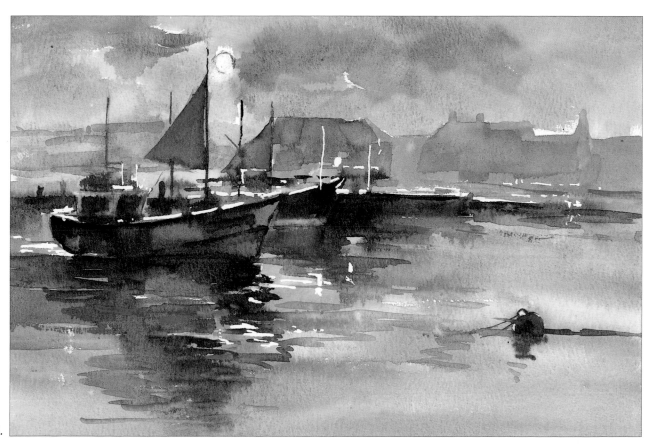

Stage 4.

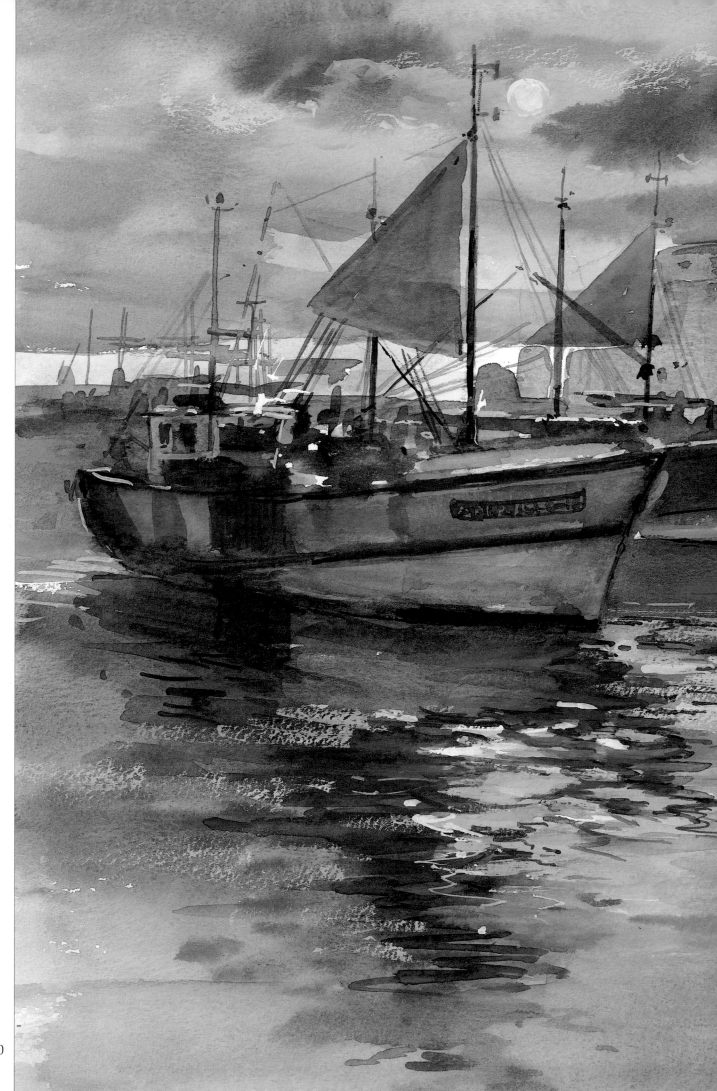

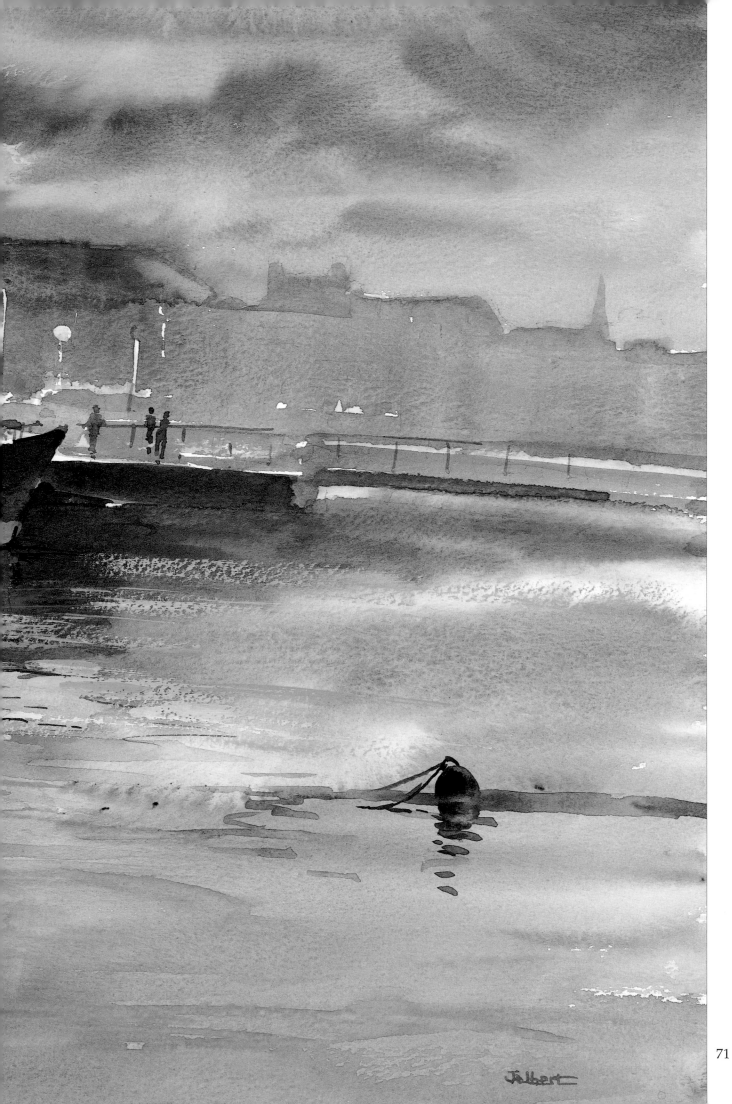

Jelbert

Aubrey Phillips

In many ways I find summer the least interesting of the seasons. I tend to surprise people who are rejoicing in weeks of intense heat and unabated sunshine when I say that such weather often bores me. I long for a few clouds drifted across the sky by a cool breeze, creating areas of light and shadow on the landscape below.

During these days of cloudless skies, when to me the landscape appears flat and uninteresting, I often find it much more satisfying to seek subject-matter in a wood, where the strong sunlight is filtered through the foliage, creating dappled areas of light and shade. Under these conditions I am able to study a myriad of different shades of green, with the foliage rendered transparent in places under direct light in the shadows.

Towards the end of June, when the varied greens of spring begin to drift into a general overall monotony of shade, I begin to look for features which will provide a little uplift of colour. I make full use of aerial perspective, in which the density of the atmosphere imparts a cool blue-grey aspect to the distant forms of woods, hills and mountains.

As the season advances, cornfields begin to ripen into shades of gold and the land is transformed by the plough into rich earth colours.

Summer sketchbook

Here I have painted some sky studies, choosing some of the clouds that I find so welcome in the vacant summer skies.

Sky study No. 1

This is an example of a cloud study painted on *dry* paper (RWS rough surface 300gsm (140lb)).

Sky study No. 2

Below you can see another sky study on *damp* paper. I have used the same paper and colours as in the first study, but the effect is softer and less textured.

Castletown, Isle of Man

Original size: 19 x 28cm (7 1/2 x 11in).
Paper: 425gsm (200lb) Bockingford.
Brushes: Nos. 8 and 12.

I was attracted by this tranquil summer scene with its calm sea and wide, cloud-crossed sky.

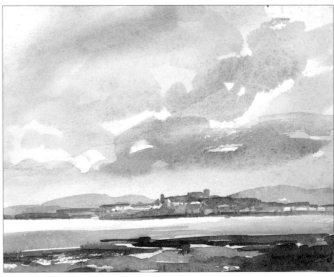

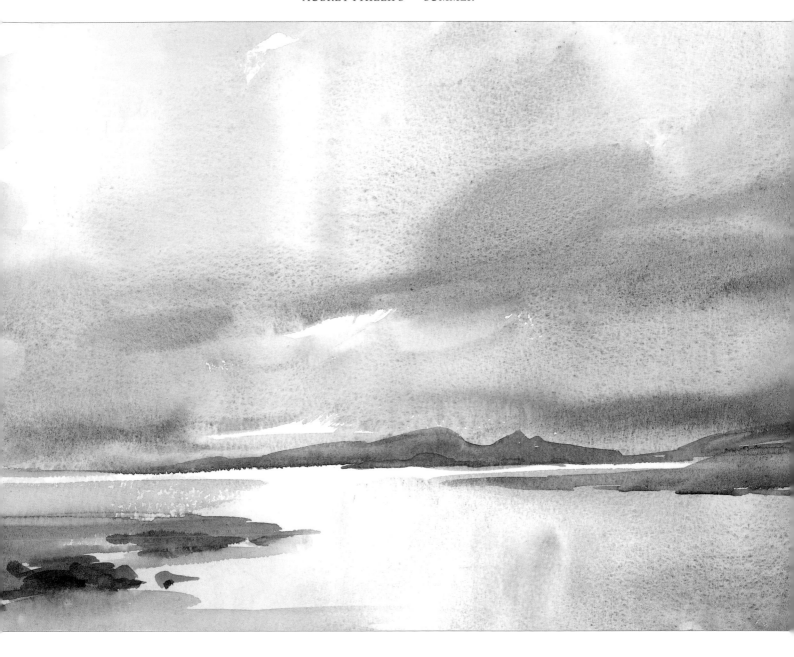

Ardnamurchan: a calm evening

Original size: 27 x 38cm (10½ x 15in).
Paper: 425gsm (200lb) Bockingford.
Brushes: 7.5cm (3in) hake; Nos. 8 and 12.

In this study I attempt to convey the calm of evening over that lovely coast at Ardnamurchan, the most westerly part of the British mainland.

There is a stillness in the atmosphere as the sun sinks low in the sky, shedding its light over the quiet water as it breaks from the edge of a dark cloud. The shapely contours of the Isle of Rhum stand out in blue-grey tones across the calm levels of Sanna Bay.

I begin with the most vital part of the picture, the sky; then, for the warm cloud high on the right, I use a mixture of raw sienna and light red, with softer touches over to the left, drifting into a pale wash of monestial blue. I mix a wash of ultramarine and burnt umber and apply it to create the clouds while the first wash is still wet; then I repeat these washes in the areas of water below. I take care to leave areas of paper untouched to make the light in the sky and its reflection in the water below.

I allow the sky to dry before washing in carefully the contours of the Isle of Rhum, using again a mixture of ultramarine and burnt umber (in a stronger tone than that which I used in the clouds).

Viridian and burnt sienna give me the warm green of the nearer headlands on each side, with burnt umber drifted in for darker warm tones. All these are added to the water area when it is dry.

Summer in the Malverns

Original size: 27 x 38cm (10½ x 15in).
Paper: RWS rough 300gsm (140lb).
Brushes: 7.5cm (3in) hake; Nos. 8 and 12.

This was painted on a warm sunny day in midsummer, with the evening sun beginning to colour the high clouds and distant hills and creating areas of light and shade over the landscape.

Stage 1

I begin by dealing with the sky, which dominates the entire mood of the subject and sets the tone of the background behind the hills. Here I do not begin with any pencil drawing (in fact, I seldom do) but depend on creating form with the brush. (In the exercises I have suggested elsewhere in this book, I have attempted to demonstrate the direct use of the brush.)

I mix light red with raw sienna for the warm light on the clouds, and pale monestial blue for the background sky, taking care to retain areas of white paper as highlights. I mix ultramarine and burnt umber for the grey areas of cloud. Then I carry down over the entire area of the paper below a soft combination of all these colours, drifting in some viridian and adding raw sienna into this on the right, and burnt sienna across the bottom. This covers the whole of the paper in a continuous wash of rather soft tints.

Stage 1.

Stage 2

Next I mix up a wash of ultramarine and burnt umber, stronger than that I used in the clouds, and shape the distant hills against the background of the sky, which had been allowed to dry. I soften this wash at the sides and base into the background by adding some water.

Stage 3

I now prepare a fairly strong wash of monestial blue and burnt sienna and form the wooded hills across the middle distance. The base of the hills on the right of the picture is dry, which creates a definite contrast, but on the left the hills are still damp. This allows the colours to blend, giving a soft effect. I drag the brush across the dry paper on the lower left-hand side, creating a textured area for the surface of the field.

Stage 4 – the finished painting *(shown overleaf)*

I continue with a strong mixture of monestial blue and burnt sienna, drawing in with the brush the shapes of the trees and hedgerows in the middle distance. The nearer middle-distance fields are painted using a mixture of raw sienna and viridian, and burnt sienna for the foreground to the left, indicating a ploughed field.

To complete the work, I again use monestial blue and burnt sienna to shape the nearer trees on the left firmly, retaining, however, some of the softer forms beyond them.

Stage 2.

Stage 3.

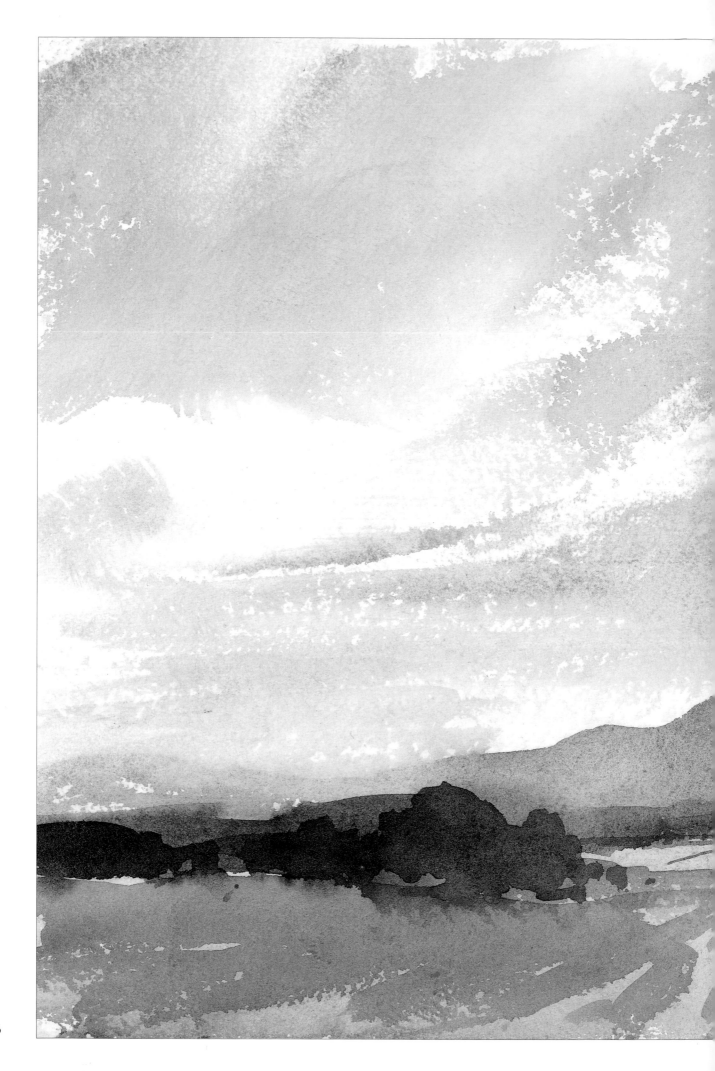

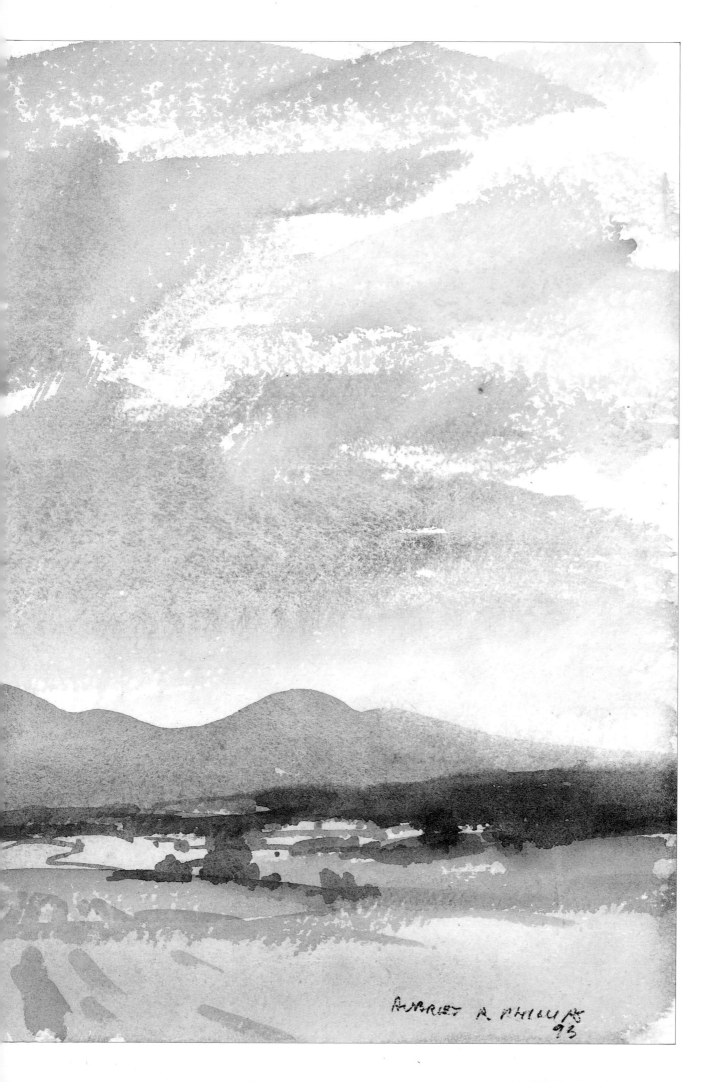

HARRIET A. PHILLIPS
93

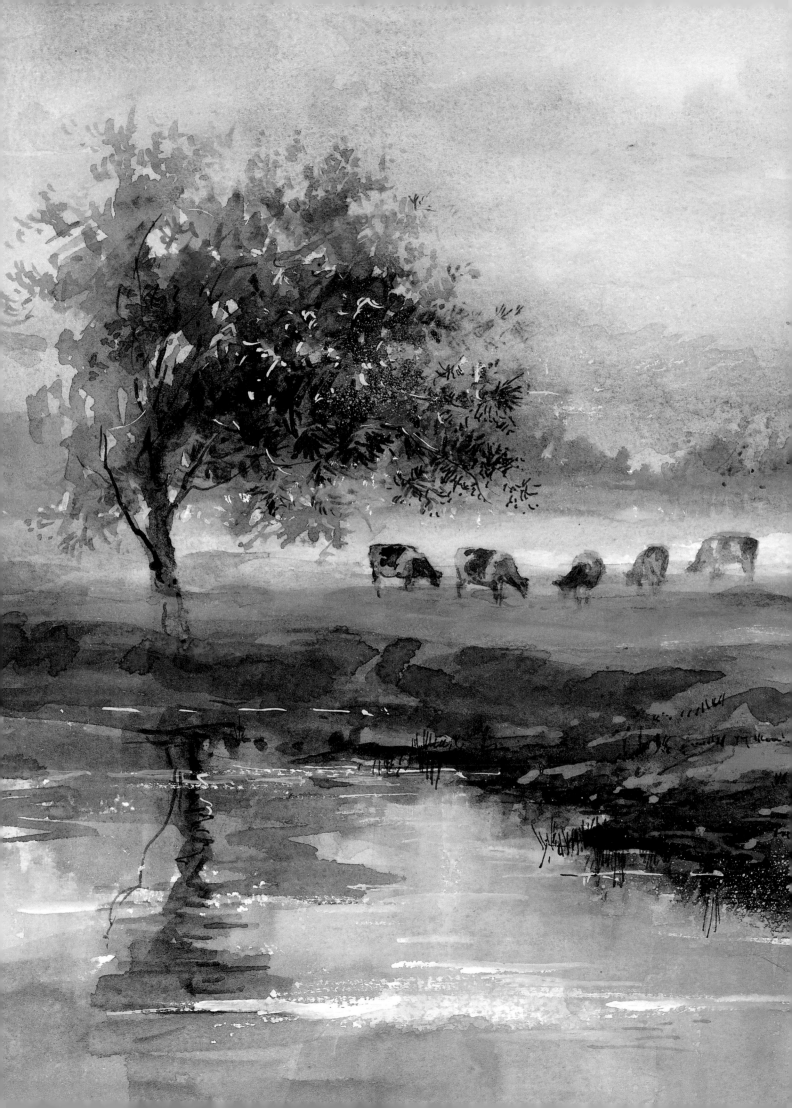

Autumn

'*A season of rich and mellow contrasts: mists nestling in river valleys; spiders' webs bejewelled with crystal droplets...*'

Autumn mist by Wendy Jelbert.

79

Wendy Jelbert

Autumn is a season of rich and mellow contrasts: mists nestling in river valleys; spiders' webs bejewelled with crystal droplets gleaming in the gentle morning sun; honeysuckle rambling in the hedgerow, caught between the seasons, displaying both berry and flower; in the orchards, blushing apples hanging heavy on each arched branch, waiting to be harvested; bonfires fuelled by a feast of twigs and fallen leaves; majestic gold and bronze trees, resplendent with sparkles of filtering sunlight. The season offers such a wealth of textures, moods and variety that you will hardly know where to start!

Colours

Here I have spread out some of my favourite colours. Autumn is ablaze with yellows (permanent and Naples), orange (ready-mixed in tube or pan form), vermilion, alizarin crimson, burnt sienna, Vandyke brown and cobalt violet. In this colour-test I have dropped and splashed several hues together and watched them react, so that I can use any good results in my future paintings.

These colours are just right for the rich reds and browns of the autumnal rosehips on the opposite page.

Autumn sketchbook

Cow parsley and sorrel (below)

Original size: 18 x 25cm (7 x 10in).

This picture uses a limited palette.

Sketch in the details and draw in the cow parsley and ferns with the masking fluid and ruling pen. Then wash in the gentle sky with a combination of cerulean blue and burnt sienna. The foreground and middle distance are painted in watery Naples yellow dotted with areas of soft Vandyke brown and burnt sienna. Strengthen the posts with Vandyke brown and cerulean blue, and use burnt sienna and blue with Vandyke brown and cerulean blue for the distant woods.

When everything is dry, rub off the masking fluid and wash highlighted markings back in with permanent yellow and a splattering of burnt sienna.

Finally, paint details of the sorrel and the foliage in vermilion and neat permanent yellow.

A few hedgerow alternatives (opposite)

I often encourage my art class to work out ways of composing a picture other than the one before them. In the exercises on the opposite page I have tried out a few ideas.

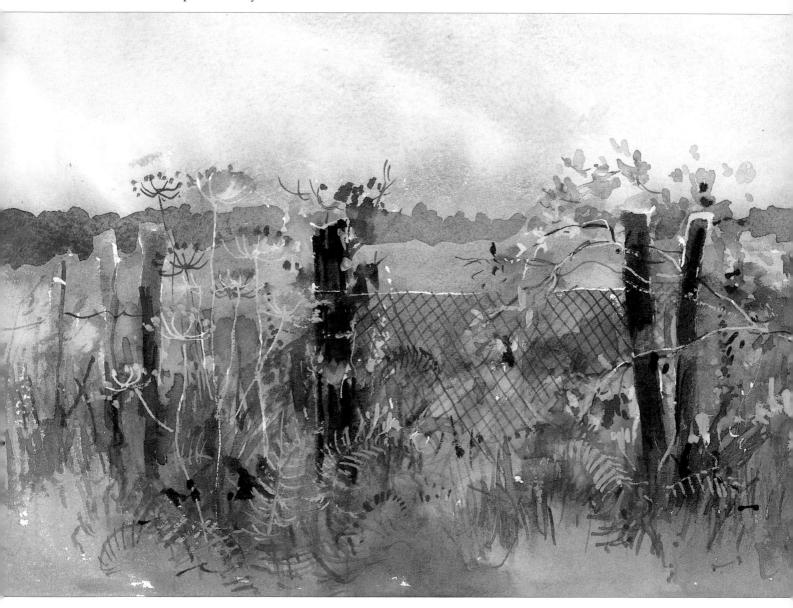

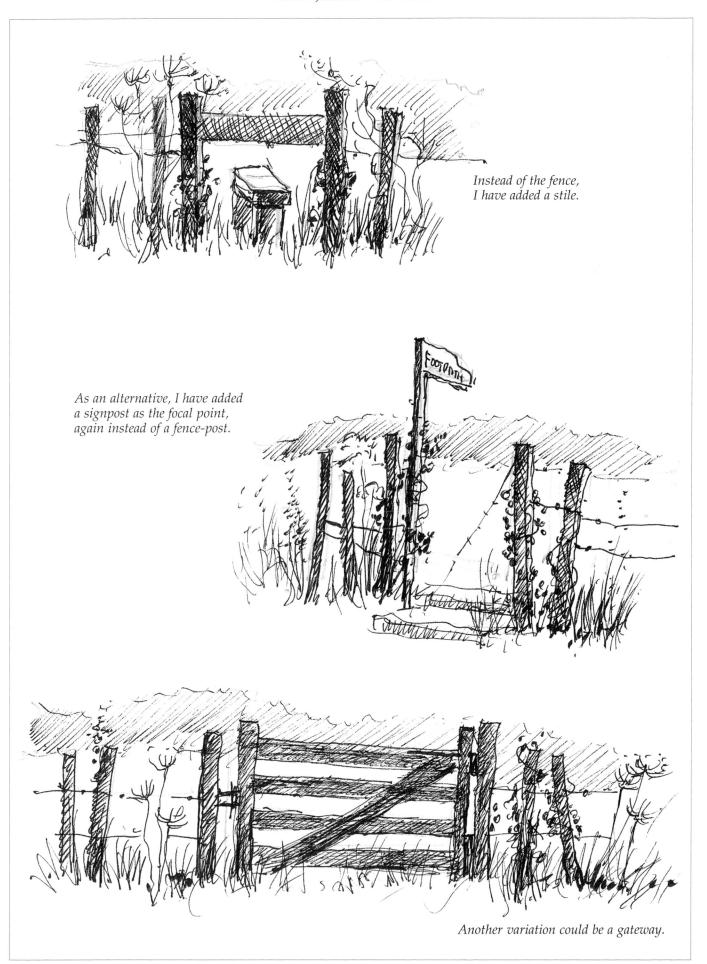

Instead of the fence,
I have added a stile.

As an alternative, I have added
a signpost as the focal point,
again instead of a fence-post.

Another variation could be a gateway.

Autumn mist

Original size: 30 x 40cm (12 x 16 in).

Here the white mists of autumn are lingering on the low-lying watermeadows where these cows are grazing.

Stage 1

Develop the drawing with a blue aquarelle pencil, paying particular attention to the placing of the cows and the main tree, as the tree reflection needs to be a main feature. Place highlighting on the animals, into the tree, and zig-zagging across the water.

Stage 1.

Stage 2

Dilute some cerulean blue and apply it to the uppermost section of the sky, then quickly paint it down into the fields, dipping your brush into alizarin crimson, neat cerulean blue and brown madder, and building up foreground interest. To achieve the diffused effect of the distant line of trees, wash in a mixture of burnt sienna, cerulean blue and yellow ochre so that some of the silhouette runs into the sky. As the wash begins to dry, repaint the darker tufts of grass in the foreground.

Stage 2.

Stage 3

Rewet the sky, if needed, and paint over it with a gentle application of burnt sienna and a tiny dot of brown madder, building up a warmish glow for the final image. If the sky is still workable, burnt sienna could be applied straight into the sky.

Re-establish the same colour, only darker, in the tree, and quickly dot in a deep green (yellow ochre and olive green) and watch it run into the paint. For the water, paint over a wash of permanent yellow, gently dropping blue and orange (the latter made from ochre and crimson) into the area.

Stage 3.

Stage 4

While the paint is still wet, paint in the foreground bank. Put the reflections into the water with olive green and

Stage 4.

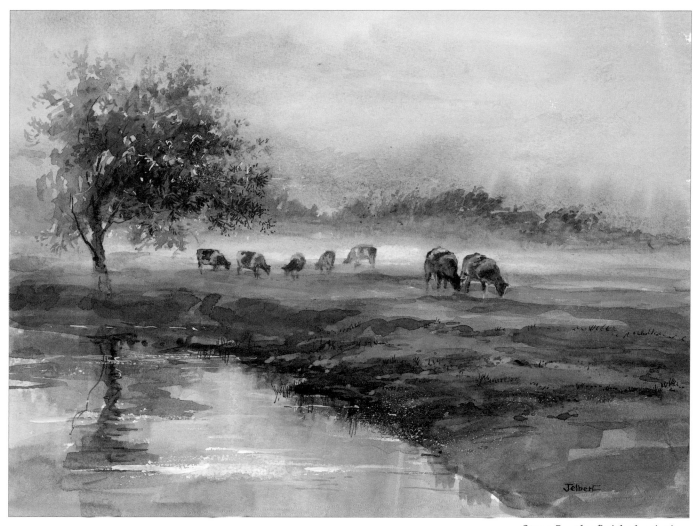

Stage 5 – the finished painting.

touches of violet (made from crimson and blue). Using this colour but with added blue, establish the leaf textures on the tree and bankside grasses with a rigger brush. Then paint in more details on the distant trees, and allow the picture to dry completely.

Rub off all the masking fluid, and squeeze out a little white gouache ready for the first 'mist' glaze. Using a flat-headed brush, apply a wash of milky white, building up the appearance of mist towards the distance, and highlighting the shapes of the cows.

Stage 5 – the finished painting

Finally, refine the existing masses, and add details to the reflection, trees, and foreground, using a brown steel-nibbed pen. Yet another glaze of white gouache may be added to intensify the mist. Then paint over the white shapes where the masking fluid was, using pale blue.

Pull some of the colours into the water, giving a more natural effect to the water, and then, finally, apply a sweep of white gouache across the water to give the impression of captured light glimmering on the surface.

This painting is shown much larger on pages 78 and 79.

Aubrey Phillips

I find the season of autumn rather a difficult time to paint, chiefly on account of the riot of colour it produces. It may be an overwhelming experience to view nature's glorious display in its entirety, but any attempt to convey this in a painting calls, I always feel, for considerable restraint.

For me, the period of late autumn, when many of the leaves have fallen, or have been torn away by strong winds, leaving little foliage covering the stark bare branches of the trees, is a far more attractive time, and translates better into a painting.

Autumn sketchbook

Trees (below)

In this exercise I have washed several colours together, creating shades of green. I allowed this to dry partly, and then, with a damp brush, lifted out shapes which suggest tree trunks and branches. It is important that the wash is allowed to become partly dry, for if this is attempted immediately after the wash has been made, the colours will simply close back over the areas which have been lifted.

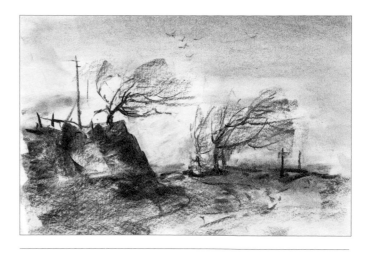

Windswept trees – the Malvern Hills (above)
Original size: 29 x 41cm (11½ x 16in).
Paper: cartridge.

In this charcoal study I have attempted to convey the effect of an autumn gale sweeping over the Malvern Hills and lashing the trees in its fury, their gnarled and twisted forms bearing witness to the battering of countless autumn and winter storms. In order to emphasise further the windswept trees I have used the firm, static shapes of solid rock, posts and fencing, which provide a contrast to the bent trees.

Showery weather (below)
Original size: 29 x 41cm (11½ x 16in).
Paper: cartridge.

I find a quick charcoal sketch very useful, especially when I am attempting to capture the swiftly changing effects of a passing storm, with its dramatic play of light and shade, over the distant landscape. A few written notes on colour, too, can be very helpful in translating the study into watercolour when I am back in the studio.

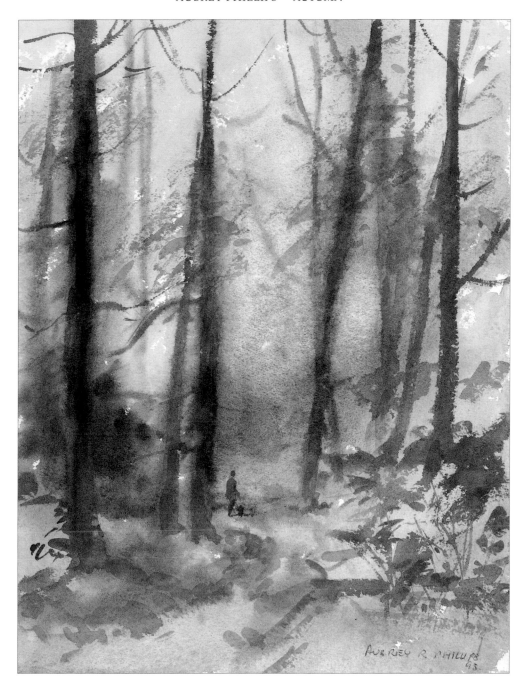

Autumn woodland

Original size: 39 x 29cm (15½ x 11½in).
Paper: Richard de Bas 480gsm (300lb) rough.
Brushes: 7.5cm (3in) hake; No. 12; rigger (for branches).

For this picture I chose a 'portrait' format to help give the feeling of height to these tall trees.

For the most part this study was worked in rather a wet state, with a wash of monestial blue for the background of the sky, with a mixture of light red and raw sienna dropped into it, suggesting the warmer colour of the foliage. This same mixture was carried over the entire foreground. I used ultramarine and burnt umber for the distant trees, with monestial blue and burnt sienna, in a darker tone, for the nearer ones. Burnt sienna was also applied in the lower foreground area, while the paper was in a damp stage. The darker tree-trunks and branches were laid in after the paper had dried, together with the foreground area to the right, suggesting texture. The more positive areas of foliage on the trees were also applied over a dry background, using burnt sienna and burnt umber. Working into the background while it was still wet, or at least partially wet, helped to suggest that misty atmosphere which is a particular feature of autumn.

Finally, the figure of the man with his dog helped to convey a sense of scale and added a touch of human interest to the scene.

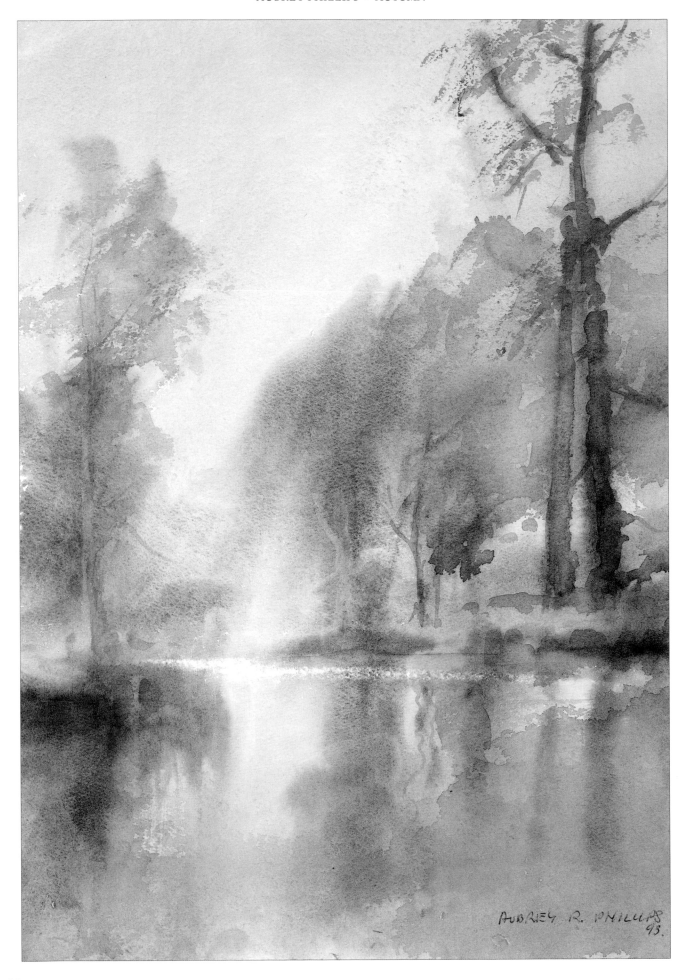

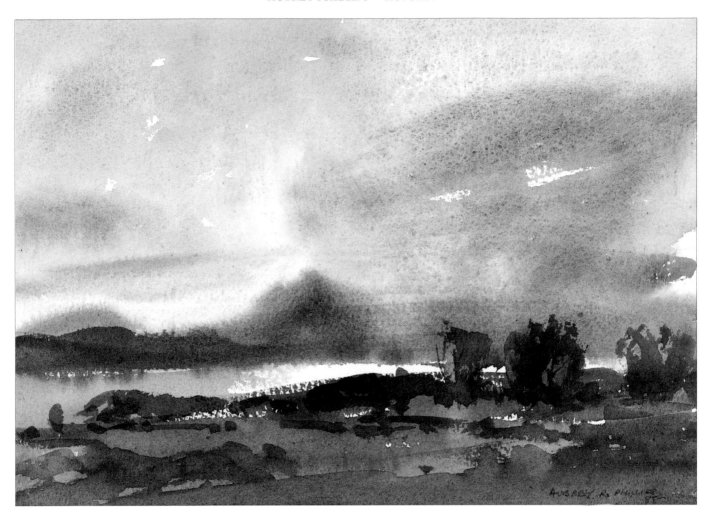

Misty morning on the Avon: October

Original size: 39 x 29cm(15½ x 11½in).
Paper: Richard de Bas 480gsm (300lb) rough.
Brushes: 7.5cm (3in) hake; No. 12; rigger (for branches).

My approach in this picture was very similar to that in *Autumn Woodland* (see page 87), and I used the same colours. I worked into the sky area while it was still wet, softening the forms of the distant trees, then I treated the area of water in the foreground in the same way. The tall trees on the right and the nearer foliage were painted on to a dry background.

An important feature of this study was the effect of October morning mists rising from the river and creating a feeling of mystery; I felt that the soft light breaking through and sparkling on the water was an interesting feature.

During autumn I feel a sense of sadness for the ending of the year, which I have attempted to convey in my picture.

Highland weather: north-west Scotland

Original size: 23 x 30cm (9 x 12in).
Paper: Arches 300gsm (140lb) rough.
Brushes: No. 12.

Weather plays a very important part in my landscapes, creating a mood and atmosphere, and there can be no other region in Britain which is so subject to dramatic changes in weather as Scotland. High mountains are lost in the clouds, are unveiled again by the winds, and then their majestic contours are illuminated by the sun and mirrored in the clear waters of the loch below.

This was the kind of mood I attempted to convey in my study *Highland Weather.* I treated it in a very broad way, with the distant mountain forms softened by mist and the dark storm-cloud on the right giving a sense of drama to the scene. The sun was breaking through, with its light sparkling on the waters of the loch, creating a dramatic contrast to the surrounding darks.

I retained the white of the paper, untouched by washes, for this highest light, with the deep tones of the trees to the right against it, and the dark warm tones of the foreground creating a strong supporting base to the composition. I used very little colour in this work, the general effect being dependent on tonal contrasts.

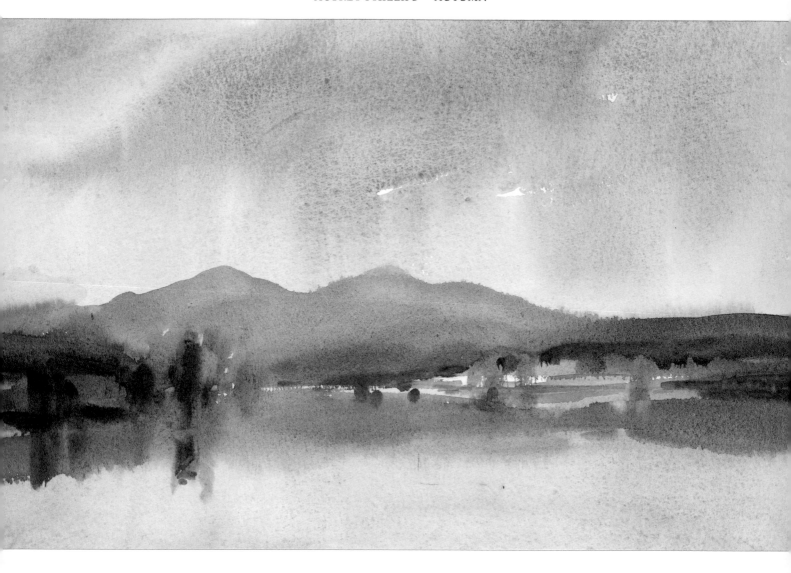

Severn floods and the Malvern Hills

Original size: 28 x 38cm (11 x 15in).
Paper: Bockingford 425gsm (200lb).
Brushes: 7.5cm (3in) hake; No. 12; No. 8.

Flood waters hold a fascination for me, chiefly because under such conditions the whole subject is completely changed. Large areas of water reflecting a light sky into what would otherwise be a darker area of land transform all the tonal relationships. (A covering of snow has the same effect.)

Both of these conditions attracted the Impressionists, who have left us some wonderful interpretations of these effects.

In this picture I was attracted by the calm still mood of the subject. Floods from the River Severn had spread over the riverside meadows, reflecting the sky and the distant Malvern Hills, but it was the flood water and its reflections that played the major part in creating the mood of quiet stillness.

I begin with the light warm glow in the sky, using a mixture of raw sienna and light red, and above that I wash a grey tone (ultramarine and burnt umber with a little monestial blue) to the upper left. These washes are repeated in the water area below.

Before the sky wash is dry, I mix again ultramarine and burnt umber and establish the contours of the Malvern Hills, repeating their shapes in the water. This wash is still wet, which gives me a soft edge to the reflections. I use light red and burnt sienna for the distant light area of trees on the right, together with their reflections in the water. I add darker touches of burnt sienna and burnt umber on each side for the woodland areas; also a stronger mixture of ultramarine and burnt umber than I used for the hills.

I complete the study with the dark tree forms and their reflections, using burnt umber with a little ultramarine added. Throughout the work I strive to maintain a direct, broad approach, with the washes kept fairly moist, since the *mood* of the subject is my chief aim.

Autumn in the Malverns

Original size: 29 x 39cm (11½ x 15½in).
Paper: Richard de Bas 480gsm (300lb) rough.

In this picture I try to capture the mood of a calm still day, which can often be characteristic of the season.

First of all I work out the composition and tonal relationships in charcoal, which makes me feel more confident when I take up my watercolours and start the picture.

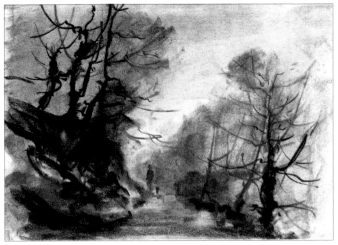

Preparatory charcoal sketch.

Stage 1

I wash in a warm mixture of light red and raw sienna over the greater part of the paper. I take care, however, to preserve a small area untouched as a highlight in the lower part of the sky.

Into this wash I float a mixture of ultramarine and burnt umber for the upper area of the sky, which I then repeat in a stronger tone for the distant soft tree-shapes lower down on the right.

In the foreground, to right and left, I add a touch of raw sienna with viridian, creating a soft green. All this I carry out on the whole area, which remains wet.

Stage 2

With the paper now dry, I begin to shape up the trees with a mixture of burnt sienna and ultramarine, dragging the brush on its side and making use of the texture of the paper.

In the foreground area, to right and left, I use a more liquid wash of viridian and burnt sienna with burnt sienna over the pathway. I further strengthen the grey in the trees to the right, using burnt sienna mixed with ultramarine and blending it into the previous wash.

Stage 1.

Stage 3 – the finished painting (shown overleaf)

Using a strong wash of ultramarine and burnt umber, I draw in firmly the trunks and branches of the trees, to right and left, over the dry surface of the paper, and further strengthen the foliage by dragging the brush. I wash in the shadows over the foreground, again using burnt umber and ultramarine.

Once again, I choose to add a figure and a dog, which provide a sense of scale.

Stage 2.

91

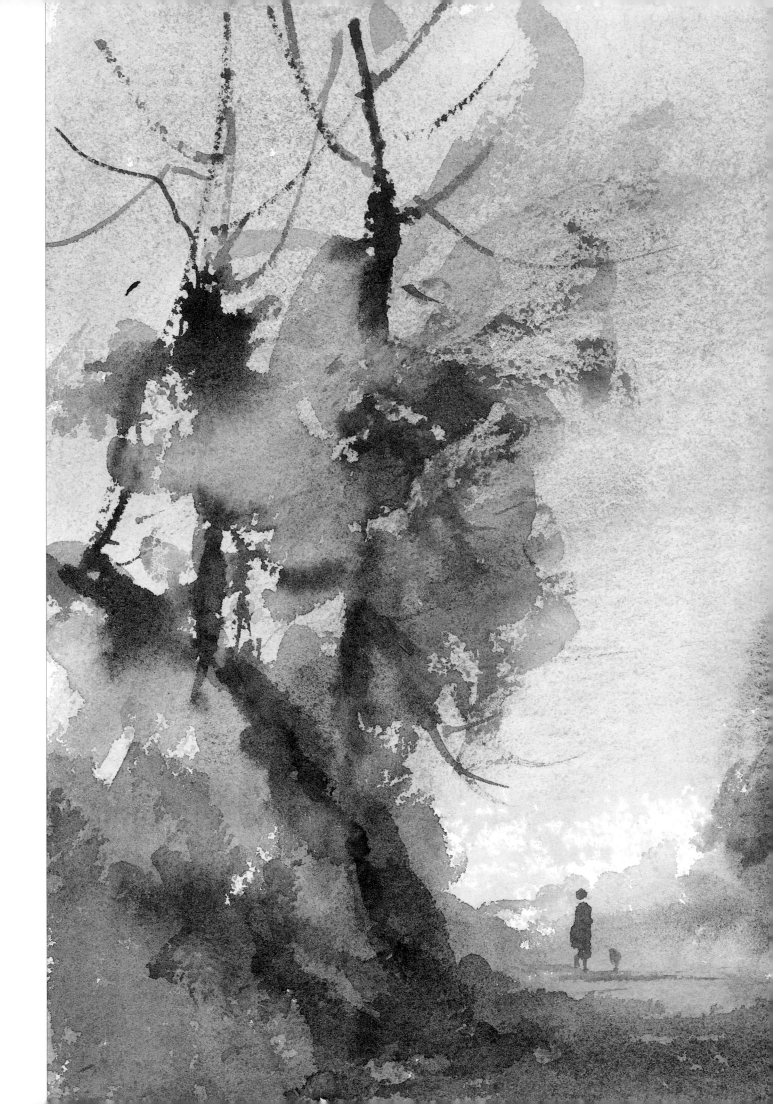

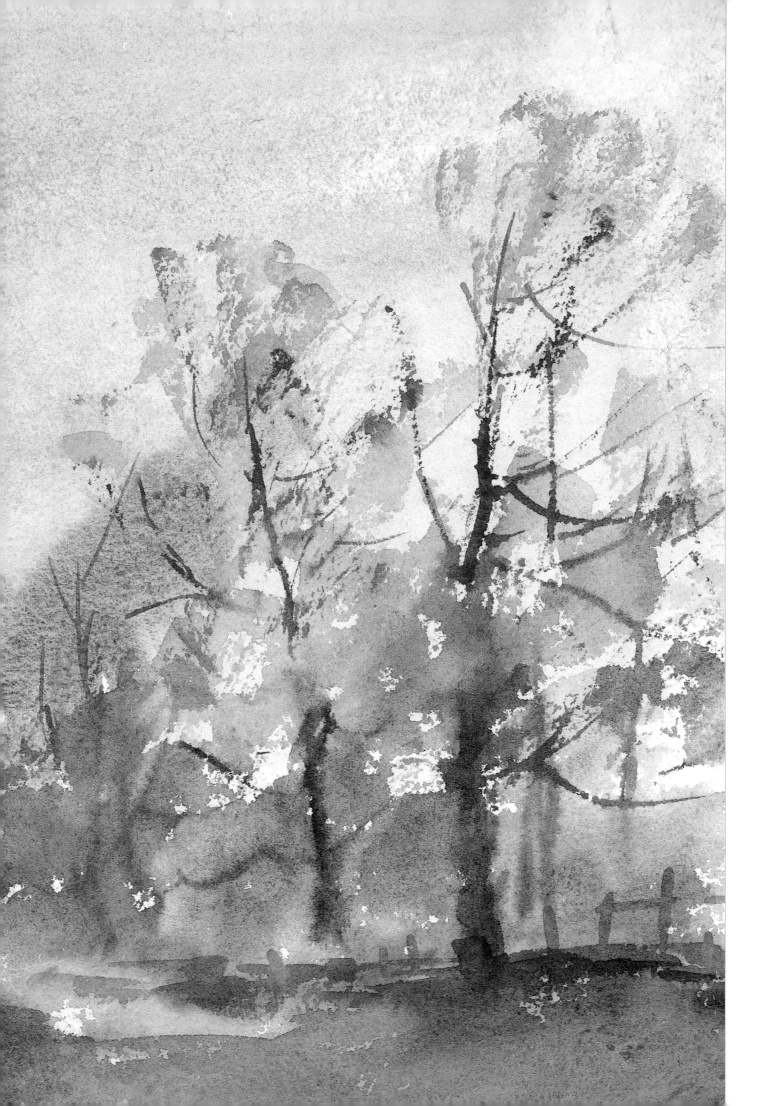

Timothy Pond

Autumn is my favourite time of year. It is a time of change and contrast. As the earth tilts and the sun's curve grows shallow the colours of the leaves change from green to red, yellow, and brown, and a noticeable chill develops in the air. Early-morning mists may give way to a crisp, clear sunlight that illuminates the changing leaves, or they may hang in the valleys all day. Gazing up, it is possible to see where these translucent leaves overlap and create a variety of tones in changing hues. It is these leaves that I enjoy painting the most; their colours are often so vivid that it is necessary to push the colours in my watercolour box to their limit by using them unmixed

and being careful not to get any traces of other pigment in the watery solution. However, the beauty of these leaves is short-lived, and they fall twirling or are drifted in gusts by strong winds that strip the boughs bare.

There are many different images that remind us of autumn: bonfires of brown leaves; roasting chestnuts; stags' antlers resembling the shapes found in the bare boughs of trees. When the leaves fall from the trees it is easier to see the grey squirrel frantically foraging for food, preparing caches of fruit and nuts so that he can survive the winter.

Falling leaves – study No. 1.

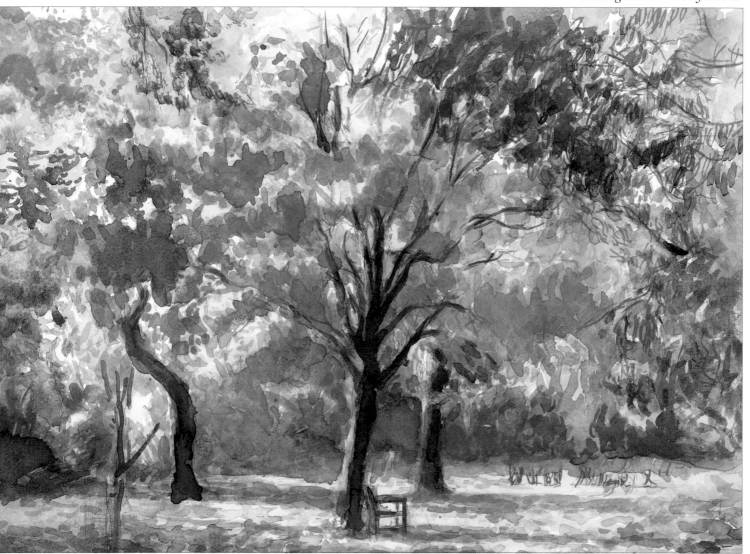

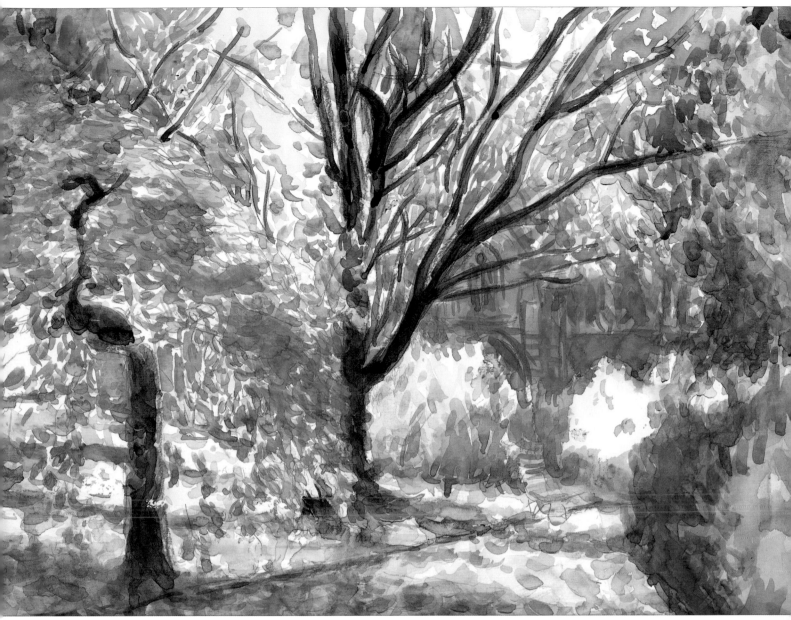

Falling leaves – study No. 2.

Autumn sketchbook

Falling leaves, Russell Square, London

Original size: No. 1: 37 x 42cm (14¹/₂ x 16¹/₂in).
No. 2: 29 x 42cm (11¹/₂ x 16¹/₂in).
Paper: 300gsm (140lb) mould-made acid-free.
Brushes: Nos. 1, 3 and 6; rigger.

These two studies are sketches of trees at varying stages of turning and shedding their leaves. They are both painted in a loose fashion; I am aiming to get more of an impression than an exact copy of what is before me. In the second study I like the contrast and interest of the church in the background. The quality of the light falling through the leaves reminds me of stained-glass windows. The medium of watercolour lends itself well to depicting such a scene.

Colours in the light are more intense in hue than colours that are in shadow. Shadowed colours are not only darker in tone but also greyer or bluer in hue. Getting the right balance between the light and shad-owed colours will give you the feeling of light in your picture, and whenever I am painting my pictures I am always juggling with this.

Autumn in the park

Original size: 29 x 42cm (11½ x 16½in).
Paper: 300gsm (140lb).
Brushes: Nos. 1, 2, 5, 7 and 10.

I was particularly drawn to this scene because of the way light caught the golden leaves. In my depiction I wanted to convey to the viewer the spell that this tree cast and I was not so much interested in making a slavish copy as in capturing the initial impact the tree had on me.

Looking at a tree, there is such an endless wealth of detail that to attempt to draw every twig and leaf would be very difficult. Instead I try to simplify and be selective; I look at the tree as a pattern and draw the shapes between the branches rather than the branches themselves.

Stage 1

First of all I spend some time selecting the view of the tree that I find the most satisfying. I imagine how it is going to fit on to the paper to create a strong, balanced composition. Sometimes I half close my eyes to reduce detail and enable me to see the landscape as blocks of tone. Looking at the large tonal areas will help me find the way to give my picture impact.

Once I have selected my view I start making the initial drawing with a fine brush and diluted French ultramarine. I do the drawing quite carefully, making sure that I get the proportions right. However, I do not draw and then colour my paintings as two separate stages: throughout the painting I draw with the brush, redefining and reobserving the shapes. This approach will give a variety of marks that can give a painting vitality. I make no attempt to disguise my brush-marks.

Next, I lay in my tonal washes with a large brush and block in all the shadows in the first stage. These, like the drawing, are done with French ultramarine.

Stage 1.

Stage 2

Leaves change from green to yellow because chlorophyll, the chemical used for photosynthesis, has been broken down and absorbed by the tree. The disappearance of the green chlorophyll means that previously masked yellow pigments become visible. The light shines through the yellow leaves, imparting an incredible brilliance – to capture this I will need to be careful to keep my colours clean and not let any other pigments run into them.

With a wide brush I start laying in my lightest and brightest colours. For the yellow I use pure cadmium yellow deep and with a loose wash cover the whole area of the tree, massing the leaves together rather than painting them individually. I also paint this colour on the ground to colour the fallen leaves. The green wash for the tree on the left of the composition is mixed by adding a little cerulean blue to cadmium yellow deep.

Stage 3

To develop the form of the tree I need to paint the shadows that fall on the leaves, which I do by painting yellow ochre over the areas in shadow. This time I try to simulate the texture of the leaves by painting with a round-headed sable brush in a wispy movement.

To suggest the green grass which is not obscured by the fallen brown leaves I blob on to the paper a mixture of Hooker's green and lemon yellow. Next I develop the shadows in the background of the painting by adding a little Payne's grey and Prussian blue to my French ultramarine underpainting. As I put the paint on I keep looking and redrawing with the brush. The black boughs of the trees are painted in using Payne's grey, and I add a wash of lemon yellow on the left of the painting.

Stage 2.

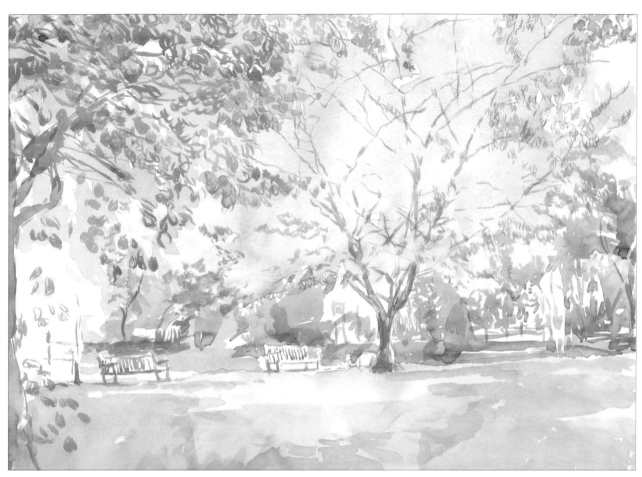

Stage 3.

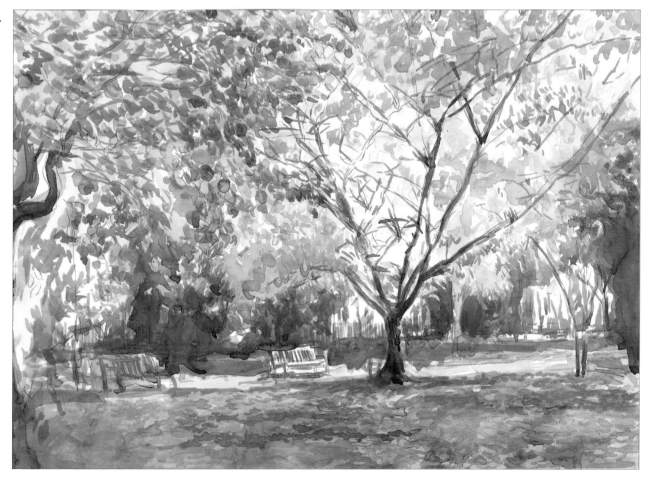

Stage 4 – the finished painting

The picture does not yet convey my excitement about the subject, so I reapply a wash of cadmium yellow over the golden leaves on the tree and ground, which gives them a lot more zing. The branches are drawn while the underlying wash of yellow is still wet, and I flick black paint with the brush. Remember – painting is really a question of *self-expression*, not just of copying nature.

Now I increase the tonal contrast between the shadowy background and the lit tree by adding purple, the colour which complements yellow. Placing complementary colours side by side increases the vibrancy of the colours.

In a painting the eye is immediately drawn to the strongest tonal contrast. I have placed mine where the central tree trunk crosses in front of a break of white light in the background, thus creating a focal point.

There is an interesting interchange of light and shade on the two park benches. The more central one is in the light, and I have left the white paper to come through; on the other bench the reverse has happened and it is in shade against a little strip of light that is falling behind it.

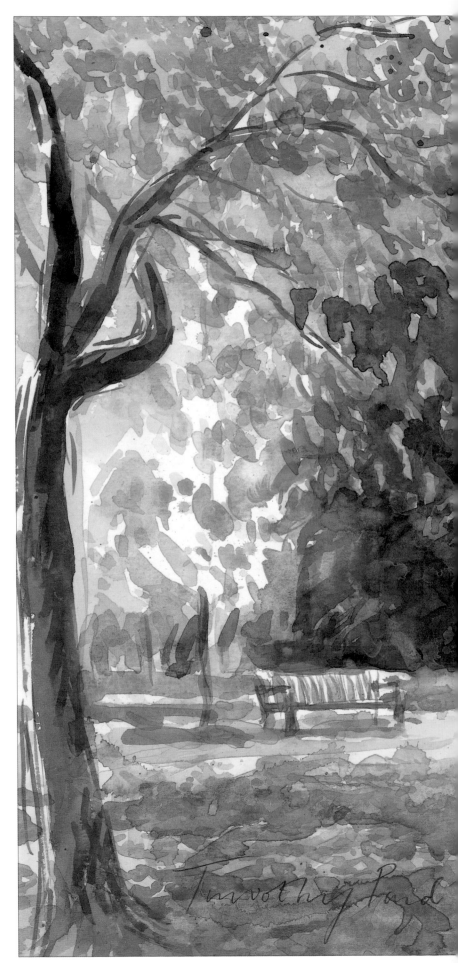

Stage 4 – the finished painting.

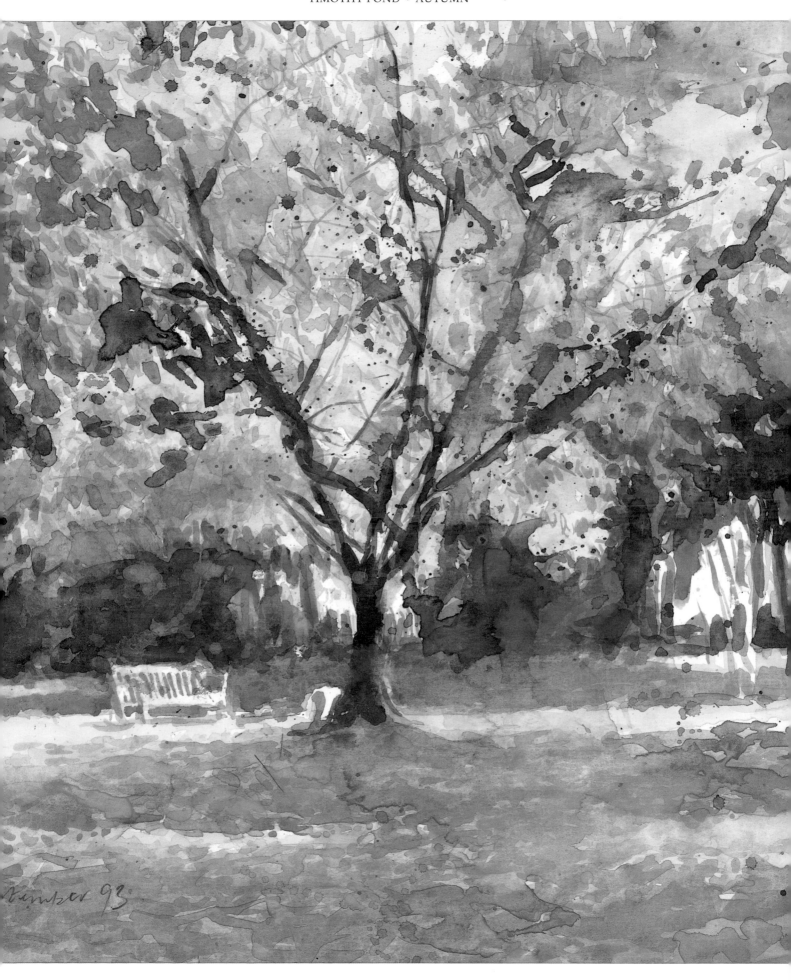

Dale Evans

After spring, autumn comes a close second in my best-time-of-year ratings. I wake up again, the sharp bite in the air is energising, without inducing my spring euphoria, and I want to go walking. Whether I do or not these days is a different matter, but the urge to wander is a strong component of my autumn feeling.

The interest in being out and about stems from a sense of being able to see again after feeling half blind all summer. This has nothing to do with my eyesight. It is more that the density of British summer foliage is such that footpaths become impassable and everything at eye-level or foot-level is either obliterated by bleached green foliage or deeply shaded, whereas in autumn, as plants come into fruit or die back, I am always able to find things of interest to look at. Masses of colourful fruits, seeds and vivid fungi at eye-level or foot-level rekindle my interest in looking and make it well worth the effort to get out and about. There is also a quality to autumn sunshine that actually enhances colours; even dingy browns and greys are transformed by its yellow glow, almost to the point of gaudiness.

Colours

My autumn colour impression is fairly predictable, with a cobalt blue sky, dark clouds and a mass of rusty golds and oranges. These colours reflect my perception that in autumn sunlit objects seem to regain and vibrate with their own individual colours, after having lost them to the bleaching glare of summer.

My mental picture of autumn has strong colours, and the beauty of painting autumn foliage is that artist's earth pigments – Indian yellow and red, yellow ochre, and the siennas, etc. – are perfectly matched to the colours we actually see. An area of blue, whether water or sky, would be needed to balance such a mass of yellows and oranges.

Landscape motifs

The most obvious sign of autumn is when mixed woodland which has been a uniform dull green all summer suddenly, over just a few weeks, becomes a patchwork of colours as individual trees announce their identity with their own characteristic leaf colour.

Colour impression.

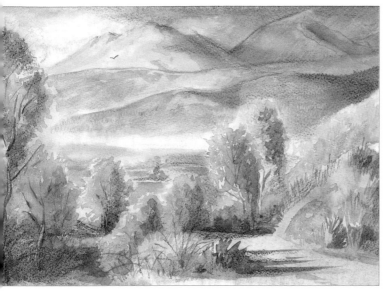

Preliminary rough.

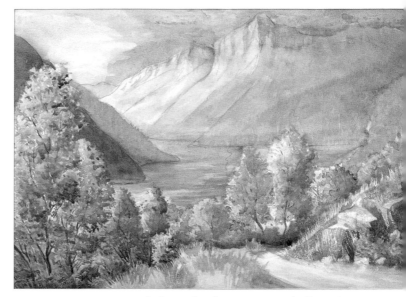

Autumn landscape – second attempt.

Autumn landscape

Preliminary paintings

I wanted to include this patchwork effect of treetops, so the main feature of this preliminary rough is the high vantage point.

The dark sky area in my first impression suggested rain clouds, and I decided that heavy clouds approaching, threatening to block out the sun, would suit my feeling that autumn quickly gives way to winter gloom. The large areas of light/dark contrasts on the distant mountains are intended to add to the slightly menacing mood. (I was well into my second unsuccessful attempt before I hit on the idea of the ruined castle which I used in the final painting.)

This motif of a lake, trees and a path cropped up in several picture books on Scotland. I particularly liked it because the lake provided a complementary blue and because glimpses of water through the foliage gave a sense that the path led somewhere. I used dark mountains in the background contrasting with bright sunlit foliage to enhance the low angle of autumn sunshine. However, I was not really happy with this particular background.

A second attempt with a very unrealistic block of table mountain in the background turned out to be equally unconvincing. The problem lay with trying to put too much in, so I decided to simplify the background and use more contrast to define the form of the trees and mountains. I also had too many colours. I was stuck until I came across a photograph of a castle above a river valley. This provided what I had so unsuccessfully been trying to achieve with my lake and rocky table mountain.

The painting

Original size: 29 x 39cm (11¹⁄₂ x 15¹⁄₂in).
Paper: 300gsm (140lb) Not surface.

Having had trouble with the preliminary roughs, I started this painting without a clear direction. As I had quite arbitrarily established the position of the castle ruins, river and skyline, I relied on the mood in my mind's eye to guide the rest of the composition. I was therefore pleased that as it evolved I was able to incorporate the dark, moody clouds that had been such an important feature in my first impression.

Initially I painted the shadowed bank of trees on the left in full sunlight, but this made the foreground cluttered. This mistake, caused by trying to impose the arrangement of the foreground trees from my preliminary rough on to what had by now become a very different painting, led to a drastic remedy that I would never have considered had the alternative not been to start again: I sponged off all the offending bright colours. The resultant grubby, slightly yellow-stained paper now looked just like trees in deep shadow and it took very little extra colour and modelling to create an effect that suited the mood of the painting.

I used Indian yellow, Venetian red and cobalt blue for most of this painting, with just a touch here and there of viridian and cadmium yellow in the foliage and some Davy's grey in the dark rain-cloud. The background and sky were painted mainly wet-in-wet, while the foreground was created by overlaying colours, with just a little masking here and there to keep highlights. Much of the modelling of the trees and scrub was achieved by letting colours run and blend into each other.

For this painting I have demonstrated the painting of the area around the castle.

Stage 1 – detail

First I take the white off the paper with an overall wash of Indian yellow, then I pencil in the main landscape features. Since I plan to use wax on this painting, I replace these outlines with a thin greyish paint before waxing in (the wax smears if rubbed) the areas shown. (I have used black wax here to make them visible for this demonstration.)

I use masking fluid to retain the brighter highlights where the castle catches the sun.

Stage 1 – detail of castle area.

Stage 2 – detail

Now I paint in the distant mountains. This is done before the sky is painted, so that the sky washes will soften their outlines. Using Indian yellow I paint areas of the darkened hillside to represent raised contours on the slopes, in order to give the mountains some bulk. The glow of the vegetation catching the sun along the shadowed hillside in the foreground is achieved by first painting a line of yellow then drawing light vertical lines in wax over it to protect the bright yellows from subsequent darker washes.

Stage 2 – detail of castle area.

Stage 3 – detail

I mask off the area of trees in the middle distance; then, wetting the whole area, I lay in my sky wash of Venetian red, gradually making it paler towards the ridge of the mountains. When it is dry I wet the area below this ridge line and rapidly wash on a mixture of cobalt blue, Venetian red and Indian yellow, following the contours and letting the wash pool a little along the skyline. While this is still wet I drop in darker tones along the 'valley' lines. Where needed I drop in extra Indian yellow to strengthen and model the contours between these valleys. These washes soften and blend into the earlier coat of Indian yellow.

I create the rain-cloud (not shown in this section) by wetting the whole area above the trees and green hillside. Then I mix a very dark wash of my three mountain colours, plus a little Davy's grey, and drop this into the top left-hand area of the sky, allowing it to feather its way down the picture and dry without being touched. The streaky-bacon sky effect is achieved by painting horizontal lines of masking fluid across the lighter area of the sky. When I remove this it will lift off the Venetian red, leaving soft-edged paler areas to represent white clouds against the pink sky.

Stage 4 – detail

I remove the masking fluid from the clouds and the bank of trees in the middle distance. I model the individual trees with various autumn mixtures of Indian yellow, cobalt blue and Venetian red, adding viridian for the darker tones. As this paint is added, the wax I applied earlier reserves lighter tones, giving the effect of sunlight just catching the tops of some trees.

Stage 5 – the finished painting (shown overleaf).

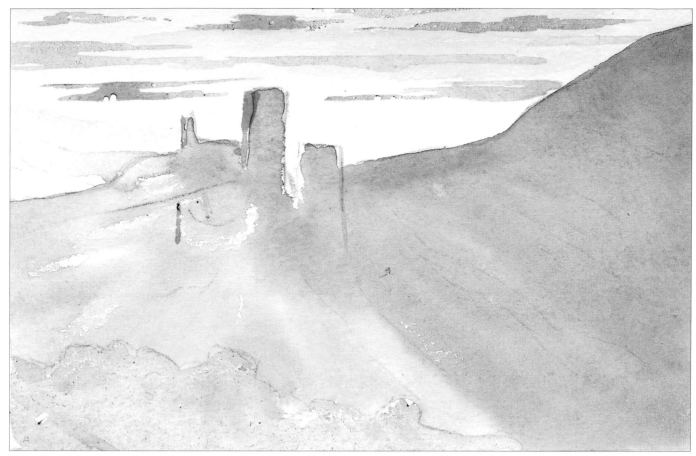

Stage 3 – detail of castle area.

Stage 4 – detail of castle area.

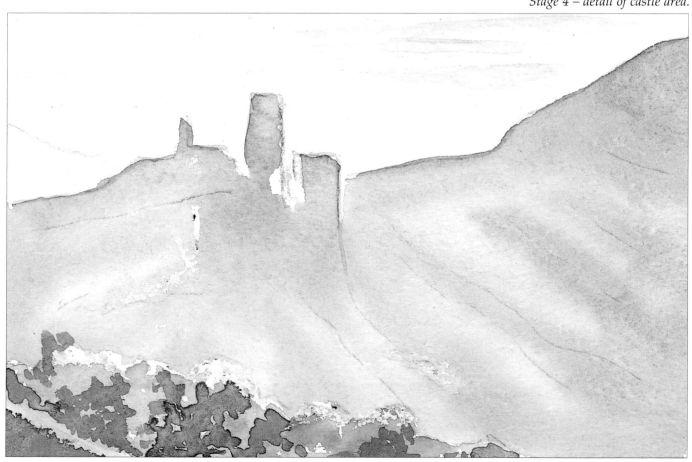

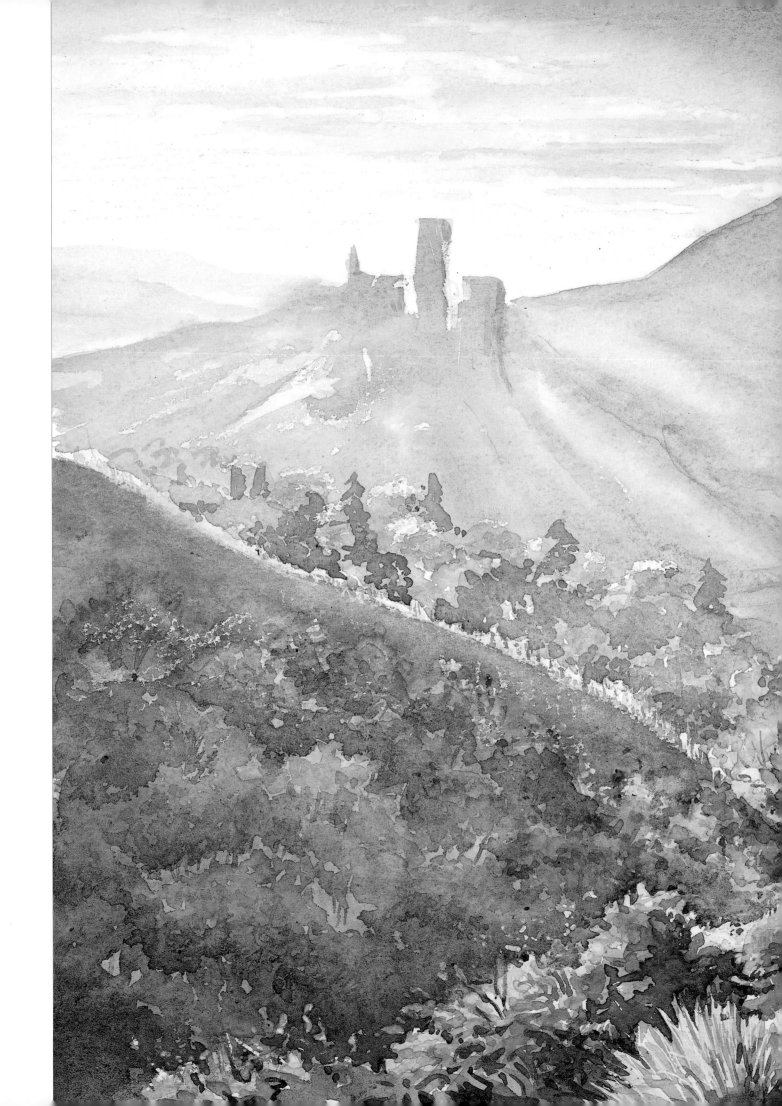

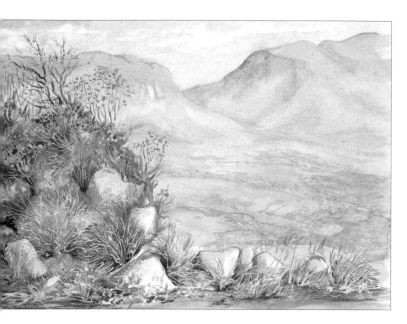

Cretan mountain in October

Preliminary painting *(above)*

In this painting I tried out a different autumn feeling. Mediterranean regions have very little remaining deciduous woodland to provide a patchwork of autumn colours and I was interested to see if I could capture autumn without such an obvious seasonal clue. It is painted partly from memory and partly from photos taken while in Crete one autumn, where even in October it is still hot. In trying to create the appearance of being on a mountain I did not put in a middle distance. It looks a bit like two separate pictures, so for the final version I added lower slopes to the foreground mountain to lead the eye more comfortably into the distance.

The viridian green used for the olive trees in the valley turned out too vibrant; I decided that a mixed green made with cobalt blue and yellow ochre would be better.

The painting *(right)*

Original size: 34 x 46cm (13¹/₂ x 18in).
Paper: 300gsm (140lb) Not surface.

A hike to a vantage point such as this on the higher slopes of a Cretan mountain is to my mind best done in the early morning – that is the time to enjoy the sunshine and spectacular views before a heat-haze develops and the rocks begin to scorch.

Late September/October Mediterranean rains cause a short flush of autumn-flowering bulbs, tiny pink cyclamen, bright-yellow sternbergias, etc. These scattered flowers tucked between rocks are difficult to spot amongst the uniform straw colour of the skeletons of the previous season's plants. I was there just as the first of these flowers were coming through and my main interest was

concentrated on the variety of dusty, spiky seed-heads. I have gone a bit overboard on detailing these with a technique of successively masking off lighter tones and waxing areas to give a dusty texture.

I used yellow ochre, madder brown (alizarin), and cerulean blue throughout the painting. I chose this blue for its tendency to precipitate out in colour mixes. Little pools of pure blue in the hollows of the paper create a dusty effect.

The painting simply proceeded from top to bottom. I painted the sky first, then the mountains, and finally the foreground, which I worked on with wet cotton buds to soften edges and create a dusty effect.

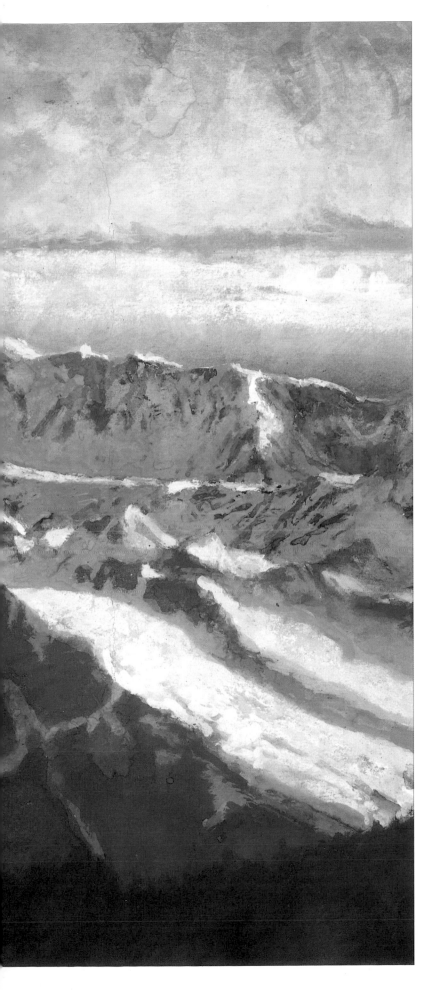

Winter

'Morning frost on stems of grass; fog veiling and unveiling the landscape; trees bent in the wind.'

Winter in the Chugach Mountains by Timothy Pond.

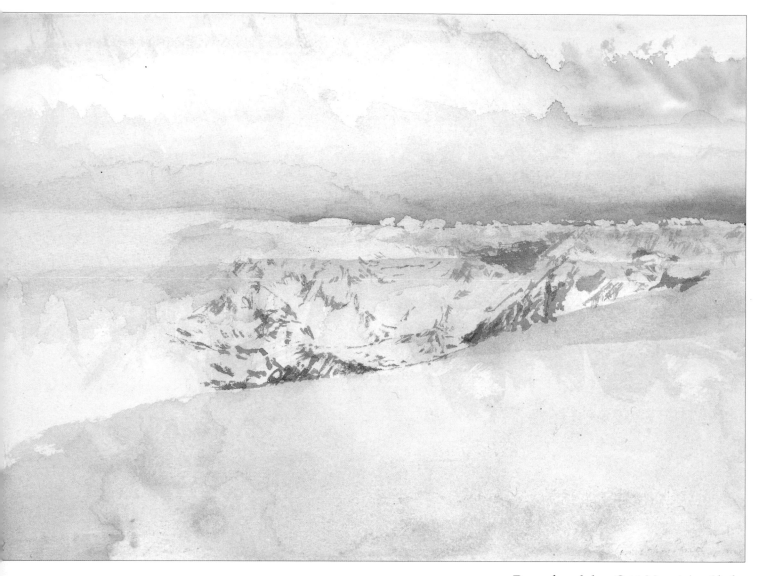

Dawn from below Goat Mountain, Alaska.

Timothy Pond

In winter the days are short and the nights long; the summer's warmth has fled and there can be a bitter chill in the air. Yet, for all its harshness, winter has a beauty unique to itself: morning frost on stems of grass; fog veiling and unveiling the landscape; trees bent in the wind: all these can make interesting studies for the watercolour artist.

However, Britain's winters can be very wet, and a damp Christmas is a lot more likely in most parts of England than a white one. These are difficult conditions for the watercolour landscape artist, as the moisture in the air will prevent a wash from drying, or a sudden downpour may ruin a day's work. Often my winter sketches are speckled with rain, which can enhance their atmospheric quality. A good tip when going out sketching in winter is to wrap sketchbooks up in plastic bags to keep them dry!

I enjoy painting snow, and when in 1991 I was lucky enough to go as the artist on an Alaskan expedition, I found watercolours most suitable for my purposes: they were light to carry, and their transparent washes and speed of execution were good for capturing the ever changing light and moods of a wintry landscape. Since I could work so fast with them, I was able to capture cloud formations as they passed across the skies.

At secondary school I was not recognised as being particularly outstanding at art until we were set the task of drawing a winter's landscape. Instead of approaching the drawing in the usual conservative manner we were encouraged to tackle it with broad expressive marks conveying the drama of the season. I became very involved in this drawing, biting the edge of a hut on the horizon with a scrawling black line. It is important to remember not to be too tentative with your work but to attack it with gusto and get a sense of real involvement.

Winter sketchbook

Dawn and moonrise from below Goat Mountain, Alaska

Original size: each 24 x 33cm (9¹/₂ x 13in).
Paper: 300gsm (140lb) mould-made acid-free.
Brushes: Nos. 1 and 4; rigger.

These two paintings are of the same view, from beneath Goat Mountain in the Chugach mountain range, Alaska, but were painted at different times of the day. Both were painted from the mouth of my tent, looking over a seemingly endless range of unnamed snow-covered mountains.

Early morning and evening, when the light is soft, are my favourite times to paint. On the glaciers dawn arrives at around 3 a.m. At that time of day, if the weather is clear, a pink light catches the snowy peaks, and in my dawn sketch I have tried to catch the unusual light effects.

The second sketch was painted much later on, when the whole mood and atmosphere of the mountain range had changed. The moon and white peaks are picked out in white gouache.

Moonrise from below Goat Mountain, Alaska.

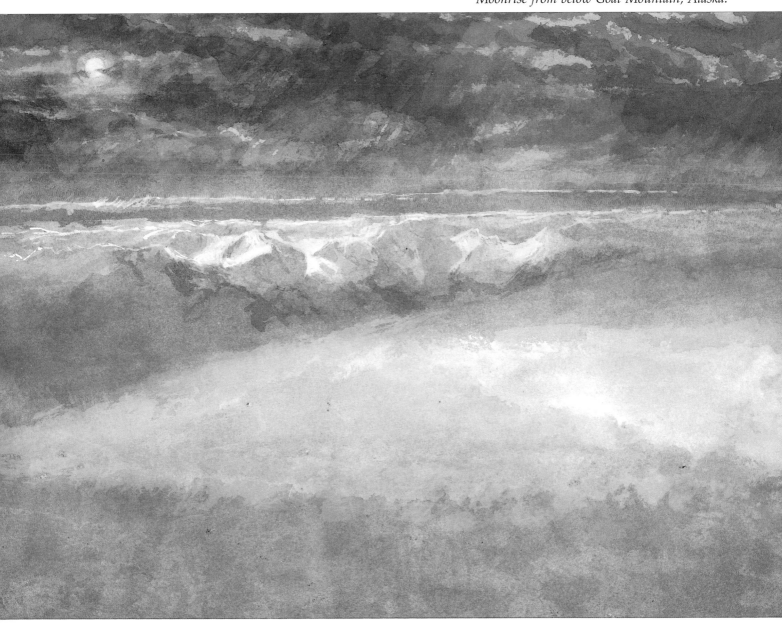

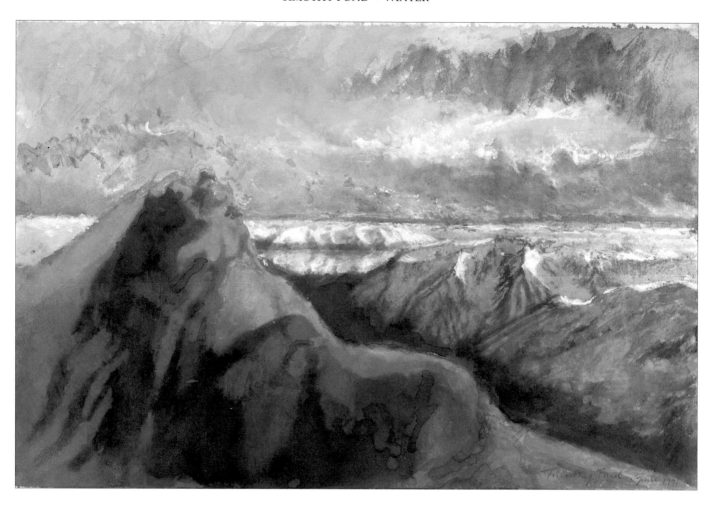

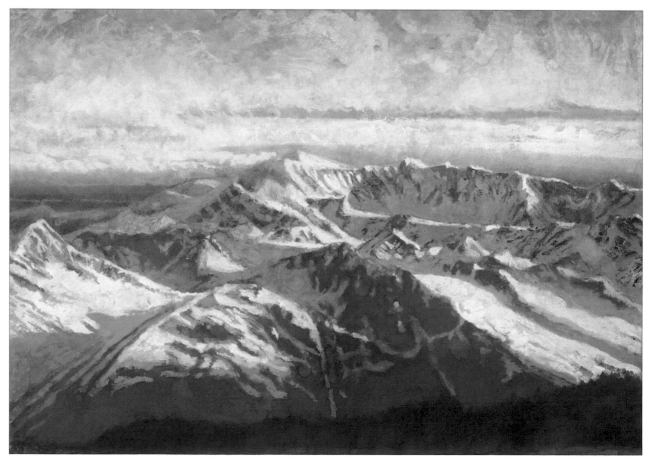

Winter: from Adria, Alaska *(top left)*

Original size: 34 x 52cm (13¹/₂ x 20¹/₂in).
Paper: 300gsm (140lb) mould-made acid-free.
Brushes: Nos. 1 and 4; rigger.

It would be very difficult to complete a large watercolour on such a precarious spot as this painting shows! Hence I painted this picture in the comfort of the studio, using drawings, colour studies and photographs. I do occasionally use photographs in my work, but really it is always a good idea to back these up with drawings and colour notes, as photographs rarely capture all the subtleties of hue found in the landscape. In this painting I wanted to convey the sense of awe I felt as I looked across the Chugach Mountains at an apparently infinite sea of nameless peaks.

The tops of the nearer mountain peaks were picked out with a pinkish light and those in the distance were reflected in a still lake.

Winter in the Chugach Mountains, Alaska *(bottom left)*

Original size: 50 x 72cm (19¹/₂ x 28¹/₂in).
Paper: 300gsm (140lb) mould-made acid-free.
Brushes: Nos. 1 and 4; rigger.

As watercolour is a transparent medium, I generally lighten my colour mixture with water rather than paint; the white paper shines through the wash and provides the only white a watercolourist really needs. However, there are times when it is useful to have some white body colour, especially if I am working on a snow scene, or on a mid-tone watercolour paper, or need to make corrections. Permanent white gouache is more opaque than Chinese white watercolour and is more satisfactory for this purpose.

So in this painting of the Chugach Mountains I chose to make use of white gouache in places for snow effects. I would not like to prescribe a rigid technique for water-colour painting. Every landscape is different and may ask to be tackled in a different way. By experimenting with the medium, you will develop confidence and an under-standing of how to manipulate paint. I feel free in my paintings to mix watercolour with pencil, ink, wax crayon, or gouache, depending on the effect I want to achieve.

An extensive section of this painting is shown considerably larger on pages 108–109.

A winter landscape

Preparatory sketches

Original size: both 23 x 28cm (9 x 11in).
Paper: 300gsm (140lb) mould-made acid-free.
Brushes: (1) Nos. 1, 4, 7; rigger; 20mm (³/₄in) Dalon brush.
* (2) Nos. 1 and 4; rigger.*

1. A view of a mountain called 'Eagle River'. In this sketch I wanted to capture the effect of the light falling on the jagged surface of the rock face. This is the mountain that can be seen in the distance on the left of the final composition.

Eagle River from Raven Glacier.

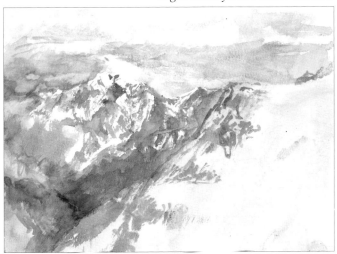

2. A view up the mouth of Raven Glacier. In both of these small sketches I wanted to capture the cold light of winter and the immense, imposing scale of the glaciers and mountains. This sketch was made just as a 'white-out' was clearing; you can see the cloud lifting and unveiling the landscape.

Raven Glacier, Alaska.

113

The painting

Original size: 29 x 42cm (11½ x 16½in).
Paper: 300gsm (140lb) mould-made acid-free.
Brushes: Nos. 1, 2, 5 and 8.

This painting is a visual account of the day I described thus in my diary:

'After several early-morning false starts, by the fifth day at base-camp weather conditions finally looked favourable and we planned to leave at six o'clock that evening. Because the first part of our journey would involve climbing an ice wall, we would need good weather conditions to start. An air of anticipation hung over the camp all day, and while the rest of the group let off steam tobogganing on some nearby slopes, I sketched the view up the mouth of Raven Glacier, where we would later be hiking. To mix my paints I melted snow for water!'

Stage 1

First of all I mix up a good drawing colour for the rocks protruding through the snow. This I make with a mixture of Payne's grey and French ultramarine. With a fine brush I carefully sketch the shapes of the rocks.

When I sketch out of doors I am trying to collect enough information to be able to make a full-blown composition in the studio, so it is important that I try to make my drawing as accurate as possible. However, there is an infinite amount of detail in the rocks, and painting every detail would not allow the painting to breathe. Therefore when I am observing the shapes I use the brush in a feathery motion to convey the feeling of distance and atmosphere.

Stage 1.

Stage 2

Now I have drawn in the mountain range with my brush and indicated a few friends who were sledging on the slopes. Figures and animals can add a spontaneous touch and human scale to a picture. I wanted the figures to appear dwarfed by the immense scale of the mountain rising up behind them.

I have sketched the mountain in the distance in pure French ultramarine to accentuate the feeling of depth. It is a rule of atmospheric perspective that colours become blue in the distance.

Stage 3

Glaciers are not easy things to paint! Besides being heavily crevassed, they are composed of compact molecules of ice which absorb all the colours of the spectrum except blue, which is reflected. The nearest equivalent I could get to this was building up light washes of cerulean blue. At the mouth of the glacier I paint some loose brush-strokes of cerulean blue.

Shadows on snow are painted with pure blue as well. I found French ultramarine especially good for this and by painting the foreground in shadow I help to emphasise the feeling of depth. Other colours I paint at this stage are the green bank on the right-hand side, which is made from a mixture of yellow ochre and viridian, and the jacket of one of the sledgers, which is painted with cadmium red.

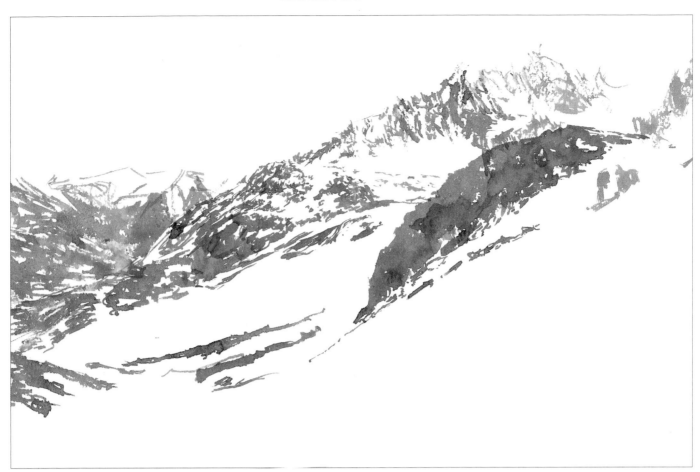

Stage 2.

Stage 3.

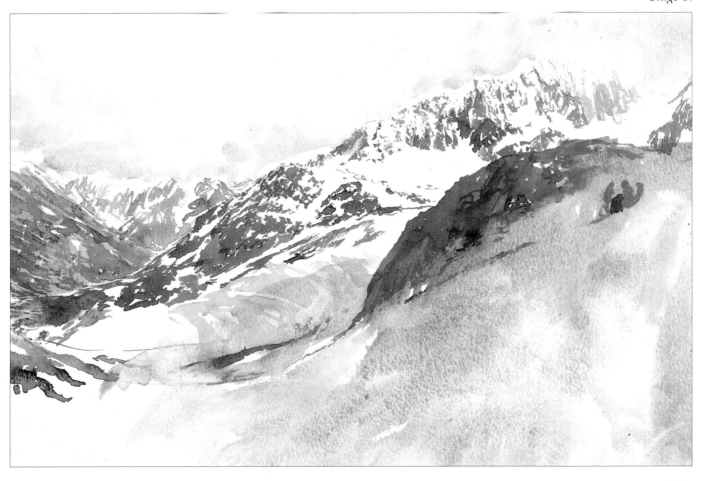

Stage 4 – the finished painting

Towards the completion of a painting, it helps to stand back and see what can be done to unify and enhance the composition, and, in the case of this painting, to intensify the drama.

Now I paint in a dark-blue storm cloud with a mixture of French ultramarine and Payne's grey. The rock formation in the foreground is darkened with ivory black.

In the final stages of a painting I like to increase the contrast between the darks and lights to strengthen the impact of the painting. Here I touch up the details of the rocks in the distance to give the crispness of the way the light catches the snow. The final touches of 'a little more darkness here and a little more lightness there' are important to give the painting sparkle, and they really can make a picture come alive.

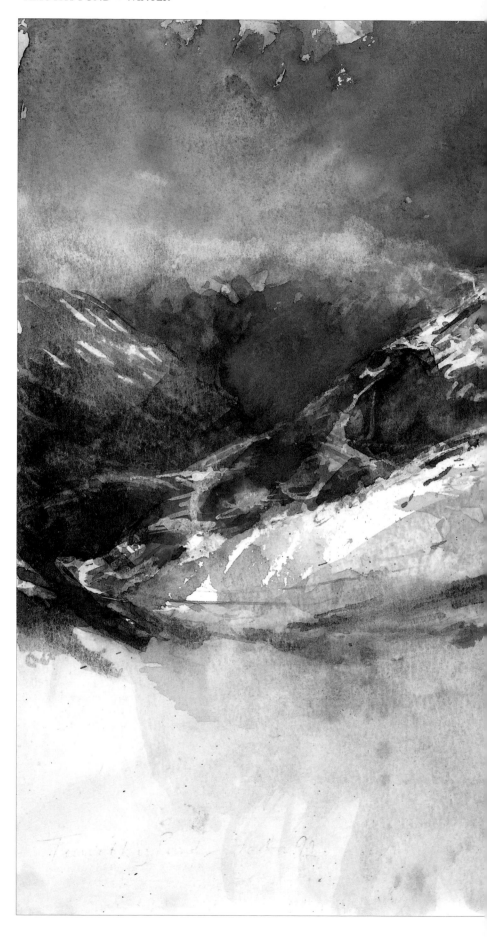

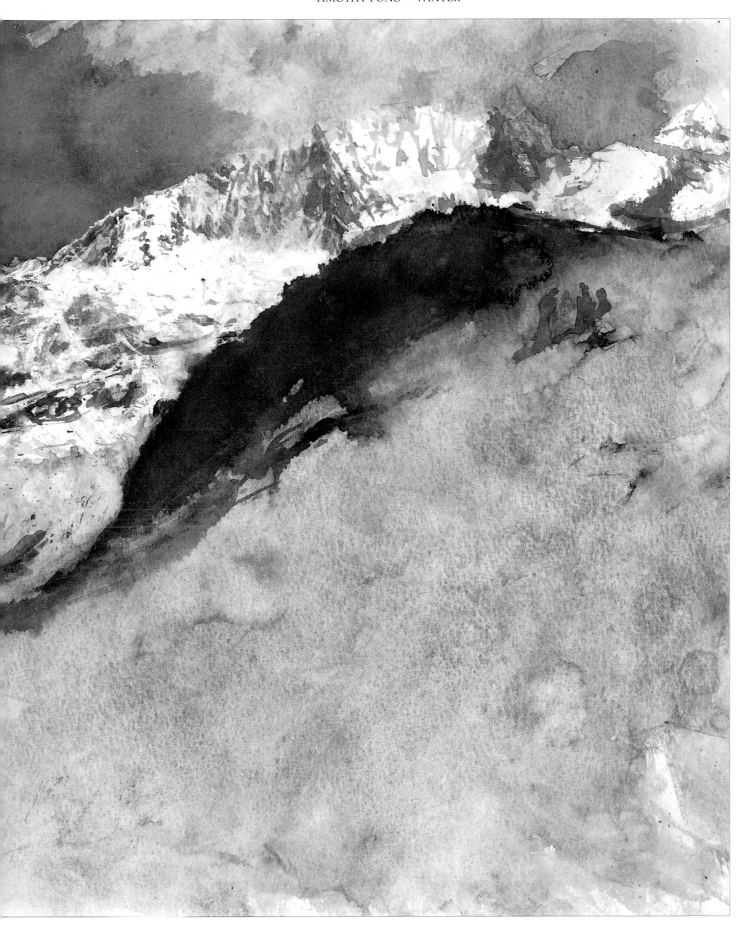

Dale Evans

Winter is 'bare bones' time for most British landscapes. Britain's natural vegetation being predominantly deciduous, geological features, once stripped of their leafy cover, are revealed in all their glory (or inglory). With dull grey overcast skies reflected in rivers, lakes or puddles it takes a good sunset, dawn or snowfall to make me pay any attention to the general dreariness of winter.

I have not experienced any really wild blizzards, and it has been years since I did any winter walking, so my first pencil compositions were a disaster – and my colour attempts were even less convincing. I thought that of all the seasons I would find snowy winter landscapes easiest, but I could not get started; eventually I was not even sure that, for me, winter necessarily means snow. We certainly do not see much of it in Cardiff, and perhaps I do not have romantic associations with it. I see a more desperate aspect of snow. As a child I watched as dead or nearly dead sheep were dragged from drifts as high as houses, my job being to search for small holes on the surface of the snow which had been melted from below by the sheep's warm breath.

In fact, the more I thought about snow and ice and winter in general, the more I came to the conclusion that although lemmings, with their winter larders, sub-snow runways and communal bedrooms, are thinking along the right lines, perhaps bears have the best attitude towards winter…

Winter sketchbook

Colours

Despite two or three colour impressions of winter I could not find a mood, but then this quick doodle made me think again. The colours – yellow ochre, cobalt blue and cadmium red – reminded me of a winter 'revelation' I experienced a few years ago. While looking at a patch of well-trodden snow at about two o'clock I could see vivid violets, blues and yellows in shadowed footprints. Soon, with my eye 'tuned in', I was able to see the full rainbow spectrum in expanses of apparently featureless undisturbed snow and I was astonished that I had never seen it before.

I wondered if the romance of my winter painting was to be found in these rainbow colours.

Colour test 1.

Colour test 2.

Colour test 3.

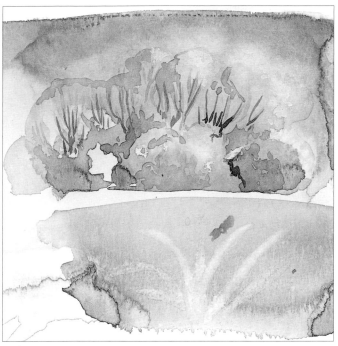

Colour test – trees.

Landscape motifs

I still could not come up with a subject, and I remained stumped until one day I had a conversation with a friend about morning hoar frosts evaporating so quickly. Enthusiasm stirred within me as she described a recent frosty-morning walk and I accepted her offer of a photo she had taken. The image had everything I needed and was very similar to one of my first colour impressions. A frosted scene also posed the challenge of how to paint it. I quickly sketched out a composition of the 'frosty morning'.

The colour test opposite convinced me that it would be difficult to capture a frosty texture with a watercolour and masking fluid approach, and I would need a 'trick' of some sort. I decided that a wax-resist approach would work best.

Colour experiment – winter.

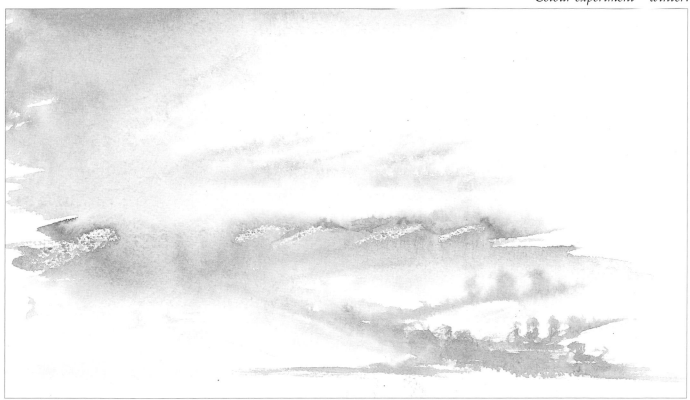

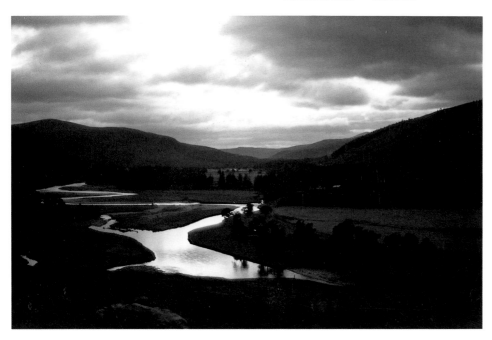

My photograph of a Scottish valley which inspired the Winter *painting.*

Winter

First thoughts

Having chosen to represent a pleasant, safe rural scene in my demonstration painting, I felt that I still wanted to express the quiet menace that I associate with snow and ice.

I recalled picture research I had done a year or so before for backgrounds to paintings of swans in their Arctic breeding grounds, and then I also remembered the same desolate chill of emptiness that I had experienced in the Scottish highlands, one August about five or six years previously.

This silver-ribbon river motif is based on a view along the Inverey valley. I had stopped my van especially to look at this scene and take this photograph. I was camping on my own and was probably feeling a bit vulnerable, as I was also debating whether it would be a safe place to park for the night. I decided against it, but something about the view had obviously become associated with that feeling of being alone in a magnificent but potentially hostile place. With the last dusk light reflected along the length of the river, dark silhouettes of hills on either side exaggerated the silver brilliance.

The memories sparked off by the photograph tied in with the memories of the atmosphere I had become aware of when looking at similar views of tundra regions in summer, where meltwater trapped in shallow rivers and pools by the permafrost also reflects back silver.

Although neither the photograph nor the summer tundra views are snow-scenes, I wanted to see if this motif would lend itself to a desolate, menacing winter interpretation.

Winter: a first compositional sketch.

120

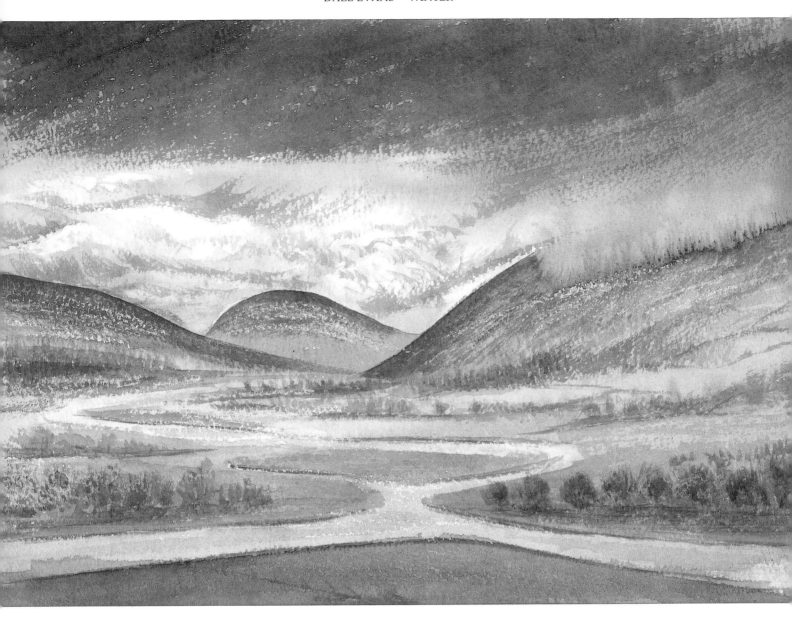

Preliminary painting (above)

Original size: 29 x 39cm (11½ x 15½in).

When I had painted this picture, I decided that the motif did in fact work well, but that I had taken the gloom factor a little too far. I needed a more expansive landscape to capture an icy, haunting Alaskan or Siberian emptiness.

The painting (shown overleaf)

Original size: 29 x 39cm (11½ x 15½in).
Paper: 300gsm (140lb) Not surface.

By choosing an earlier time of day for the final painting I have been able to introduce more colour, but at the expense of the strength of the silver-ribbon motif, which here is only loosely suggested. However, by altering the scale of the trees, etc., the painting now has the quality of open emptiness that I wanted. Cyanine blue, alizarin crimson and yellow ochre were used for the sky, with the addition of burnt sienna and brown madder (alizarin) for the distant forests.

The river was masked out after a first overall coat of yellow ochres to give a hard edge and the tops of the main trees were also protected. I stroked candlewax roughly over the background hills and trees to create the effect of snow. Several alternate layers of wax and various washes were laid to build up the density of colour gradually until I was happy with it. Having a warm middle distance and a relatively cool foreground breaks the general rule of thumb for colour perspective, but I think it contributes to the icy spacious feeling I wanted to capture.

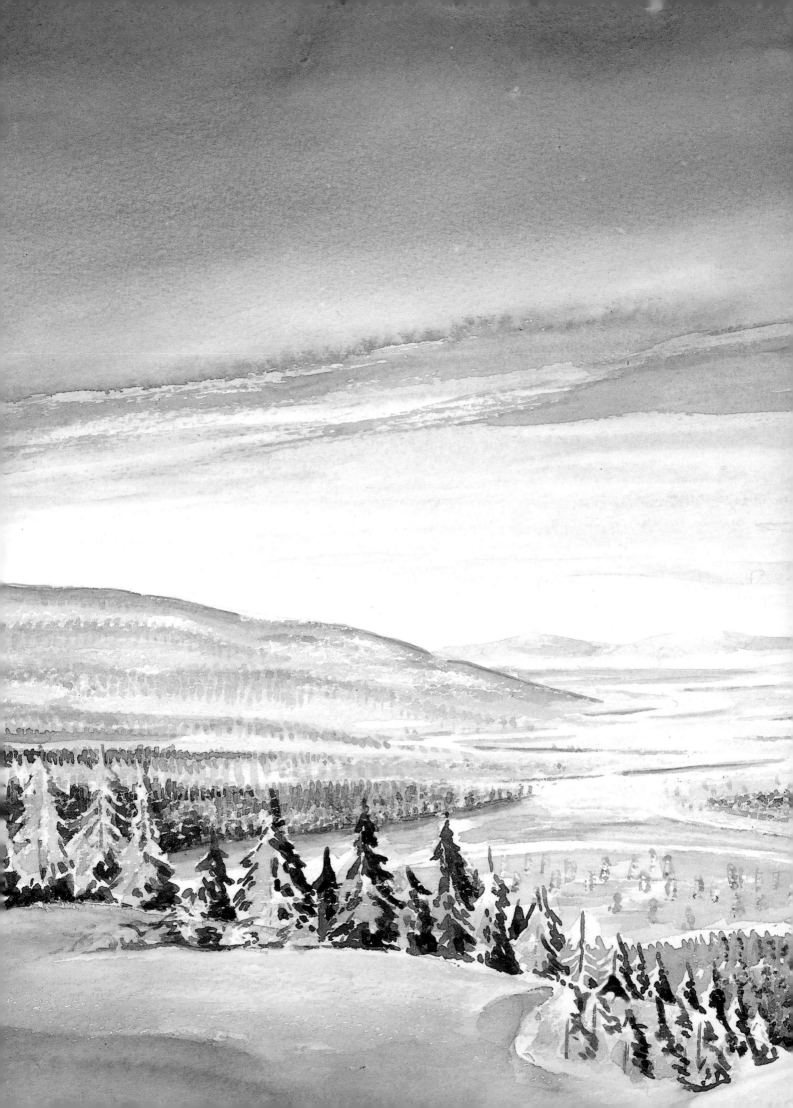

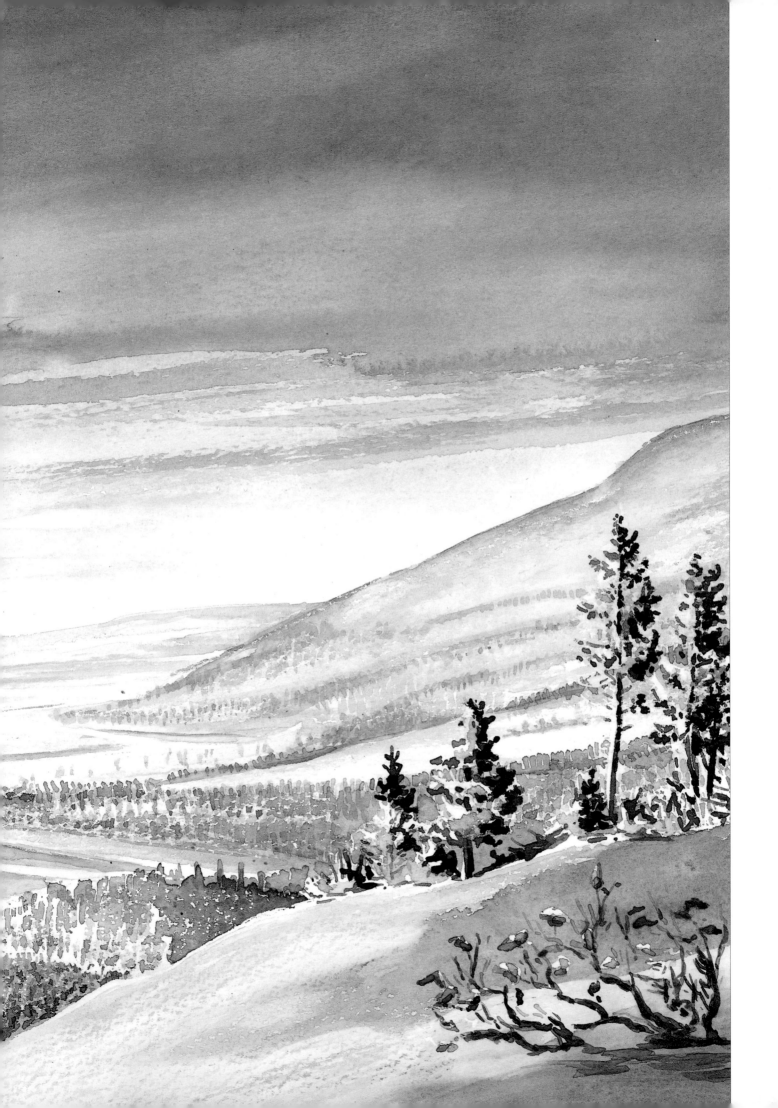

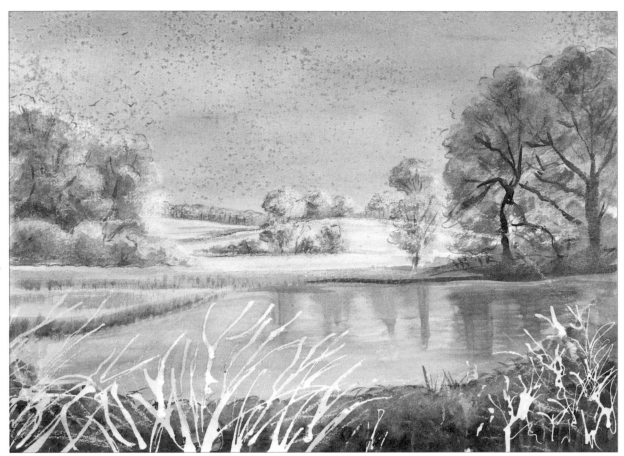

Preliminary painting.

Frosty morning

Preliminary painting

Here I extracted the main elements, condensed the view, and exaggerated the colours. In this rough I was mainly concerned with testing the candlewax-resist technique to see if it would capture the fuzzy effect of frosted treetops, and especially the spiky, frosted foreground. I compared the effect with my usual masking-fluid technique and decided that a combination of the two worked best, using masking fluid to keep very bright whites. (The speckles in the sky have nothing to do with this painting: I used a piece of scrap paper that was damaged!)

The painting

Original size: 30 x 41cm (12 x 16in).
Paper: 300gsm (140lb) Not surface.

For the final painting I stayed more or less with the same composition but generally tightened up the drawing, especially in the foreground. I also toned down the sky colours to give an icier feel to the painting. I was tempted to add sheep to the distant fields but decided against it.

Stage 1

First of all, I lightly pencil in the skyline and foreground vegetation. Then, using a stick of candlewax, I loosely outline the tops of the main tree-forms and the foreground vegetation. (I have used black wax for this stage

Stage 1.

124

of the demonstration as candlewax is virtually invisible against the white paper.)

I apply the wax lightly and freely, just covering the top of the grain of the paper and leaving bare paper in the hollows to take paint. I flood a wash of Indian yellow over the paper which (when candlewax is used) runs off the underlying wax drawing, making it easier to see, and proceed to the next step. Then, while it is still wet, I wash alizarin crimson down to the skyline, as shown. I allow this to dry completely, then, starting with dense paint at the top left-hand corner, I quickly stroke a wash of cobalt blue down the paper, fading off towards the right and giving way to the yellowy-pink skyline.

Stage 2 – detail

This demonstrates the wax-resist technique for an area of trees in the middle ground (a similar process combined with masking fluid was used for the foreground). I lighten the top waxed edges of the treetops where needed with a cotton bud and use a wash of raw sienna to strengthen their general form. I leave the sides, which catch the sunlight, somewhat paler.

I use a few loose horizontal strokes of the same wash to colour the fields and reed-beds. When this is dry I apply another light coat of wax over the raw sienna. This will protect and retain speckles of yellow as I now loosely dab on a darker mix of cobalt blue, raw sienna and burnt sienna to suggest the mid-tones of a mass of bare branches and twigs. The same mix is used to define the edge of the pond and also tree trunks and branches.

Stage 2 – detail of middle ground.

Stage 3 – detail

I lightly suggest distant trees with a more bluish mix which speckles where it overlies the coat of wax. On the crowns of the trees, areas are brightened and enriched with dabs of burnt sienna.

When this is dry I apply another light coat of wax and with a darker mix add the deeper tones to the trees.

Stage 3 – detail of middle ground.

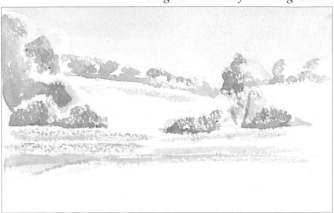

Stage 4 – detail

With more light strokes of wax I mask off further areas of the trees and with a darker mix of cobalt blue and the siennas I add the deepest shadowed tones. I strengthen the tree trunks and branches with a few light strokes of the same mix and define the vertical shadows at the edge of the reed-bed.

I add the water by first wetting the whole area and stroking on horizontal lines of the sky colours, cobalt blue and alizarin crimson. These mingle and blend with the Indian-yellow wash already on the paper. Then, working wet-in-wet and using light horizontal brush-strokes, I paint in a mix of the darker tree colour, which gently spreads to form the tree reflections.

Finally, I add the darkest tones where they are needed, especially in the water reflections. I now add the foreground with the masking technique described for the spring and summer paintings. By gradually masking off lighter tones with both masking fluid and wax before proceeding to a darker wash of paint, I create the impression of tangled, bedraggled winter grasses.

Stage 4 – detail of middle ground.

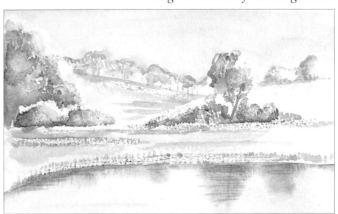

125

Stage 5 – the finished painting

When the masking fluid is finally removed, the first masked areas are brilliant white and, along with the wax-resisted frosted twigs, contrast starkly with the view behind.

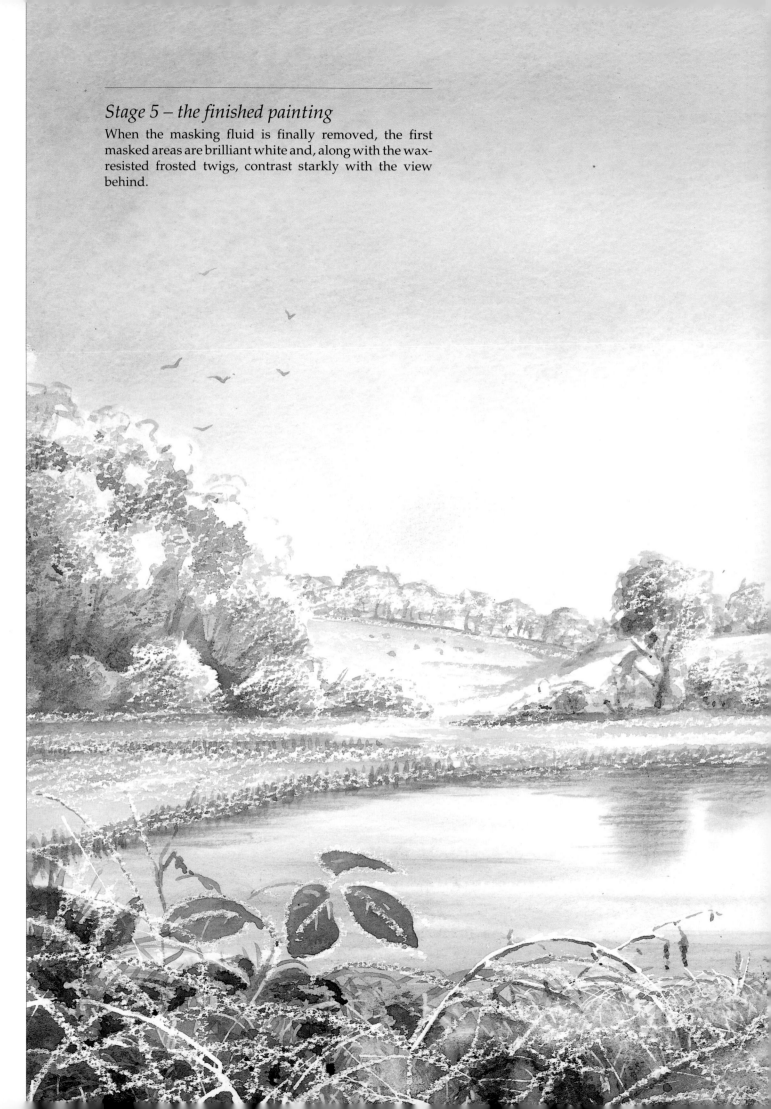

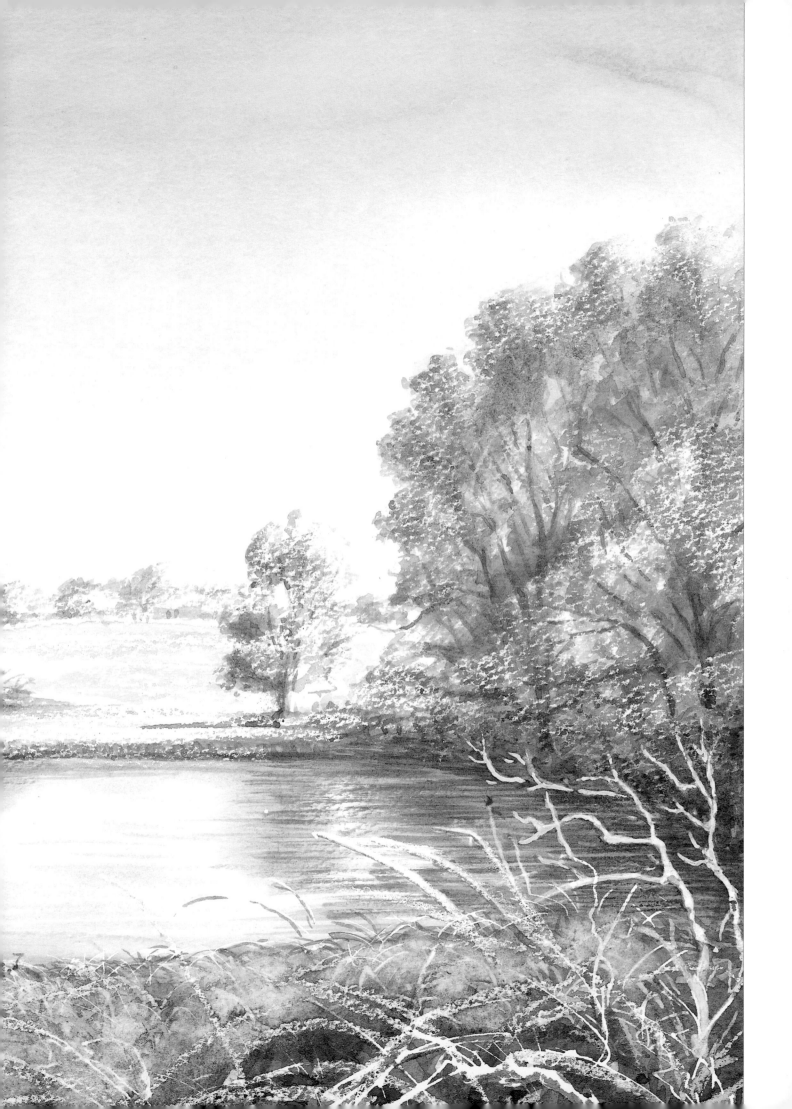

Wendy Jelbert

Winter has inspired artists throughout the ages in different ways. Many painters have left the whiteness of the virgin paper to create the very essence of snow. Its starkness evokes a special beauty and inspires a boldness and strength that no other season demands.

Winter may be the season of bleakness, but there is always a trace of colour. These brief, tantalising glimpses fascinate me: rosehips, almost spent, but clinging on in tangles of undergrowth; massed old man's beard, majestic in purple and bronze net-like waves, cascading over the tops of hedgerows; or the pearly pastels of snow itself.

All these memories of winter conjure up landscapes ready to be placed on paper: the crunch of frozen ground on frosty morning walks with one's breath stifled in scarves yet escaping intermittently in tiny blasts from the warm folds; skeletal tree shapes writhing towards a steel-grey sky; ice-patterns on window-panes; freezing January rain encrusted on wild haws; and even today the occasional chestnut-seller on a street corner! I store up all these cameos in my mental sketch-book. In nature, all is in readiness underfoot, geared towards the gradual welcome return of spring.

My favourite winter colours, which I have laid out for you below, are cerulean blue, flesh, mid-grey gouache, Naples yellow, cobalt violet, Vandyke brown and alizarin crimson.

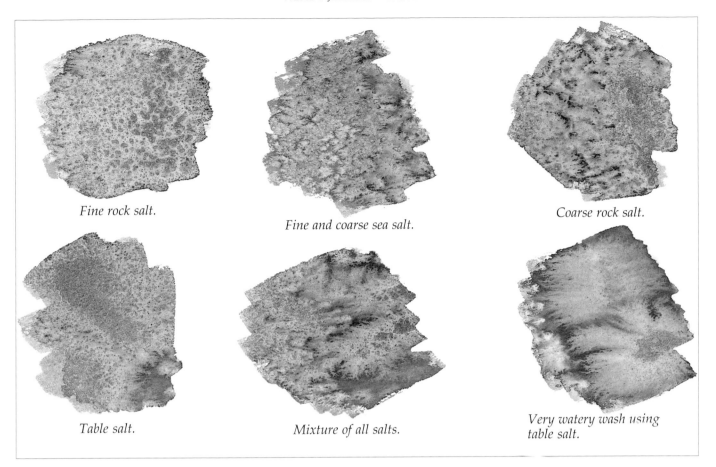

Fine rock salt.

Fine and coarse sea salt.

Coarse rock salt.

Table salt.

Mixture of all salts.

Very watery wash using table salt.

Snow textures

Portraying snow can be extremely difficult – that endless stretch of white needs special treatment. Here I have tried to help with some tricks!

The addition of salts into your initial wash can create a wealth of textures. The washes can explode into the most attractive mottled or starred formations, creating some effects of drifting or driving snow. These exercises are influenced by the paper you decide upon, the water used, the intensity of the watercolour wash, and the type of salt scattered into your picture, so there are many variations.

All exercises should have a strong wet first wash. You should leave the salts untouched for several hours, and they should be bone dry before you brush them off with a clean duster. I have used Winsor blue watercolour and a Not 300gsm (140lb) watercolour paper.

Using salt effects to create a wintry picture.

129

Winter sketchbook

Crocuses

Painting white flowers against a white background is both a challenge and a joy! The artist has to use his skills to create subtle differences in the 'whites', such as making them into soft pastel shades, so that they show up. This is what I did in the crocus painting (right). The white flowers, accompanied by yellow and purple ones, are surrounded by clumps of crisp white snow. The highlights are the untouched watercolour paper, and the slightly darker tones are made up of white gouache mixed with pale shades of violet and blue.

Snowdrops

In this small wintry painting I used masking fluid, applied with a ruling pen, on all the lightest areas to achieve the spiky cold branches and the sharpness of tone I needed. The shape of the bridge echoed the graceful arched form of the snowdrops (which attracted me to paint the scene), while the lovely backdrop of dense trees contrasted in texture and colour with the bridge and the flowers in the foreground.

Crocuses.

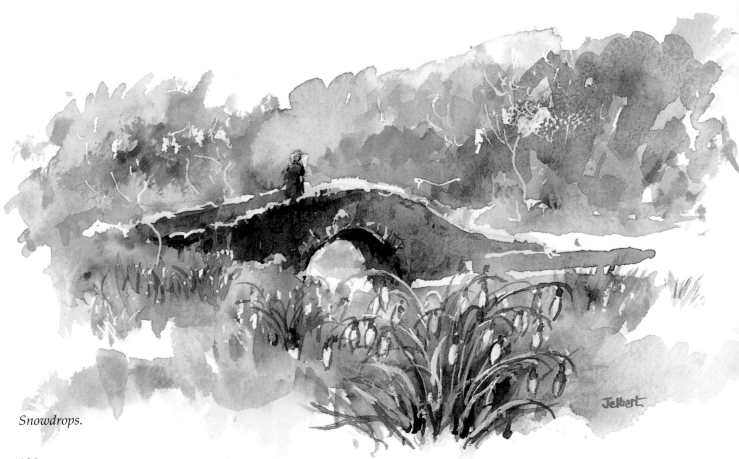

Snowdrops.

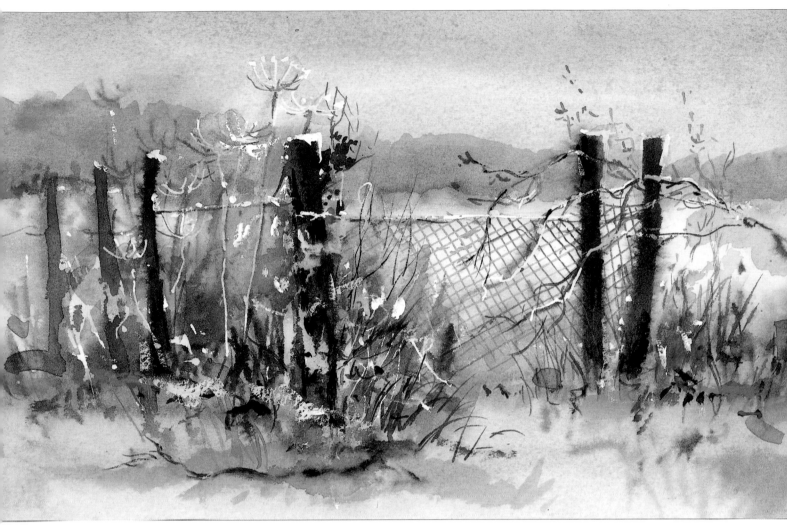

Winter hedgerow.

Winter hedgerow

Original size: 18 x 25cm (7 x 10in).
Paper: 300gsm (140lb) Langton Not surface.
Brushes: soft round-headed No. 6; flat-headed 6mm (¼in)
brush; No. 1 rigger.

This dark, rather startling winter scene is full of contrasts and very limited in colours.

A little masking fluid was used in the cow-parsley shapes and the grasses and across the barbed-wire fence. Cerulean blue is the dominant colour, with mixtures of this colour and Vandyke brown for the posts and shadows, and Naples yellow for the bright distant field and glimpses of green in the undergrowth. This time the chicken-wire is dark against the light, and these details, along with some of the scattered twigs and branches, were created with my rigger brush. The steel-nibbed pen used in the *Autumn Mist* demonstration on pages 84–85 could be used as an alternative.

The remaining posts were painted in with Naples yellow and cerulean blues, and the light areas of snow were made with white gouache, using the end of my little finger and my rigger brush!

Winter landscape – a quick study of a field.

131

Snowfall

Original size: 30 x 41cm (12 x 16in).

I wanted a really chilly feel to this painting, so I made good use of the icy crystalline effects achievable by using salts in a watercolour wash.

Stage 1

In this simple watercolour the positioning of the two trees, balancing the space opposite them which contains so little detail, is very important.

Sketch in these features using a blue aquarelle pencil, then draw in the snow-laden areas on the trees and the lightness in the distance with the ruling pen and masking fluid.

Stage 1.

Stage 2

For the sky, use a strong wash with cerulean blue and Payne's grey and then run the blues down into the foreground. While the paint is still wet, blot in the distant wood with burnt sienna and a touch of blue.

Stage 2.

Stage 3

The first two stages are painted in swiftly, as this initial wash has to take the sprinkling of the salt.

Quickly scatter fine sea-salt over the whole work and let it dry thoroughly. This could take several hours, depending on the warmth of the room. As the salt is working, you can study the lovely patterns that are forming on your painting.

While you are waiting, paint in the trees and the small shrub using Vandyke brown and a little blue.

Stage 4

When the grains of salt are completely dry, carefully brush them off, then rub off the masking fluid in preparation for the next stage.

Using a rigger brush, paint in the small shrub on the right-hand side, and add the beginning of the pathway with an intensified version of the colour you have already used.

Stage 5 – the finished painting (shown overleaf)

Complete the picture by adding tiny twigs in the main trees (with diluted Vandyke brown) and scatter and refine details of jutting grasses and branches in the snow and at the base of the trees and shrub.

Finally, paint in the gently meandering path using a mixture of burnt sienna and blue.

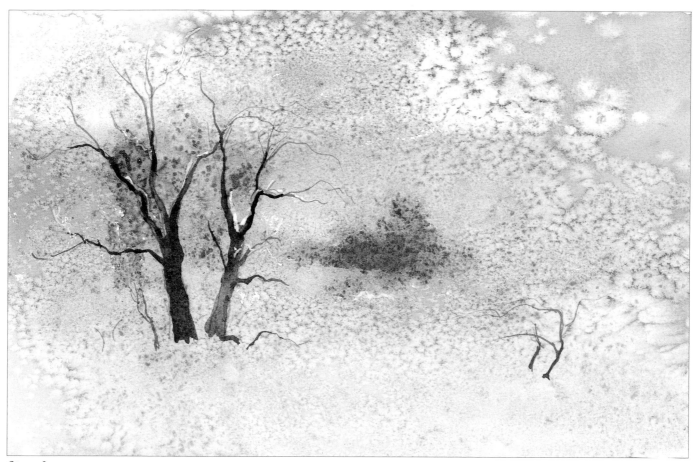

Stage 3.

Stage 4.

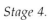

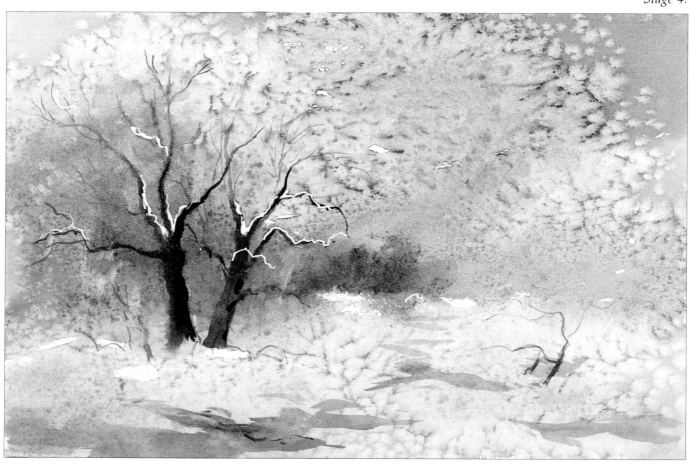

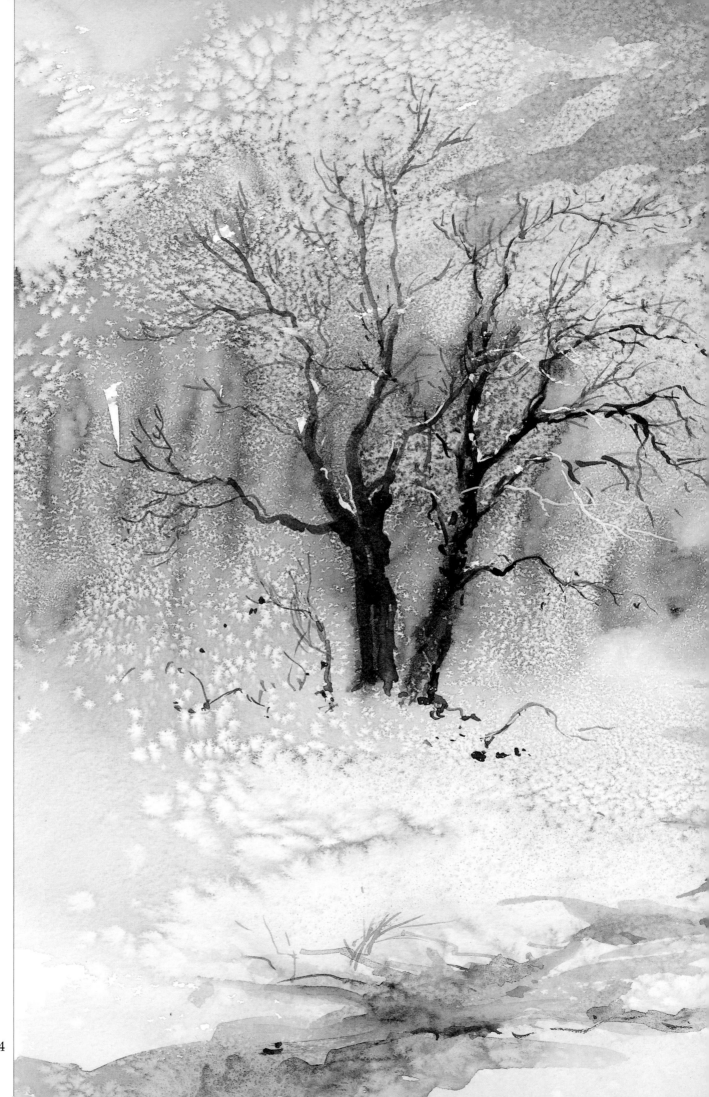

Jelbert

Aubrey Phillips

Although I surprise some people by saying that I find high summer the least interesting of the seasons, their surprise is even greater when I say that I find winter in many ways the most inspiring. There is something about the starkness of winter which appeals to me, with the bare branches of trees opening up distant views which are lost in the full foliage of summer. The sun, with its lower arc in the sky, creates more dramatic lighting effects, with long shadows; or a fall of snow may create a reversal of normal tonal relationships. The moisture-charged atmosphere emphasises the effect of aerial perspective when the distant landscape is viewed in lovely blue-greys against the nearer warm colours which often survive from autumn.

By wearing sensible protective clothing and choosing, if possible, a position in the sun and out of the wind, it is possible to work without undue discomfort. I have often encountered greater difficulties when working from nature in the summer than I have in winter.

Colours

Paper: RWS 300gsm (140lb) rough.
Brushes: No. 12.

In this exercise using winter hues (shadows on snow, winter sunsets, bare branches...), at A, B, and C you will see the colours softly blending together.

I have used the following colours (from left to right in each case): for A, ultramarine, light red, burnt umber, and burnt sienna; for B ultramarine and burnt umber; and for C monestial blue and burnt umber. I use a number of these colours in the painting *A Frosty Evening*.

At D I have washed in ultramarine, and at E monestial blue. After allowing these washes to dry, I laid across them cadmium red, light red, and alizarin crimson so that instead of the colours blending together (as when wet), the transparent effect appears with the lower washes showing through, thereby creating a different colour effect.

Winter sketchbook

A frosty evening

Original size: 27 x 37cm (10½ x 14½in).
Paper: Not (American cold-pressed) 425gsm (200lb).
Brushes: Nos. 5, 8 and 12; No. 4 rigger.

Stark, bare trees show dark against the fading glow of sunset and there is a quiet stillness, with a nip of frost in the air.

I retained the untouched white paper in much of the lower part of the picture, to express the light on the snow.

First I washed in the sky to establish a good contrast, using cadmium red, burnt umber and French ultramarine (I mixed them together on the paper, with a little monestial blue towards the top). While this was still damp, I again added some French ultramarine and burnt umber for the soft shapes of the distant trees against the sky.

Then, while this area was drying, I mixed up a warm dark tone of monestial blue and burnt sienna, with the latter predominating, for the main tree. I applied this to the dry background with the No. 12 brush, using it on its side with a dragging motion to achieve the open effect of bare branches and twigs. I used the same mixture for the hedgerows, varying the tonal strength and employing the No. 4 rigger brush (both its point and its sides) to shape up the main trees further.

Finally, I washed in some monestial blue to which I had added a little burnt umber for the shadows on the snow, making sure that I retained enough white paper to create the light.

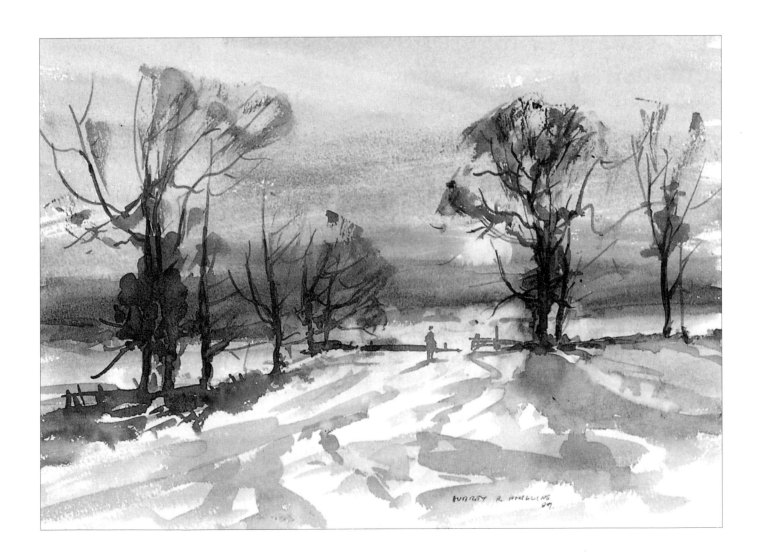

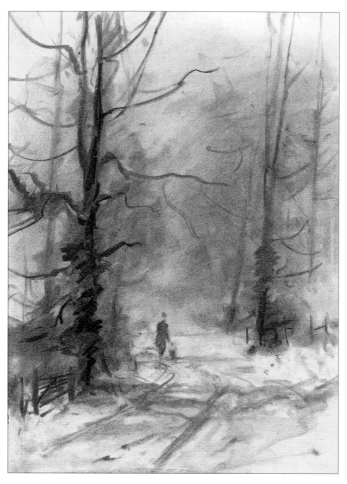

*A snowy morning in a Worcestershire lane –
charcoal sketch.*

A snowy morning in a Worcestershire lane

Original size: 42 x 29cm (16½ x 11½in).
Paper: Richard de Bas 480gsm (300lb) rough.
Brushes: No. 12.

It was a bright, sharp winter morning that inspired this painting. I love this kind of a subject with the sun low in the sky casting shadows across the road which reflect the blue of the sky and contrast with the russet colours of the hedgerows. Here the leaves from autumn still retain their warm tints, giving an uplift of tone, and the bare branches of the ivy-mantled trees stand out against the mysterious shapes beyond.

Under these conditions it is difficult to work in watercolour direct, as washes do not dry quickly enough, so I usually make studies in pastel or charcoal which can be carried out swiftly, and without the problems of drying. This work is based on a charcoal study on cartridge paper which explores composition and strong tonal relationships. I chose a 'portrait' (upright) format for this picture in order to express the tall stark shapes of the trees against the sky and distance.

I began by washing in the sky with monestial blue at the top in a very liquid wash, blending in to light red as I brought it down to the low horizon. Into this I drifted a stronger mixture of ultramarine and burnt umber, suggesting the soft shapes of the distant trees. I then washed in the shadows across the road, together with the ruts, using a pale wash of monestial blue followed by a mid-tone of burnt sienna to the left below the tall tree. This gave me a useful warm area.

Mid-tones of cool grey, again using ultramarine and burnt umber, were put in above this and repeated in the hedgerow on the right. I finished the picture by drawing in firmly the nearest dark trees on each side with a strong tone of monestial blue and burnt sienna, and by adding a little viridian to the trunk of the tree on the left to suggest ivy climbing up it. The gate was then added, using a mixture of burnt umber and ultramarine.

I was careful to retain the white of the paper, which indicates the light on the snow.

*A snowy morning in a Worcestershire lane –
the finished painting.*

Midwinter in the Brecon Beacons.

Midwinter in the Brecon Beacons

Original size: 15 x 27cm (6 x 10½in).
Paper: RWS 300gsm (140lb) rough.
Brushes: Nos. 8 and 12.

In this small watercolour you can see how a few well-chosen washes can create a snowy scene in just a few strokes.

First I wash on monestial blue, stronger at the top of the paper and then softer, with a touch of light red, as I bring it down, leaving the lower part of the paper untouched.

I prepare a mixture of ultramarine and burnt umber, making a cool grey, and apply it to the first wash (which is now dry), carefully shaping up the peaks of the Brecon Beacons. I drift in more light red when this wash is still wet, and shape up the lower slopes of the mountain with monestial blue and burnt umber. I add more burnt umber to the lower right-hand side, and touches of grey, prepared with ultramarine and burnt umber, to the left. You will now see that the first sky wash has given me the proper tint for snow-covered mountain peaks.

Using a strong wash of burnt umber, with a little ultramarine added, I shape up the trees and buildings. Finally, using monestial blue and dragging the brush over the white paper, I create the textured areas on the snow in the foreground.

Snow in Herefordshire

Original size: 27 x 38cm (10½ x 15in).
Paper: RWS 300gsm (140lb).
Brushes: 7.5cm (3in) hake; No. 12; No. 4 rigger.

Stage 1

First I wash in the sky area with a pale mixture of light red and a little ultramarine. Into this I add a darker wash of burnt umber and ultramarine to the right for the deeper-toned clouds, and, with the same mixture but a little

Stage 1.

stronger, for the distance on the left. When these washes are dry, I add burnt umber to the right below the dark clouds. I leave the lower half of the paper untouched.

Stage 2

When these first washes are dry, I shape the trees on the right, using a fairly strong mixture of burnt umber and

Stage 2.

ultramarine and adding burnt sienna into the lower area of the right-hand tree while the wash is still wet. The dark grey to the left of the trees is also made from ultramarine and burnt umber. I lay in the foreground shadows with a pale wash of monestial blue.

Stage 3 – the finished painting

I prepare large quantities of a good strong wash of monestial blue and burnt sienna and boldly wash in the dark shapes of the large trees on the left, using a No. 12 sable brush and dragging it on its side to create texture. I add more burnt sienna (particularly to the tree on the right) while the wash is still wet, and shape the trunk and branches using the point of the rigger brush.

Next I place the figures, using a touch of cadmium red for the one on the left, which gives me a bright warm spot which contrasts with the cooler surrounding colours. The untouched white paper which I have maintained for the foreground snow is an important feature, especially when contrasted with the darker sky.

Stage 3 – the finished painting.

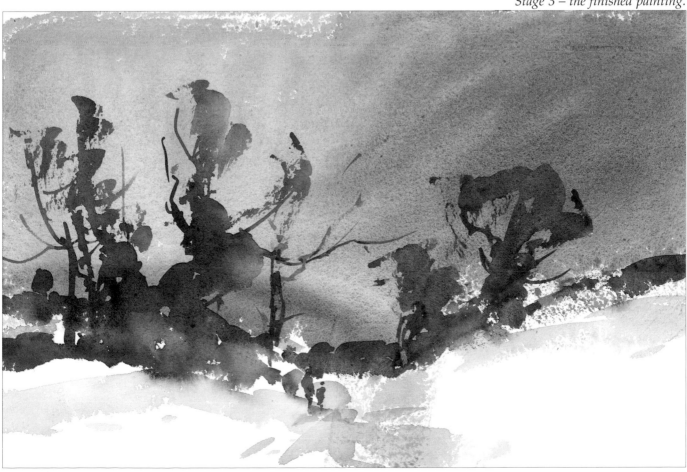

Conclusion

We have been together now through the changing seasons, from gentle spring mornings in water-meadows, where tree forms are dissolved in rising mists, to winter's icy blast. Naturally, we all have our favourite seasons and conditions, and what greater creative satisfaction can there be than going out and responding in the way that we know – that is, in terms of paint – and bringing away something that may give pleasure to our fellows?

I find there is much today that goes under the name of Art which I am unable to come to terms with, but I continue to derive immense satisfaction from contemplating the work of that great lover of nature, John Constable. We have not only his paintings and studies but also his lectures to give us a further insight into his feelings for nature. He says that the happiest hours of a sufficiently happy life were spent by a stream, and his most serene in the open air, with his palette in his hand.

It is a great happiness when men's professions and their inclinations accord.

Misty morning on the Windrush – charcoal drawing.

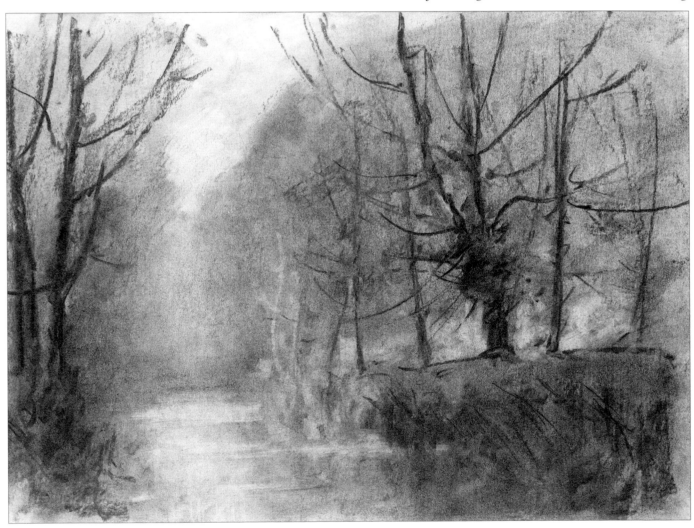

Index

OTHER BOOKS PUBLISHED BY SEARCH PRESS

Painting the Secret World of Nature
Frattini, Lester, Perkins, Sanders

This is a book for artists and nature-lovers alike. It will inspire the artist to take a closer look at the 'hidden world' – the tiny flower and fallen leaf – to find a wealth of exciting new subject-matter. These four artists show how they use watercolours to capture the secret world so easily missed by the casual eye.

Painting in Watercolours
edited by Yvonne Deutch

Although this book was first published in 1982, it is now one of the classic volumes on basic watercolour painting techniques. It provides a good foundation course for the beginner and gives sound advice on choosing materials, mixing colours, laying washes, developing a sketch, and producing a finished painting.

Painting in Oils
edited by Michael Bowers

This book provides a complete course for the budding artist. There are four contributing artists, each of whom take their favourite subject – landscapes, flowers, or still life – and discuss the basic techniques and how to develop skill and style.

Painting with Pastels
edited by Peter D. Johnson

This book, profusely illustrated with colour sketches and studies, is an ideal introduction to this fascinating medium. In it, five artists demonstrate the versatility of pastels, and offer guidance and inspiration along the way.

Painting in Acrylics
Campbell Smith, Clouse, Davies, Jelbert, Turner

Acrylics is an increasingly popular medium, and in this book, five artists give their personal approach to a range of subject-matters, including textures, flowers, landscapes, waterscapes, and miniatures.

Painting Animals in Watercolour
Sally Michel

Animals are fascinating but not an easy subject. In this book Sally Michel shows how to study animals, their forms, movements and characteristics, and how to transfer these observations into delightful paintings of horses, dogs, cats and many other domestic and wild animals.

Drawing for Pleasure
new edition edited by Valerie C. Douet

Bringing together many talented professional artists, this comprehensive book offers hundreds of pictures, sketches and details as the fourteen artists tackle different subjects such as landscapes, figures, trees, flowers, and still lifes.

The Technique of Icon Painting
Guillem Ramos-Poqui

The author brings to life the sacred and beautiful art of Byzantine icon painting with many rich examples, all illustrated in colour. He discusses initial composition, preparation of a panel, oil and water gilding, and egg-tempera technique. This is an essential source-book on the history, technique and meaning of icon painting, and it would make a lovely gift.

Illuminated Calligraphy
Patricia Carter

This, one of our best-selling titles, is proving to be a gret source of inspiration for all manner of craft enthusiasts such as calligraphers, artists, embroiderers, and tole and china painters. Techniques and guidelines for gilding are offered, together with over sixty design ideas for borders with flowers and leaves, banners, ribbons, ropework, and geometric patterns.

Creative Handmade Paper: how to make paper from recycled and natural materials
David Watson

David Watson develops the 'recycling paper' theme in this delightful book. Using household equipment, he shows the simple task of making recycled paper from not only waste paper but also plants, leaves, straw and many other organic materials found around the home and garden. He gives advice on dyeing, scenting, embossing and watermaking, and finally there is a section on sculptured pictures and collages made from paper pulp.

Leisure Arts and Understand How to Draw
Learn the secrets of successful painting and drawing with the *Leisure Arts* and *Understand How to Draw* series. There are over forty-five titles, covering various subjects in a range of media. Beginners will find all the help they need to get started, while more experienced artists will pick up useful tips and hints. Each book is colourfully illustrated and written by outstanding professional artists who give expert advice on materials, tools and techniques, plus step-by-step demonstrations and details, accompanied by clear instructions for each stage.

If you are interested in any of the above books or any of the art and craft titles published by Search Press, then please send for a free full-colour catalogue to:

SEARCH PRESS LTD
Dept. B, Wellwood, North Farm Road, Tunbridge Wells,
Kent TN2 3DR, England
Telephone: (0892) 510850 Fax: (0892) 515903